WALTER BENJ/

'This is a stunning work, offering the most compelling account of which I am aware of Benjamin's project and how it works itself out across the range of his writings.'

Jay Bernstein, University of Essex

The writings of the Weimar philosopher and critic Walter Benjamin continue to provoke controversy in the fields of philosophy, critical theory and cultural history.

In this major reinterpretation, Howard Caygill argues that Benjamin's work is characterised by a focus on a concept of experience derived from Kant, but applied by Benjamin to objects as diverse as urban experience, visual art, literature and philosophy. The book analyses the development of Benjamin's concept of experience in his early writings, showing that it emerges from an engagement with visual experience, and in particular the experience of colour. By representing Benjamin as primarily a thinker of the visual, Caygill is able to bring forward previously neglected texts on inscription and the visual field and to cast new light on many of his more familiar texts.

Howard Caygill is Professor of Cultural History at Goldsmiths College, University of London.

WALTER BENJAMIN

The colour of experience

Howard Caygill

London and New York

First published 1998
by Routledge
11 New Fetter Lane, London EC4P 4EE

Simultaneously published in the USA and Canada
by Routledge
29 West 35th Street, New York, NY 10001

Typeset in Garamond by M Rules
Printed and bound in Great Britain by
Creative Print and Design (Wales), Ebbw Vale

British Library Cataloguing in Publication Data
A catalogue record for this book is available from the British Library

Library of Congress Cataloguing in Publication Data
Caygill, Howard.
Walter Benjamin : the colour of experience / Howard Caygill.
p. cm.
Includes bibliographical references and index.
1. Benjamin, Walter, 1892–1940—Contributions in philosophy of
experience. 2. Experience—History. I. Title.
B3209.B584C38 1998
193—dc21 97–16700
CIP

ISBN 0–415–08958–1 (hbk)
ISBN 0–415–08959–X (pbk)

For Gillian

In the blinding light before the Kremlin gate the guards stand in their brazen ochre furs. Above them shines the red signal that regulates the traffic passing through the gate. All the colours of Moscow converge prismatically here, at the centre of Russian power.

Walter Benjamin, *Moscow*

CONTENTS

CONTENTS

PREFACE AND
ACKNOWLEDGEMENTS

Walter Benjamin's enigmatic legacy has generated a vast and growing body of commentary and interpretation. His contributions to metaphysics, theology, cultural history and literary and art criticism are at once forbiddingly abstract and sensitive to the most inconspicuous, concrete detail. A broadcaster on children's radio during the Weimar Republic, he was also the author of some of the most esoteric philosophical texts to be written in this, or any, century. Such paradoxes, alongside the circumstances surrounding the preservation, publication, and translation of his writings, have resulted in a proliferation of à la carte Walter Benjamins: the Marxist literary critic, the theologian, the surrealist, the philosopher of language, the philosopher of history, the born again romantic, the melancholic, and even the 'swinger' . . .

The reading of Benjamin ventured in this book tries to avoid adding another dish to the menu. It is modelled on Benjamin's own method of 'immanent critique' which refrains from biographical speculation, explicit polemic with other critics and the use of the first person singular. The reading is nevertheless informed by three interpretative strategies which arise from its particular cultural context and stage in Benjamin's reception. The first is an emphasis on the philosophical aspect of Benjamin's thought, especially with respect to the Kantian origins of his concept of experience. The second is the argument that Benjamin's concept of experience leads him towards the transformation of philosophy into cultural history, while the third is the claim that the model of experience informing Benjamin's work emerges from the visual rather than the linguistic field.

Much of this book was written in Paris, in a quiet street off the Boulevard de Clichy. I would like to thank my friends in Paris – Richard Beardsworth, Pablo Caravia, George Collins and Catherine Morel – for their company and critical inspiration. I wish also to thank Jay Bernstein, Greg Bright, Jon Cook, Judith Mehta, David Owen, Edi Pucci and Alan Scott for their criticism of the work in progress. I promised long ago to dedicate this book to Gillian Rose; now it must be dedicated to her memory.

REFERENCES AND ABBREVIATIONS

Published texts are listed under date of publication; unpublished texts by date of composition. The page number cited after the date of publication or composition refers to the English translation if available, or to the German collected works; I have modified translations wherever necessary.

The following abbreviations are used to refer to the major collections of Walter Benjamin's work, in German and in English translation:

GS *Gesammelte Schriften*, vols I–VIII, ed. Rolf Tiedemann and Hermann Schweppenhäuser, Frankfurt am Main: Suhrkamp Verlag, 1972–.

C *The Correspondence of Walter Benjamin, 1910–1940*, eds Gershom Scholem and Theodor W. Adorno, trs Manfred R. Jacobsen and Evelyn M. Jacobsen, Chicago and London: Chicago University Press, 1994.

CB *Charles Baudelaire: A Lyric Poet in the Era of High Capitalism*, tr. Harry Zohn and Quintin Hoare, London: NLB/Verso, 1983.

I *Illuminations*, tr. Harry Zohn, London: Jonathan Cape, 1970.

OWS *'One Way Street' and Other Writings*, tr. Edmund Jephcott and Kingsley Shorter, London: NLB/Verso, 1979.

SW *Selected Writings, Volume 1: 1913–1926*, eds Marcus Bullock and Michael W. Jennings, Cambridge, Mass. and London: Harvard University Press, 1996.

UB *Understanding Brecht*, tr. Anna Bostock, London: NLB/Verso, 1973.

INTRODUCTION

The tradition of Baudelaire's works is a very short one, but it already
bears historical scars which must be of interest to critical observers.
(Walter Benjamin)

The reception of the work of the Weimar philosopher and critic Walter
Benjamin (1892–1940) has vindicated his own insight into the ways in which
the past is continually transformed through its interpretation by the present.
The body of his writings bears the scars of the various disputed phases of its
postwar reception, whether Marxist, theological, cultural critical or philo-
sophical. In each case, the reception has selectively shaped the *oeuvre* by
bringing out a particular feature or phase of Benjamin's authorship and dis-
creetly tucking away the others. The effect is an inevitable levelling of
Benjamin's work, and the reduction of its constituent paradoxes into stages of
a developmental narrative or *Bildungsroman*.

Benjamin himself proposed a distinction between two phases or 'production
cycles' in his work, a claim which, characteristically, he then immediately
qualified. In a letter to his friend Gerschom Scholem of 30 January 1928 he
described himself at work on a project which, if completed, would bring to a
close the *One Way Street* production cycle (*Produktionskreis*) in the same way
that 'the book on the German mourning play closed the Germanistic one'.[1]
His reference is to the *Arcades Project* – 'The Paris Arcades: A Dialectical
Faerie' – which, in spite of his hope that this would be the 'work of a few
weeks,' was to occupy him for the remaining twelve years of his life and
would never be completed. By regarding the *Arcades Project* as a continuation
of *One Way Street* Benjamin points to a substantial overlap of several years
between the two cycles, for while the latter was not published until 1928, its
origins may be traced back to the city writings of the early 1920s, such as the
work on the German Inflation of 1923, and the seminal essay on Naples
written with Asja Lacis and published in the *Frankfurter Zeitung* in 1924.

The schema of two overlapping production cycles is complicated by further
discontinuities within and continuities between the two phases acknowledged
by Benjamin. His work may be subdivided into a number of smaller periods
and even discrete genres which in their turn overlap each other. The first
'Germanistic' phase of his authorship comprises three further phases: the
writings associated with Benjamin's participation in the pre-1914 Berlin Youth

Movement, his academic work at the Universities of Freiburg, Berlin and Bern (1912–19), and his postwar translations and cultural criticism up to and including his failure to habilitate with the *Origin of the German Mourning Play* at the University of Frankfurt in 1925.

The second 'One Way Street' phase is also internally divided, this time by a persistent overlap between the *Arcades Project* and the work on German literature. In a letter to Scholem of 20 January 1930 from Paris, Benjamin reflected on his achievements since embarking upon the *Arcades Project* in 1928. He now describes his two main objectives as continuing work on the *Arcades Project* and gaining the laurels 'as the foremost critic of German literature'.[2] The latter required no less than the 're-creation' of the genre of literary criticism, a genre which Benjamin claimed had not been taken seriously in Germany for fifty years.

To the chronological divisions between the various phases and periods of Benjamin's authorship may be added a number of generic distinctions between the kinds of work that he wrote. From the generic perspective Benjamin's criticism may be divided into three distinct, but again overlapping groups of writings spanning all phases of his authorship. These groups comprise the short critical article, the academic metacritique and the works of philosophical criticism.

The first group of writings comprises the scores of short, critical reviews which were written quickly, indeed from the mid-1920s often dictated, and destined for rapid publication in the booming Weimar newspaper and weekly review market. This source of income largely ceased after the Nazi seizure of power in 1933 and Benjamin's flight to Parisian exile, although he was able occasionally to publish in the French press and in Germany under pseudonyms. During his period of exile Benjamin turned to the detailed historical research in the Bibliothèque Nationale associated with the *Arcades Project*, supported by stipends from among others the Institute for Social Research headed at this time by Max Horkheimer. Benjamin described his short critical reviews positively as the tactical manoeuvres of the 'strategist in the literary struggle' and negatively as 'hackwork' but in any event did not rate them as a significant part of his oeuvre. Nevertheless, although occasional pieces, the short reviews are model contributions to the difficult genre of the short critical essay and often yield invaluable insights into the development of Benjamin's thought.

At the opposite end of the generic spectrum are what may be described as academic treatises which combine historical research with metacritical reflection on the theory of criticism. The first contribution to this genre was Benjamin's doctoral dissertation at the University of Berne entitled *The Concept of Art Criticism in Early German Romanticism* (1919) to which may be added the *Origin of the German Mourning Play* with its metacritical 'Epistemo-Critical Prologue' (1928) and the incomplete *Arcades Project* with its metacritical supplements *The Author as Producer* (1934) 'Convolut N'

(mid-1930s) and the *Theses on the Philosophy of History* written at the beginning of 1940.

The third generic group of Benjamin's writings emerges between the short critical notices and the academic treatises and comprises Benjamin's major critical essays. These writings confront criticism and philosophical reflection, an innovative synthesis first fully achieved in the essay on *Goethes Wahlverwandschaften* (1922) and then developed further in the essays on Proust, Kraus and Kafka. In these and other extended critical essays Benjamin realised his ambition to create a new genre of criticism. In the genre of 'immanent critique' Benjamin brought together philosophical reflection and the close reading of a literary text in a way that continues to provoke fascination and controversy among his readers.

Viewed from another perspective it is possible to regard the phases of Benjamin's work as thematically unified. The overlap between the two cycles may be read as indicating some continuity between the work on the German mourning play and the genealogy of modernity ventured in the *Arcades Project*. The continuity between them may be described in terms of the development of a Kantian concept of experience through an extension of a Nietzschean method of active nihilism. The themes of experience and nihilism are evident in all phases of his authorship, from the work of the Youth Movement period, through the mystical and religious anarchist writings of early 1920s and into the Marxist work of the early 1930s. The concepts of experience and nihilism offer a thread of continuity in discontinuity between the 'Germanistic' analyses of the decay of Christian experience following the Reformation undertaken in the *Origin of the German Mourning Play* and the decay of modern experience described in the *Arcades Project*.

An anticipation of Benjamin's concept of experience may be found in a note dating from 1887 in which Nietzsche raised the possibility of an ambiguous nihilism, one which was both active and passive. Nihilism could be interpreted both as creative – a 'sign of strength' and a 'violent force of destruction' – and as a 'decline and recession' in which 'the synthesis of values and goals (on which every strong culture rests) dissolves'.[3] Benjamin's work may be read as an exploration of the ambiguity of nihilism, an attempt to establish a 'method called nihilism' which would offer both a diagnosis of the experience of a passively nihilistic culture as well as identifying the chances for an active nihilism emerging within it. His analysis of passive nihilism focused on the 'decay of experience' – Nietzsche's dissolution of the 'synthesis of values and goals' – provoked by the destruction of traditional forms of community and their relations to nature by the development of capitalist social relations and technology. This analysis, however, is inseparable from an assessment of the chances for an active, even religious nihilism which nests within the decay of experience, manifesting itself above all in the experience of destitution.

The Benjamin of this book attempts to extend the concept of experience bequeathed by Kant by transforming it into an anti-Hegelian but nevertheless

speculative philosophy of history inspired by a Nietzschean active nihilism. This is a Benjamin whose project is the exploration of the possibilities of a discontinuous experience of the absolute, a project whose beginnings may be traced in the early philosophical writings and whose implications are followed through in the later criticism and cultural history.

Yet this is not to argue that for Benjamin philosophy is a master discourse which holds sway over his critical and historical investigations. The concept of experience itself necessarily exceeds philosophy, and puts into question the relationship between philosophical reflection and its objects. To a large extent Benjamin's thought may be understood as an attempt to extend the limits of experience treated within philosophy to the point where the identity of philosophy itself is jeopardised. In place of a philosophical mastery of experience, whether that of art, of religion, of language or of the city, Benjamin allows experience to test the limits of philosophy. The work of philosophical criticism according to the 'method called nihilism' allows experience to invade, evade and even ruin its philosophical host.

One of the ways in which Benjamin makes philosophy vulnerable is to insist that experience is not primarily linguistic, that it does not take place within the field of linguistic signification. This flies in the face of recent interpretations of Benjamin's philosophy as 'metacritical' and in the lineage of Georg Hamann's linguistic critique of Kant's concept of experience.[4] Here, on the contrary, it is argued that the inspiration of Benjamin's speculative concept of experience is less linguistic than chromatic, that the paradigm of experience for him is not linguistic signification but chromatic differentiation. In Kantian terms his concept of experience emphasises the complexities of intuition – the 'axioms' or 'things seen' – over those of the understanding – the 'acroams' or things spoken. The result is a concept of experience far more recalcitrant to philosophical reflection than the linguistic metacritiques of the concepts of the understanding.

The recasting of Benjamin's concept of experience bears with it severe implications for the understanding of his critical and historical work. The focus upon the colour of experience reveals a Benjamin who is above all a thinker of the visual. Instead of the visual being regarded as an appendage to the linguistic, as in the many readings of Benjamin's theory of allegory, it is here given its proper dignity, shifting the motivation of Benjamin's work from problems of signification and expression to those of inscription and the mark. This shift opens up a previously underestimated dimension of his work and brings forward previously neglected (and hence untranslated) texts on inscription and the visual field. It also casts a new light upon many apparently familiar texts such as the *Work of Art in the Epoch of its Technical Reproducibility*.

These arguments are developed through four chapters which combine historical, philosophical and critical analysis. The first and perhaps most philosophically challenging chapter focuses upon what Benjamin described in

his early writings as the 'comprehension' and 'recasting' of Kant's concept of experience. What may appear to more impatient readers as unnecessarily drawn-out philosophical and philological work on the early writings is necessary in order to question the universally accepted assumption that Benjamin's thought begins in a linguistic metacritique of Kant. The second chapter explores the implications of this new concept of experience for Benjamin's literary criticism, showing how the concept of experience was both the condition of his critical insights while at the same being modified by them. The third chapter reconstructs Benjamin's analysis of the experience of the visual and the work of art, while the fourth presents Benjamin's analysis of the experience of modernity in terms of his work on the city and urban experience. The work ends with an afterword which revisits the theme of 'the messianic' in Benjamin's thought and seeks to relocate it within his speculative concept of experience.

1

THE PROGRAMME OF THE COMING PHILOSOPHY

> Past things have futurity.
>
> Walter Benjamin, *The Metaphysics of Youth*, 1914

The concept of experience

All of Benjamin's writings, whether dedicated to literature, art history or the study of urban culture, may be read as anticipations of a 'coming philosophy'. At the heart of this new philosophy is a radical transformation of the concept of experience bequeathed by Kant's critical philosophy. The matrix for this transformation is to be found in the few short published articles and numerous unpublished fragments surviving from the period between 1914 and 1921. These difficult, opaque and often unreadable texts are crucial to any interpretation of Benjamin's thought. In them Benjamin distanced himself from the tradition of academic neo-Kantianism in which he had been trained at the universities of Freiburg, Berlin, Munich and Bern[1] and sought, in the words of a letter to Gerhard Scholem, dated 22 October 1917, to 'comprehend [Kant] with the utmost reverence, looking on the least letter as a *tradendum* to be transmitted (however much it is necessary to recast him afterwards)' (C, 97–8). The subsequent development of his thought may be understood in terms of such a 'comprehension and recasting' of Kant's transcendental concept of experience into a speculative one.

The 'philosophy of the future' intimated by Benjamin and partially realised in his later works introduced the 'absolute' or 'infinite' into Kant's deliberately finitist concept of experience. Benjamin pursued this course in a way which deliberately rejected both the direction and the implications of Hegel's earlier speculative transformation of Kant's philosophy in the *Phenomenology of Spirit*. The 'coming philosophy' is an anti-Hegelian speculative philosophy driven by the nihilistic refusal of any attempt to grasp or comprehend the absolute through finite categories.

The ambition to extend and transform Kant's concept of experience is the thread which runs through Benjamin's otherwise disparate early writings. Although the transformation of Kant's transcendental into a speculative concept of experience is first declared programmatically in the 1917 fragment *On Perception* and the 1918 *On the Programme of the Coming Philosophy*,[2]

intimations of it pervade the writings of this period. It informs and motivates Benjamin's acknowledged contributions to linguistic, aesthetic and political philosophy[3] as well as his less familiar work in the fields of mathematics, geometry, logic and the philosophy of colour.[4] In these writings Benjamin questions not only the structure of Kant's concept of experience, but also its basic assumptions that (a) there is a distinction between the subject and the object of experience and (b) that there can be no experience of the absolute.

Benjamin's recasting of Kant's concept of experience challenged not only the norms of Kant exegesis, but more significantly the very self-definition of philosophy. His extension of the bounds of experience to include 'sooth-saying from coffee grounds' threatened to dissolve the bounds of sense that were so carefully demarcated by Kant and policed by his philosophical heirs. For Kant, the parameters of possible experience are constituted by the facul-ties of intuition, understanding and reason anatomised in the *Critique of Pure Reason*. He assigns to intuition the pure forms of intuition (space and time), to understanding the twelve categories of the understanding (unity, plurality, totality, reality, negation, limitation, substance, causality, commu-nity, possibility/impossibility, existence/non-existence, necessity/contingency), and to reason the ideas of reason (God, World, Soul). In elaborating his con-cept of experience, Kant rigorously distinguishes between the contributions made by each faculty to experience. Nevertheless, the critical philosophy hinges on the conviction that it is possible to establish a relationship between intuition and understanding given the rigorously prescribed conditions of the subsumption of the material of sensibility intuited through space and time under the categories of the understanding. However, critical philosophy denies legitimacy to any supposed relationship between intuition/under-standing and the ideas of reason.

In his critique of Kant's concept of experience, Benjamin not only extended the neo-Kantian attempt to dissolve the distinction between intuition and understanding, but went further in seeking a (expressly non-, if not anti-Hegelian) concept of 'speculative experience'.[5] This recast the distinction between intuition/understanding and reason into an avowed metaphysics of experience in which the absolute manifests itself in spatio-temporal experi-ence, but indirectly in complex, tortuous and even violent forms. In this way Benjamin evades Kant's exclusion of the absolute from all but moral experi-ence without accepting the Hegelian view of a developmental history of spirit, or the continuous process of mediation between the absolute and spatio-temporal experience.

The proposal to break down the distinctions between intuition, under-standing and reason has led historically either to a revival of pre-Kantian dogmatic metaphysics or to a form of Hegelianism. Benjamin, aware of both possibilities and of the traditional Kantian objections to them, nevertheless insists on a 'transformation of the transcendental philosophy of experience

into a transcendental but speculative philosophy'.[6] For this transformation not to lapse into a gesture of empty philosophical radicalism it was necessary to address the architectonic of Kant's concept of experience. An essential preliminary to any speculative recasting of the distinctions between intuition, concept and idea is to show that the totality expressed by the ideas of reason appears in intuitions and concepts, and, by implication, that spatio-temporal experience contains elements of both categorical universality and rational totality.

This is the project informing the early fragments in which Benjamin sought to comprehend the Kantian tripartite architectonic of experience (reason/understanding/intuition) as but one of a number of possible infinite but bounded surfaces of experience. To achieve this comprehension it was necessary for him to recast the Kantian topology, beginning with a reorientation of infinity and totality with respect to the forms of intuition (space and time). Such a reorientation put into question a further assumption of the critical philosophy, namely the distinction between the *activity* of reason and understanding and the *passivity* of intuition, as well as that between the visual (geometrical) axioms of intuition and the acroamatic (discursive/linguistic) categories of the understanding.

Benjamin's elaboration of a non-Hegelian speculative experience provoked many false starts and unhelpful digressions, and may even in the end be judged as a cautionary failure. It left in its wake the ruins of a number of uncompleted/uncompletable projects, of which the *Arcades Project* is but the most striking instance. Even at the outset of his authorship, Benjamin's texts are often fragments of uncompleted projects, while his correspondence is littered with the remains and traces of abandoned works. Two of the most significant early ruins are the projects dedicated to the study of 'perception' and to 'fantasy and colour'. The surviving groups of fragments associated with these projects provide important evidence for Benjamin's ambition to comprehend and recast Kant's concept of experience and to chart a new philosophical space able to contain the experience of the absolute. They also establish the tension between visual, linguistic and rhythmical aspects of experience which spans the entirety of Benjamin's *oeuvre*.

A point of entry into the complex philosophical matrix of Benjamin's early thought is afforded by the enigmatic fragment from 1917 'On Perception In Itself'. This reads, in its entirety,

> Perception is reading
> Only that appearing in the surface is readable . . .
> Surface that is configuration – absolute continuity.[7]

Although anything but perspicuous, this fragment contains the key for an entrance into the philosophical world of the early fragments. Unfortunately, as is often the case with Benjamin, the key itself has first to be deciphered. The

train of thought moves from the proposition that perception is reading to a transcendental definition of the conditions of the possibility of legibility (namely, of what can qualify to be read, or which appears on a surface) and then to a speculative statement of the condition for the transcendental condition of legibility itself (namely, the configured character of the surface).

Inverting the order of the phrase allows us to see that a surface (Benjamin will use the example of a blank page) is a particular mode of configuring appearances for subsequent reading or perception. In this way Benjamin fulfils the condition of a Kantian transcendental argument by stating, however obliquely, the conditions of a possible experience and by specifying the object of such an experience in terms of *appearance*. What is not Kantian is the way he situates the particularity of the transcendental condition of experience within the speculative context of the infinite configuration of surfaces or 'absolute composition'. The transcendental is thus a fold in the surface of speculative configuration, implying that perception is not the receptivity of impressions but the 'reading' of appearances that are themselves already organised. Even more significantly, experience as reading is not divided between an active 'reader' (subject of experience) and a passive 'read' (object of experience). The 'read' is by no means a passive datum but makes as active a contribution as the 'reader' to the accomplishment of 'perception as reading'.

Benjamin's speculative concept of experience situates Kant's configuration of the conditions of experience first as a condition of legibility and then as one of a number of possible conditions. In terms of the fragment under discussion, the 'transcendental' is made up of the conditions of legibility afforded by a particular surface while the 'speculative' comprises the set of such possible surfaces of legibility. Benjamin explored both of these dimensions, first in his work on colour and configuration and then subsequently in his reflections on language and translation. Both areas of work traced the outline of a transcendental but speculative philosophy in which a transcendental account of the infinite readings (or perceptions) possible within a given surface of legibility (or set of conditions of possible experience) is supplemented by the speculative claim that these conditions are themselves but one of an infinite set of possible surfaces or conditions of experience. The speculative configuration is both folded into and exceeds the particular surface of legibility, allowing Benjamin to conceive of a double infinity: the transcendental infinity of possible marks on a given surface (or perceptions within a given framework of possible experience) and the speculative infinity of possible bounded but infinite surfaces or frameworks of experience. The transcendental infinity of possible legible marks on a given surface is framed and supplemented by the speculative infinity of possible surfaces for inscription and legibility. The exploration of the complex relationship between the two infinities provided the occasion and motivation for much of Benjamin's subsequent work.

A transcendental but speculative philosophy

For the fragment on perception to fulfil the requirements of a 'transcendental but speculative philosophy' capable of describing the conditions for the conditions of the possibility of experience, it was necessary for Benjamin to define more closely the emerging philosophical lexicon of terms such as surface, configuration and appearance. He does not do so in the writings of 1917 and 1918 since he had already established their usage in earlier writings. The basic thought informing the fragment 'On perception in itself' and other texts from the period is recalled by Scholem in *The History of a Friendship*. Evoking his conversations with Benjamin over the summer of 1918 in Bern, Scholem wrote 'Even then he occupied himself with ideas about perception as a reading in the configurations of the surface – which is the way prehistoric man perceived the world around him, particularly the sky.' He added 'This was the genesis of the considerations which he employed many years later in his notes *The Doctrine of the Similar*.'[8] The outline of the thought enveloped in Benjamin's often obscure early fragments may be clarified by a brief anticipation of the later sketch.

The short essay from 1933, *The Doctrine of the Similar* and the revised version from later in the same year *On the Mimetic Faculty* both develop genealogies of perception as reading.[9] This is expressed formulaically in the later version as: '"To read what was never written." Such a reading is the most ancient: reading before all languages, from the entrails, the stars, or dances' (1933b: 162). Configuration is regarded as the condition of legibility: to be legible (i.e. to conform to the conditions of a possible reading or experience) is not the consequence of an intended meaning, but is rather the discovery of a 'non sensuous similarity' between configured patterns. As the example of the dance suggests, these patterns are not exclusively spatial – for space itself is but a particular form of 'non sensuous similarity' or patterning – but can also be temporal, expressed in accent, metre and rhythm. Indeed, it is crucial for Benjamin's argument that space and time (Kant's forms of intuition) be regarded as modes of configuration whose plasticity, or openness to other forms of patterning, can 'decay' or be otherwise 'transformed'. Space and time which feature as the givens of transcendental philosophy become modes of configuration which can be understood speculatively as providing the contours of but one among many possible configurations of experience.

The 'decay' or 'transformation' of a particular configuration of experience is a significant stage in the transition to a new form of reading associated with language and writing – or 'the most perfect archive of non sensuous similarity'. The transition from reading 'what was never written' to writing proposed in both versions of the 1933 text effects a reduction in the complexity of configuration. Instead of patterns being read against each other in a complex space in which there is no foreground or background (the sphere of speculative experience), configurations are interpreted according to their relative position

on a given uniform extended surface. Configuration is thus transformed into inscription, reducing the speculative reading of the similarity between patterns into the transcendental reading of graphically inscribed marks upon an infinite but bounded surface. In the later essays this transformation is regarded as a 'reduction' characteristic of 'modern human beings' whose perception or 'experience' is reduced to reading events within a plane of uniformly extended space and time. Within the given plane, those aspects of configuration excluded from the paradigm of inscription manifest themselves in distorted form, assuming portentous and even ridiculous shapes or otherwise registering their presence in violent spatial or temporal disturbance.[10]

Returning to the fragment from 1917, it is now possible to identify the 'transcendental but speculative philosophy' as the attempt to comprehend speculative configuration beyond its transcendental confinement within a particular surface of inscription. The latter, indeed, is exemplified by the Kantian structuring of experience in which objects appear in the uniform space and time of the forms of intuition, then to be read in terms of the universality of the categories. Totality is either excluded from the realm of experience, as in the case of the ideas of reason, or it is always yet to come in what Hegel described as the 'bad infinity'.[11] In his attempts to develop a speculative (but, again, non-Hegelian) concept of experience, Benjamin effectively transforms inscription into a special case of the more inclusive, speculative domain of configuration.

At its most general, this transformation leads to an intensive metaphysics in which space and time are informed by an immanent totality. The implication of the immanent totality in spatio-temporal experience is understood by Benjamin in two inconsistent and even contradictory ways. The first stresses complexity, and looks to the ways in which an immanent totality may manifest itself in the complex patterns and distortions of spatio-temporal experience. The other dissolves space and time into totality, and threatens to collapse the complexity of spatio-temporal patterning into a closed 'redemptive' immanence. The latter would mark the advent of a speculative philosophy without transcendental supplement, one which dissolves all the conditions of possible experience into emanations of the absolute. The dissolution of spatio-temporal complexity into an absolute, immanent purity is on the whole successfully resisted in Benjamin's writing, although it occasionally manifests itself in those moments of 'pure spirit' which abolish any trace of externality or remainder. Examples of such dissolutions of complexity are the 'voice' in On Language as Such and on the Language of Man, 'divine violence' in Critique of Violence, and the 'pure language' referred to in On the Mimetic Faculty into which 'the earlier powers of mimetic production and comprehension have passed without residue'. Yet in most his writings Benjamin sustains the poise between transcendental and speculative philosophy by recognising the speculative immanent totality as a principle of method, or in the words of the Theses on the Philosophy of History, as a diagnostic 'sign of a

6

Messianic cessation of happening' through which to discern what has been excluded by a particular condition of legibility or set of conditions of possible experience. Here the immanent totality is manifest as a contour, a rhythm or a warp in experience from which it is possible to begin a reading, rather than a moment of spirit which would mark its seal and completion.

From the evidence of Benjamin's early writings it would seem that the insight into the experience of an immanent totality, in which space and time are neither separated from nor dissolved into the totality of reason, predates its philosophical articulation. It might even be said that this experience could not be given full philosophical articulation without exposing it to the risk of a metaphysics of pure spirit and that it is most successful when used indirectly as a forensic or diacritical principle. Whatever the final judgement on this point, it is indisputable that Benjamin was already working with an extremely rich and developed concept of experience as early as 1914–15. In three crucial texts from this period, *The Metaphysics of Youth*, *The Life of Students* and *The Rainbow: Dialogue on Phantasy*, he develops reflections on time and space (Kant's forms of intuition) in which totality is immanent to experience, but presented in oblique or distorted forms. With respect to time, whatever is excluded from the time of the present – whether this be past or future – announces itself obliquely in the form of distortion and exclusion, while with respect to space, a given spatial envelope such as that presented by Kant is regarded as a reduction of the chromatic totality of colour.

Benjamin's writings from the period before the First World War pose several interpretative problems. They may be read as youthful indiscretions, occasional effusions prompted by his involvement in the contemporary Youth Movement, or as uncanny anticipations of his later thought. In fact they are both, with texts such as 'The Religious Position of the New Youth' and 'The Life of Students' veering between embarrassing expressions of youthful resentment and startling anticipations of his future philosophy. This is especially the case with the concept of experience elaborated in these works which presents the tension between a sense of present destitution and intimations of the absolute in the idiom of the Wilhelmine Youth Movement. The 'youth' are nothing and yet, embodying the future, they feel they are potentially everything; destitute and excluded from adult culture, they bear the promise of the absolute: 'Youth stands in the centre of the emergence of the new. Their need is greatest, and God is nearest to them' (1914d: 72). The youth are powerless in the present, but bear the mark of the future in their responsibility for the struggle of the 'enthused with the conformists, those of the future with those of the past, the free and the unfree' (1913: 60). Whatever the judgement of the elevated tone of these essays, they indicate the emergence of a novel concept of experience which aligns exclusion and the absolute with the tensions between past, present and future.

The early essays combine a crudely idealistic idiom which celebrates the sacrificial experience of a self-destructive purity with intimations of a more

complex concept of experience. The latter received its fullest elaboration in Benjamin's farewells to the Youth Movement – *The Metaphysics of Youth* and *The Life of Students* – the latter written after the suicide of his friend, the poet Friedrich Heinle. In these essays, the relationship between history, destitution and the absolute is discussed at a far more sophisticated level than before. Both essays focus upon the problems of historical time and the dissolution of subjectivity in time. In the first, Benjamin anticipates his later use of visual art as a paradigm for speculative experience, dissolving the transcendental subject into the temporal landscape of its objects: 'As landscape all events surround us, for we, the time of things, know no time' (1914a: 12). Benjamin evokes three responses to this condition: the first is for the subject to master time by answering 'yes' to the question 'Are we Time?' (1914a: 13) subordinating time and its objects to human temporality; the second is to dissolve the subject into the 'ever widening waves' of time; while the third is to 'experience the shudder of temporality' by approaching and withdrawing from dissolution in the storm of time: 'Things perceive us; their gaze propels us into the future, since we do not respond to them but instead step among them' (1914a: 13). In the shudder between assertion and dissolution the 'I' has an intimation of its finitude in the gaze of objects and in the sharing of their different temporality.

The Metaphysics of Youth sketches an experience of temporal complexity that exceeds any opposition of subjective and objective temporality. In *The Life of Students* this insight is developed into a prescient critique of those progressive philosophies of history that violently simplify the experience of temporality. In the unlikely context of an attack upon vocational education, Benjamin claims:

> The elements of the final state are not evidently present as formless progressive tendencies, but are deeply embedded in every present moment as the most vulnerable, defamed, ridiculed creations and thoughts. To shape the immanent state of perfection clearly as absolute, to make it visible and dominant in the present, is the historical task.
>
> (1915b: 37)

In his elaborations upon this passage, Benjamin stages a complex but fascinating series of inversions from which emerge glimpses of a non-Hegelian account of speculative experience. The thought of an immanent perfection present in the most derided aspects of experience moves from an absolute idealism which rejects the present in the name of an absolute idea to a materialism which discerns the absolute in what is rejected by the present order. The expulsion of the absolute from the present may be discerned precisely in those things that the present regards as insignificant, absurd and unwanted. This train of argument is followed by a further speculative inversion which seeks to shape the immanent perfection of the destitute as a sign

of the absolute idea, to grasp it 'in its metaphysical structure'. This is the sole task of 'critique,' namely to 'recognise and free the future from its disfigured form in the present' (1915b: 38). This final step in the argument is extremely precarious, for it poises Benjamin's thought on the borders of speculative dogmatism. If the idea is meant only to recognise or bear witness to the distorted form of the future in the present, then it remains critical, serving to 'point out the crisis lying in the essence of things and to lead to a decision that overcomes the cowardly and to which the brave subordinate themselves' (1915b: 37). If the idea is redemptive, if it is meant to mend what is broken and to correct what is distorted, then it threatens to become dogmatic, bringing together past and future into an eternal present or apocatastasis.

In the inspired paragraph from *Student Life* Benjamin gains but then loses one of his later insights into the 'weak redemptive power' of the immanent absolute of the rejected and excluded. The recognition of the presence of the absolute in the most abject of 'creatures and thoughts' is immediately followed by their redemption into a metaphysical idea, an unsatisfactory resort to a classic dialectical trope. A resistance to the facile dialectical movement of the second, redemptive stage of recognition lies at the core of Benjamin's union of speculative and transcendental philosophy. Much of his subsequent work would be dedicated to exploring the power of the rejected and outmoded, and to finding a form of critique which would 'point out the crisis lying in the essence of things' without having to translate the immanent absolute into a redemptive idea. This was achieved in the *Arcades Project* not by grasping a systematic, metaphysical structure, but in precisely the way rejected in 'Student Life', that is, by 'a pragmatic description of singularities (the history of institutions, customs, etc.)' (1915b: 37). Benjamin's difficulty at this early stage consists in discovering a method by which it would be possible to present the immanent absolute without translating it into an ideal totality in the manner of Hegelian speculative philosophy.[12]

One direction of inquiry pursued by Benjamin involved the re-examination of the concept of totality. In order to sustain the thought of an immanent absolute it was necessary to conceive of a totality which was capable, paradoxically, of containing the very elements which exceeded it. The search for such a concept of totality motivated Benjamin's passing interest in geometry, set theory and the mathematics of the infinite, as well as his abiding preoccupation with the philosophy of language and the philosophy of colour. With respect to the latter, after *The Life of Students* Benjamin's attention shifted from an immanent totality of experience understood in terms of time – the future manifest in those things rejected and excluded by the present – to the immanent chromatic totality of space. In his writings on colour and space, beginning with *The Rainbow: A Dialogue on Phantasy* and *The Rainbow or the Art of Paradise* of 1915–16, and later in 1917 *Painting and the Graphic Arts* and *On Painting or Sign and Mark*, he developed both the new concept of experience and the terminology in which to express it. This surfaced in the

proposition discussed above that 'perception is reading'. He also developed a
conception of an immanent totality which was extended, in 1916, to the phi-
losophy of language, and in 1918, to the direct and explicit critique of Kant's
concept of experience.

In the dialogue on the rainbow from 1915, rediscovered by Giorgio
Agamben in 1977, Benjamin initiates a series of reflections on visual art which
he was to develop throughout his mature authorship. At this early stage these
reflections are set within a paradigmatic definition of immanent totality as a
space which is infinite but bounded. The manifestations of the absolute in the
temporal distortions and exclusions discussed in *The Life of Students* are now
more systematically formulated in terms of the tension between (transcen-
dental) formal inscription and (speculative) chromatic configuration. It would
not be too much of an exaggeration to describe this short dialogue as the inau-
gural moment of Benjamin's thought, one in which he discovered the topology
of experience that he would later develop into a new speculative philosophy.

In the dialogue, one of the characters 'Margarethe' visits her painter friend
'Georg' early one morning to tell him about her dream of an uncanny land-
scape which radiated colours of a kind she had never seen before. After
recognising these colours as the 'colours of phantasy' which, in a rush of
intoxication dissolve both the gazing self and the gazed-upon world, Georg
explains why painting is unable to represent such an experience of colour. He
tells her that painting does not begin from colour, 'but from the spiritual and
the creative, from form'. The form of painting effects the construction of
space through a principle or canon, and this, for painting at least, is 'the
infinity of space' (1915c: 20). On the basis of these initial definitions Georg
provisionally concludes that 'the surface and not colour is the essence of paint-
ing' and then proceeds to distinguish between the infinities of space conceived
as (a) surface and (b) colour. In the spatial infinity of the surface, 'the being
there (*Dasein*) of things unfolds itself into space, but not properly within it'
(1915c: 21). Space in these terms is the infinitely extended surface upon and
within which there may be inscription; however, this is a limited form of spa-
tial infinity proper to a specific form of configuration, namely 'transcendental'
inscription, or the mark which divides light and shadow.

Benjamin continues by underlining the distinction between the speculative
and transcendental infinities of colour and inscription upon a surface: 'colour
is first of all the concentration of the surface, the imagination (*Einbildung*) of
infinity within it. Pure colour is itself infinite, but only its reflection (*Abglanz*)
appears in painting' (1915c: 21). The infinity of colour informs its space; it is
not inscribed upon a space already conceived as a surface. However, within
painting colour is employed as if it were an inscription made upon a surface:

> Painterly colour is but a reflection of phantasy, in it phantasy is bent
> into creation, it makes transitions with light and shadow, it impover-
> ishes. The spiritual basis of the image is the surface . . . the surface

10

lights up the colours, not the other way round. The infinity of space is the form of the surface, it is the canon [of painting] from which the colours issue.

(1915c: 21)

Colour or infinite configuration in painting is subordinated to a particular configuration of mark and surface (inscription). This entails that a particular modality of colour – the polar contrast of black and white – becomes the canon for the spectrum of tonal values which serves as the medium for colour. For this reason, the colours of which Margarete dreamt cannot be translated from the speculative infinity of configuration into the inscription of coloured marks on a surface proper to painting. The latter is the transcendental realm of inscription and surface upon which painting projects the infinite configurations of colour, effecting in Benjamin's terms the translation of speculative into transcendental experience.

Following the discussion of the distinction between pure and painterly colour, the character of Georg draws out some further implications of the distinction. The first is that the spatial infinity of colour does not yield any external point from which to view or deploy colour, for this would project chromatic infinity onto an infinite but bounded surface. As was intimated earlier in the dialogue, in painting the being-there of things is not configured chromatically through the medium of colour but inscribed upon space as an infinitely extended surface.[13] Yet this projection severely distorts the colour of experience since it translates the chromatic configuration of the *Dasein* of things into events inscribed upon a defined spatial surface, limiting and distorting their appearance in the process.

The distortion introduced by the translation between the speculative and transcendental infinities does not only concern the being-there of things, but also, as was intimated by Margarethe's narration of her dream, the being there of gazing subjects. In place of the opposition between gazing subject and the gazed-upon surface, Benjamin elaborates a different relation. Margarete describes herself, in Kantian vocabulary, as losing her identity and finding herself transformed into a colour in the landscape:

> I too was not, nor my understanding, that resolves things out of the images of the senses. I was not the one who saw, but only seeing. And what I saw were not things . . . but only colours. And I too was coloured into this landscape.
>
> (1915c: 20)[14]

In this experience two components of Kant's account of experience – sensibility and the understanding – collapse into each other, and the experiencing subject which would contain them dissolves into its experience. The opposition between gaze and the gazed upon collapses, both threatening a nihilistic

dissolution into a pure featureless identity beyond subject and object but also promising a new chromatic articulation of experience.

The dissolution of the external subject as the point from which to mark and view a surface from without into an aspect of a wider chromatic configuration is underlined by Georg when he says that 'Colours see themselves, they have in themselves pure seeing and are simultaneously the object and organ of vision' or when he claims that 'Colour is the pure expression of *Weltanschaung*, the overcoming of the viewer' (1915c: 23). The dissolution of any place for the subject in chromatically infinite space underlines the specificity of the transcendental configuration of the subject viewing and marking a surface. Such a view of the subject inscribing upon and reading from a surface is limited and limiting. Benjamin states this most explicitly in his later prose version of the dialogue *The Rainbow or the Art of Paradise*, where he claims:

> Objects demand a form of appearance, which is purely founded on their relationship to space, which expresses not their dimensionality but their contural tension [*konturale spannung* i.e. configuration] (not their structural, but painterly form), their being there in its profundity. For without this the surface cannot achieve concentration, remains two-dimensional and gains only a graphic [*zeichnerische*] perspectival and illusionistic profundity, not profundity as a non-dimensional form of relation between spatial infinity and object.
>
> (1915d: 563)

Objects perceived by a subject as if in space are limited, the profound complexity of their contural tension sacrificed to their position upon a given surface, and the non-dimensional character of the relation between infinity and object reduced to an illusion in two or three dimensions.

The dialogue develops some of the many interesting implications which follow from this argument. These emerge from the tension between the argument for divine creation which proceeds directly according to law – without the intermediate inscriptions of form[15] – and the argument for the immanence of the chromatic infinity. For even the distribution of subject, surface and inscription is itself a configuration, and contains intimations and memories of the chromatic totality of which it is but the partial expression. In the dialogue these intimations are discussed in terms of nature, memory, and works of art. The natural beauty of the rainbow points to an infinity which is 'only colour, nothing in it is form'; it is 'the law itself no longer transposed into nature or space . . . no longer through forms derived from a canon, but the in itself beautiful, the harmony in which canon and work are the same' (1915c: 24). It is also intimated in the memories of childhood, in which 'the perception is itself scattered in colours' (1915c: 25)[16] as well as in works of art. The dialogue ends with an evocation of the chromatic infinity intimated in a particular painting, Grunewald's altarpiece in Colmar[17] which for Benjamin

came nearest, in painting, to the colours of phantasy: 'Matthias Grunewald painted the halo of the angel on his altar in the colours of the rainbow, so that the soul as phantasy can stream through its holy shapes.' (1915c: 25) Here the colours of painting and of phantasy stand in a tension: the former act as a medium for the latter, without denying their own limitation or the transcendence of the colours of phantasy.

Benjamin developed many of these ideas about colour and painting more systematically in his later fragments on the subject, which are discussed in Chapter 3. The two fragments on colour from 1917, *Painting and the Graphic Arts* and *Painting, or Signs and Marks* are especially significant for their use of the distinction between inscription and chromatic configuration. In the fragments, Benjamin maintains that a colour does not have a fixed value but gains its meaning from surrounding colours, which because they are infinitely nuanced, make the value of a given colour infinitely variable. A graphic mark, however, is an impoverished version of this infinity, since it rests on the polar contrast between the monochrome surface and the opaque contrasting mark: for example, the white page and the black mark of an inscription. Before considering this more closely in the context of the work of art, it is necessary to explore the relationship between the concept of experience adumbrated in the dialogue on colour, and that developed in other areas of Benjamin's philosophy, especially in his philosophy of language and critique of Kant.

Language and the infinities

Most accounts of Benjamin's thought start from his 1916 essay, *On Language as Such and on the Language of Man*. While the work marks an important stage in the development of his thought, it is by no means its point of departure. In fact the essay is a transitional work in which the speculative philosophy of experience just discussed with respect to colour is translated into the idiom of the philosophy of language. When read in this context many of the critical assumptions regarding the place of this text in the development of Benjamin's thought, and even the character of this development itself, become open to question. Prime among these is the assumption that the core of Benjamin's thought is the philosophy of language, and that it is above all a linguistic 'metacritique' of Kant.[18] This interpretation excludes many important aspects of Benjamin's thought, and fails to recognise that his concept of experience is not exclusively linguistic; indeed his 'transcendental but speculative philosophy' is above all an account of experience characterised by an immanent totality. Language offers but one transcendental surface for the exploration of the properties of this totality.

Benjamin's philosophy of language is an aspect, important but not all embracing, of a broader concept of experience; to view the essay *On Language as Such and on the Language of Man* from any other viewpoint would further

complicate an already intractable text. The essay was written over the summer of 1916 and is thus contemporary with Benjamin's work on the philosophy of colour. It followed a letter to Martin Buber from July 1916, in which Benjamin discusses language and writing in a way which he describes as 'entirely in keeping with' the essay *The Life of Students*. In the letter, Benjamin refuses to view language instrumentally as a means of expression or as a stimulus to action. He points instead to a 'disclosure' of the 'dignity and nature of language' which does not consist in the 'transmission of content'. This aspect of language reveals itself at its limit in the 'sphere of speechlessness' or that which is 'denied to the word' (C, 80). However, Benjamin insists, and here lies the claimed consistency with *The Life of Students*, that the 'denied' of language, the 'sphere of speechlessness' is *within* language; it is not the 'ineffable' outside of language since it is precisely this sense of external transcendence that is to be 'eliminated'.[19] Once again, but now in the context of the philosophy of language, Benjamin argues for the experience an immanent absolute, one that is formally identical to the absolute intimated in the earlier essay. Language is a complex totality which conveys at once meaning and the limits of meaning, the sayable and unsayable. The latter remains in complex ways within language, even though it cannot be spoken.

Benjamin's foray into the philosophy of language was but one of a number of explorations into the character of an immanent absolute. In order to sustain the idea of an immanent absolute it was necessary to imagine a totality capable, paradoxically, of containing elements which exceeded it.[20] In addition to the work on colour, in which the infinity of inscription was said to be contained and exceeded by an infinity of configuration, and the philosophy of language in which the unsayable is located within and at its limit of speech, Benjamin also explored the problem of an immanent totality in terms of theology, mathematics and the philosophy of the infinite. The essay *On Language as Such and on the Language of Mankind* was a self-conscious attempt to bring together these various reflections.

The essay began life as a letter to Scholem (11 November 1916) (one 'that ended up being eighteen pages long') in which Benjamin, in his own judgement, tried and failed to bring together his thoughts on 'mathematics and language, i.e., mathematics and thought, mathematics and Zion' (C, 81). The confessed failure to realise the 'systematic intent' which left the work a collection of fragments is most apparent in the absence of 'the consideration of mathematics from the point of view of a theory of language, which is, ultimately, of course, most important to me' (C, 82). Benjamin describes his 'thoughts on this infinitely difficult topic' as 'far from having taken final shape', thus underlining the provisional nature of many of the conclusions reached in the essay.[21] Unfortunately very little evidence of the depth and extent of Benjamin's mathematical knowledge survives, although a fragment towards a 'solution' of Russell's paradox casts some light on the relationship between language and mathematics pursued in the essay.

Benjamin's fragments devoted to Russell's paradox rest on a distinction between the 'judgement of designation' [*Urteil der Bezeichnung*] and the 'judgement of signification' [*Urteil der Bedeutung*]. The latter class of judgements require categories (Benjamin cites 'causality and substance') which are ascribed to the representation of a subject. By contrast, the 'subject' of a judgement of designation simply designates its 'predicate', as in the example '*a* designates the side *BC* of a triangle'. It says nothing about its 'predicate' and ascribes no meaning to it, but simply designates it by an acoustic or graphic complex or mark. Benjamin then points to the danger of judgements of designation being mistaken for those of signification, with the designations of the former being taken to *signify* and not simply *designate* a predicate. With respect to Russell's paradox, Benjamin maintains that the set of all sets simply designates a particular 'predicate' but does not signify that it exists or is otherwise meaningful.[22]

In a further series of extremely obscure fragments Benjamin seems to align designation with intention, suggesting that we think *in* intention/designation (first order) but *by* means of concepts (second-order abstraction from intention). Designation as intention becomes the extra-categorial condition for the signifying judgements of the categories. In terms of the philosophy of language, Benjamin sees linguistic and graphic units as derived from an original linguistic intention which is designative. The capacity of 'linguistic intention' to produce names by designation is both immanent to and yet exceeds a given linguistic universe, even though the latter may itself contain an infinite number of possible, signifying statements.[23] The formal similarity between this thought with that of the relationship between the universes of inscription and configuration, shows both to be aspects of the concept of speculative experience adumbrated in Benjamin's philosophy of colour.

On Language as Such and on the Language of Man translates the immanent totality of speculative experience developed in the theory of colour into the philosophy of language. The relationship between mathematics and language which, however imperfectly, informs the essay, emerges in the contrast between language as an infinitely extended field of possible utterances and language as a mode of designation and intention capable of generating an infinite number of languages. In the first case, language is analogous to the transcendentally infinite surface of inscription while in the second it is analogous to the speculative infinity of configured surfaces. Benjamin's translation of speculative experience into the philosophy of language develops the model of speculative experience proposed in *The Rainbow*, but also on occasions verges dangerously on the edge of dogmatism. Indeed the *Language as Such* essay may be read as moving through three stages, from a disciplined exposition of the speculative experience of language to a dogmatic statement of the translation of non-human languages into the human language of pure spirit, arriving finally at the disclosure of the fault in human language and a return to speculative experience.

The first paragraph of *On Language as Such and the Language of Man* proposes a definition of language as 'communication' (*Mitteilung*) which extends not only to human language, but also to animate and inanimate nature. Language is said to communicate 'spiritual contents' (*geistiger Inhalte*), although Benjamin insists that these do not exist apart from their communication in language. Notwithstanding, the following paragraph begins with the claim that 'every expression (*Ausdruck*), insofar as it is a communication of spiritual content, is to be classed as language' (SW, 62–3) Benjamin qualifies what appears to be a distinction within language of 'spiritual content', 'expression', and 'communication' by suggesting that 'spiritual content' and 'expression' are themselves language. This qualification enables him to translate his speculative concept of experience into philosophical linguistics. He does so by distinguishing between the infinity of possible contents which may be communicated *through* a language, and the infinity which communicates itself *in* a language, and which is anterior to its use as a medium of communication:

> The German language, for example, is by no means the expression of everything that we could – theoretically – express *through* it, but is the immediate expression of everything which communicates *itself* in it (*was sich in ihr mitteilt*). This 'itself' is a spiritual essence (*geistige Wesen*).
> (SW, 63)[24]

Here Benjamin distinguishes between the communication of discrete 'spiritual contents' (*geistige Inhalte*) through their expression in a particular language, and the expression and communication of a 'spiritual essence' (*geistige Wesen*) in languages.[25] Discrete languages provide the transcendental conditions of the possibility of expressing spiritual contents, while being themselves expressions of the speculative spiritual essence of language. The latter, which expresses and communicates itself in the totality of languages, is seen as the speculative sphere of linguistic intention underlying discrete linguistic surfaces.

By folding a transcendental within a speculative philosophy of language Benjamin is able to maintain the view that language communicates a content distinct from itself at the same time as claiming that communication is the expression of language. The distinction operating in the first, transcendental understanding of language is only possible on the speculative condition of the second. However, Benjamin regards the speculative hypothesis that communication is language expressing only itself as not only 'the great abyss into which all linguistic theory threatens to fall' but also, in a footnote added to this phrase, 'an abyss for all philosophising' (SW, 63 & 74). The threat posed by the identification of 'spiritual and linguistic essence' arises from the liquidation of language which follows when the differences between communication, expression and expressed are dissolved.

Benjamin is also sensitive to the related danger of an instrumental understanding of language which follows from the rigorous separation of the three

elements of communication, expression and expressed. In the first, pure case of liquidation, the elements of language collapse into each other at the limit of 'an existence entirely without relation to language' while in the second, the 'spiritual contents' to be communicated are distorted by the medium, and are consequently not communicated in their integrity.[26] Benjamin sees these dangers expressed 'in the ambiguity of the word *logos*' but strives, instead of identifying or separating the 'linguistic' and 'spiritual' essence, to 'survive suspended over this abyss' with a transcendental but speculative philosophy which is neither absolute idealism nor materialism.

Benjamin maintains this position by translating the view of two generically distinct infinities from the theory of colour first into the philosophy of language and then, through the critique of Kant, into philosophy in general. He carries over into the philosophy of language the distinction between the infinite number of possible marks on a discrete surface of inscription and the infinite number of possible configured surfaces. The translation of the first infinity into linguistics is manifest in the proposition that each language has its own infinity:

> because nothing is communicated *through* language, what is communicated *in* language cannot be externally limited or measured, and therefore all language contains its own incommensurable, uniquely constituted infinity. Its linguistic being, not its verbal meanings, defines its frontier.
>
> (SW, 64)

Not only is language understood by analogy with the infinite bounded surface of the philosophy of colour, but there also exist a number of discrete languages, each with its own 'incommensurable, uniquely constituted infinity'. Generically each infinite language is sustained by its own 'intensive totality' or communication of itself while the specific case of human language has the ambiguous property of 'naming' or translating other languages into itself.[27] At this stage in his argument, Benjamin proposes a 'paradoxical question': 'Does man communicate his mental being *by* the names that he gives things? Or *in* them?' (SW, 64). If the answer is 'by the names' then human language is the translation of other languages into itself; if it is 'in the names,' then it is the translation of itself into them. The difference between the two responses to the question rests upon a distinction between the infinity proper to human language and its relation to other possible and existing infinite linguistic surfaces: if human language is made the measure of all other languages, then it will cease to communicate anything but itself, it will have no exteriority, no recognition of limits. In Benjamin's words, it would have arrogated to itself the creative word of God, or usurped for itself the role of being the speculative condition of all other languages.

The consequence of human language making itself the measure for all

other languages – 'the language of language' – is the exposure of its own 'invalidity and emptiness'. This critical conclusion rests upon the translation of two further implications of the concept of experience developed in the theory of colour into the philosophy of language: the dissolution of both the speaking subject and the spoken object of experience. It followed from the distinction between inscription and configuration that the separation of viewer and the viewed was itself a particular mode of configuration. In the experience of the 'colours of phantasy' Margarethe did not *use* colour as a means of perception, but was herself dissolved into the experience of colour. Analogously, Benjamin dissolves the speaker into language: 'Languages therefore have no speaker, if this means someone who communicates *through* these languages. Spiritual essence communicates itself in, not through, a language' (SW, 63). There is no speech outside or prior to a language; speakers exist ineluctably within their given linguistic surface. Similarly, there is no object of speech that, outside a language, may be communicated by it, but rather, 'that which in a spiritual essence is communicable *is* its language' (SW, 63). The dissolution of subject and object of language does not belie the claim that in specific configurations of linguistic and spiritual essence it can appear as if a subject is communicating with other subjects about objects. However, for Benjamin this is an extremely restricted view of language, one whose imposition of a particular transcendental linguistic infinity suppresses other existing and possible linguistic infinities.

The consequences of one language arrogating to itself the expression of all the others are explored by means of a commentary upon the myths of the origin of human language collected in the book of Genesis. Benjamin argues that human language is nominative, and that in the act of naming 'the spiritual essence that communicates itself is *language*' (SW, 65). The 'incommensurable and uniquely constituted infinity' of this language consists in its being the 'language of language' combining what Benjamin calls 'extensive' and 'intensive' linguistic totalities. The intensive totality of human language means that it is 'absolutely communicable', that is, 'communicable without residue,' a property which permits it to serve as a pure medium. The name in human language translates an imperfect into a more perfect language, perfection being determined by the 'material density' of a language, or the ratio between its expression and communicability (SW, 73). For Benjamin, expression in the languages of nature, things and animals is 'mute', closely bound to their material medium and so relatively incommunicable, while expression in human language is less tied to its material medium and consequently more communicable.

Benjamin then develops the argument that although human language is unique in combining intensive and extensive totalities, this does not mean that it is the speculative condition of all other languages. It remains a particular surface of expression and communication and not the condition of all other surfaces; in the language of the philosophy of colour, its infinity is that of a

surface and not of configuration; it is a language and not the speculative con-
dition of all other languages. In his commentary on Genesis, Benjamin
maintains that the true speculative condition of the discrete languages is the
'creative word of God' which establishes the languages of things and animals
as well as human language:

> The infinity of all human language always remains limited and ana-
> lytic in nature, in comparison to the absolutely unlimited and creative
> infinity of the divine word.
>
> (SW, 68)

Human language is equivocal: it can either reduce all other linguistic surfaces
to its own level, confining them within its limits at the price of exclusion and
distortion, or it can transform the character and limits of its own surface in the
translation of other languages. In the second case, human language is capable
of ecstatically transforming the character and limits both of itself and of the
other languages, all of which are aspects of the speculative creative language of
God:

> In receiving the unspoken nameless language of things and convert-
> ing it by name into sounds, man performs this task [of translation].
> It would be insoluble, were not the name-language of mankind and
> the nameless language of things related in God and released from the
> same creative word, which in things became the communication of
> matter in magic communion, and in man the language of knowledge
> and name in blissful spirit.
>
> (SW, 70)

Benjamin establishes the contrast between human language and divine cre-
ativity in order to underline the consequences of human language taking itself
to be the speculative source of all other languages. Human language remains
in Benjamin's terms a particular infinite linguistic surface whose limits are
determined by translation. It can either defend these limits by translating
other languages into itself, or transform them by translating itself into other
languages. Such a transformation can only be achieved through translation; if
human language peremptorily exceeds its limits by creating – by denying the
otherness of different languages – then it introduces a damaging division
between itself and the languages of nature and God, as well as one within
itself.

Benjamin figures the shift of human language from a particular linguistic
surface with its own infinity to the presumed creative source of all other lan-
guages through the biblical myth of the Fall. In the Fall, human language
departs from naming and expressing other languages through translation and
begins autarchically to create spiritual essences. Benjamin outlines three specific

consequences of this turn. The first is the emergence of a distinction between speaker and language, evident in language becoming a means of communication. The second is the instability introduced into human language by the possibility of deception and dissemblance and with this the necessity for judgement, while the third concerns the 'origin of abstraction' exemplified for Benjamin in the invention of abstract terms such as good and evil which have no expression and which destabilise language. The 'turning away from that contemplation of things in which their language passes into man' (SW, 72) leads human language into the folly of Babel, and reduces the languages of nature to silence. Human language 'overnames' by reducing the expression of other languages to its own terms, silencing them and refusing to open itself to transformation. As a consequence it becomes the vain mastery of 'prattle' while the language of nature is reduced to mute lament and mournfulness (*Trauer*); 'Because she is mute, nature mourns' (SW, 73).[28]

Towards the end of the essay, the focus shifts from language to the character of judgement and law. Again, the pattern of argument is similar to that followed by the philosophy of colour in *The Rainbow*. There Benjamin touched on the possibility of creation according to laws of configuration which were experienced directly, and not mediated by means of form. It was implied there that form, or inscription upon a surface (*Bezeichnung*), was the 'canon' or rule for human creativity. In *On Language as Such and on the Language of Man* when human language arrogates to itself the divine power to create by means of naming, it ceases to translate, that is, to 'pass through continua of transformations' and begins to inscribe, that is, to create 'designations' or *Zeichen*. The result is the silencing of the languages of nature, their reduction to mute lament, and the madness of overnaming or designating names. By forcing the expression of other languages into its own measure, human language reduces them to itself and itself to tautology. The result is a work of translation which identifies or reduces the other to the same, a reduction which Benjamin opposes with a view of translation as the transformation of the limits of identity through the encounter with alterity:

> Translation is removal from one language into another through a continuum of transformations. Translation passes through continua of transformation, not abstract areas of identity and similarity.
>
> (SW, 70)

Here the word in translation functions analogously to the colour in configuration, having no fixed meaning but existing in a state of continual transformation according to its relationship with other colours. What is translated is not simply a discrete expression from one language to another, but the identity of language itself.

Since for Benjamin the designations of 'overnaming' have no intrinsic meaning (for 'designation' is not 'signification'), they are not 'names' governed by the

translations of the expressive language of objects, but must be ascribed meaning from without. The 'without' is no longer other – another infinite linguistic surface – but is ascribed by human language to itself; it psychotically creates its own semblance of externality. The event by which human language becomes the sole measure of its objects marks the origin of judgement; it is one in which 'in stepping outside the purer language of name, mankind makes language a means . . . a *mere* designation' and through which the word 'rooted' in the name becomes 'the word of judgement' (SW, 72). The adequacy of a designation is not to be found in truth as the reciprocal transformation of two languages through translation, but in knowledge according to the measure of a particular language which is applied to all others. Returning to the exegesis of the book of Genesis, Benjamin interprets the Fall in terms of the descent from truth as transformation to knowledge as judgement:

> The tree of knowledge did not stand in the garden of God in order to dispense information on good and evil, but as an emblem of judgement over the questioner. This immense irony marks the mythical origin of law.
>
> (SW, 72)

Law is but a particular configuration of 'language and designation' which claims to be the source of all configuration: a specific mode of translation between linguistic universes that claims to be the only one. Here, as in the work on colour and inscription, a particular configuration claims to be the source of all configuration, generating instability, violence and mourning. Nevertheless, Benjamin ends the essay by reiterating how the translation *between* languages is also a translation *of* them, in other words, a mutual transformation of their 'incommensurable, uniquely constituted infinit[ies]' into a movement of languages which unfolds the source of the configuration of linguistic surfaces, which is the word of God:

> The language of nature is comparable to a secret password that each sentry passes to the next in his own language, but the meaning of the password is the sentry's language itself. All higher language is a translation of those lower, until in ultimate clarity the word of God unfolds, which is the unity of this movement made up of language.
>
> (SW, 74)

Benjamin's questioning of the centrality of human language to the philosophy of language is inseparable from his exploration of the relationship between identity and infinity (the immanent totality) which preoccupied him during this period. Each language is identified by a particular infinity, which distinguishes it from other languages, and each may be identified as a particular

linguistic surface, but no individual language can properly claim to be the source of the configuration of all other linguistic surfaces. Although each language is identified by its own infinity, this identity and infinity is not fixed, but undergoes continual transformation or 'translation'. In the light of this argument Benjamin develops a contrast between two modes of translation. In the first, each language is transformed by and transforms the others, a movement made possible by them all being regarded as aspects of the same capacity for configuring linguistic surfaces. Although these linguistic surfaces are identified by incommensurable infinities, they nevertheless share a reference to the speculative source of configuration in God's word.[29]

The second form of translation occurs when one language surface arrogates the role of the divine word and considers itself to be the source and measure of all the others. In this case, which is that of lapsarian human language, the translation will be violent and unstable. The mutual transformation of language surfaces is succeeded by the attempt to transform all languages into human language. But because the language surfaces are incommensurable, such a forced translation will at best distort, at worst silence the translated language. This perverse transformation will also have an impact on human language, which meets the threat of the loss of signification by the introduction of laws of sense. Yet even in the midst of this distortion, there remain traces of other configurations which exceed human language and which are manifest as residues, enigmas, as well as folds and warps within, and breaks and exclusions of, the linguistic surface. It will become the two-fold task of criticism first to map these folds, warps and exclusions as they are manifest on a particular linguistic surface (*Sachgehalt*) and then to trace the speculative linguistic configuration which they indirectly disclose (*Wahrheitsgehalt*).

On Language as Such and on the Language of Man, in spite of its often allusive and obscure presentation, marks a further stage in Benjamin's development of a 'transcendental but speculative philosophy'. Following the pattern of thought established in his philosophy of colour, he regards particular languages as infinite surfaces produced by a capacity for configuring linguistic surfaces which exceeds all discrete languages. Although this capacity is named the 'creative word of God' it remains beyond every particular language, and is expressible only in the mutual transformation of these languages. In a sense, the real focus of the essay is the relationship between identity and infinity viewed from three related viewpoints. The first regards the relationship between the surface, in this case linguistic, and the limits which it sets to expression. The linguistic surface is singular with respect to other linguistic surfaces, but infinite with respect to the number of utterances which can be made within its limits. The second case explores the possibility of negotiating the bounds of a given linguistic surface through translation, or the encounter with other infinities, while the third considers the consequences of one particular infinite surface arrogating to itself the measure of all the others.

Following this experiment with philosophy of language Benjamin extended the reflection upon meaning, surface and configuration to a critique of Kant's philosophy of experience and to politics. He had, in effect, created the conditions for a speculative concept of experience.

Philosophising beyond philosophy

Benjamin's speculative recasting of Kant's transcendental account of experience involves the introduction of the absolute or infinite into the structure of forms of intuition – space and time – and the linguistic categories (*logoi*) of the understanding. Benjamin sought to avoid both Kant's scission of experience and the absolute and what he regarded as Hegel's 'mysticism of brute force' which for him reduced the absolute by expressing it in terms of the categories of finite experience.[30] Instead of pursuing the options of an absolute break or uninterrupted continuity between experience and the absolute, Benjamin developed a concept of experience in which given spatio-temporal and linguistic universes were regarded as discrete configurations through which the absolute manifested itself in patterns and rhythms, breaks and distortions. In this way, not only was the Kantian structure of experience shown to be a particular case of a broader speculative picture, but its very elements – space, time, judgement and categories – were comprehended as internally complex, unstable and violently restricting.

Benjamin's explicit argument with Kant continued after 1916 in his critiques addressed directly to Kant's philosophy of history and its 'endless task' as well to Kant's aesthetic and moral philosophy.[31] However, Kant came to feature increasingly as the 'greatest adversary', a philosophical 'despot' whose insights are 'most reprehensible' and who 'drives and senselessly whips his hobbyhorse, the logos'.[32] Benjamin's objections to Kant, whether in the theory of knowledge, ethics and politics, or aesthetics, increasingly focused on the limits set to the concept of experience informing the critical philosophy. Allied with this is the growing conviction that the restriction of the concept of experience is also a restriction of philosophy itself. For the extension and recasting of Kant's concept of experience implies that philosophising need no longer be confined to 'philosophy' and its machinery of ideas and categories. Benjamin came to realise that extending the limits of experience meant that philosophising could move beyond classical philosophical problems and texts into the critical reflection upon literature, art, and culture in the broadest sense.

The possibility of extending philosophising beyond philosophy was announced by Benjamin in *On the Programme for the Coming Philosophy* (1917–18). Paradoxically, Benjamin's most sustained and concentrated analysis of Kant's philosophy is also his farewell to Kantianism. In it he states:

It is of the greatest importance for the philosophy of the future to recognise and select which elements of the Kantian philosophy

23

should be adopted and cultivated, which should be reworked, and which should be rejected.

(SW, 101–2)

Benjamin vehemently rejects the scientific underpinning of Kant's concept of experience, drawn from Newtonian mathematical physics. For him Kant restricted the concept of experience to 'the constellation of the Enlightenment' with its 'religious and historical blindness' and consequently to 'an experience or view of the world . . . of the lowest order . . . experience virtually reduced to a nadir, to a minimum of significance' (SW, 101). Kant's concept of experience was mechanical, based on the motion of objects as perceived by a subject; it was a 'notion of experience . . . [that] did not require metaphysics' and indeed excluded metaphysics from the field of legitimate knowledge.

The question then arises of what elements of the philosophy established upon such an impoverishment of experience can be recast or otherwise adopted in the light of a 'new and higher kind of experience yet to come' (SW, 102). Benjamin's argument at this point takes a number of different directions. The first is to reject the distinction between perceiving subject and perceived object fundamental to Kant's concept of experience, both in the generic case of 'Kant's conception of knowledge as a relation between some sort of subjects and objects or subject and object' and the specific case of the 'relation of knowledge and experience to human empirical consciousness' (SW, 103). The distinction between subject and object is parochial, constituting but one of many possible surfaces of experience; Benjamin indeed regards it as a mythology on equal terms with totemism and the experiences of the insane and the clairvoyant.

Benjamin proposes that the 'new concept of experience . . . would itself be the logical place and the logical possibility of metaphysics' (SW, 104). The return of metaphysics entails the development of a speculative concept of experience or 'a new transcendental logic', signs of which Benjamin sees emerging in the neo-Kantian elimination of 'the distinction between intuition and understanding' (SW, 103). This announces a fundamental reconfiguration of the Kantian structure of experience, one in which space and time as well as the categorial organisation of experience in space and time are transformed. In spite of what appears to be a radical transformation of Kant's philosophy, Benjamin does regard certain aspects of it as retrievable. Prime among these is the 'critical trichotomy' of theoretical, practical and aesthetic philosophy, which Benjamin suggestively aligns with the relational categories while arguing that it might be applicable to 'the entire realm of culture'. The second is the doctrine of the categories itself, which Benjamin argues can be transformed in the light of the new theory of experience. Instead of the categories 'exploited in a one-sided way by Kant in the light of a mechanical experience' Benjamin makes room for 'a theory of orders' in which the categories would be situated as one of the set of 'higher ordering concepts of philosophy' (SW, 106–7). The

extended set of 'primal concepts' (*Urbegriffe*) would include all forms of configuration, from the linguistic to the visual. Benjamin envisages the new 'transcendental logic' of 'categorial and related orders' as providing a new framework for knowledge appropriate to an extended concept of experience.

Benjamin's ambition of supplementing Kant's 'transcendental' with a new 'speculative' logic in *On the Programme of the Coming Philosophy* faces two basic difficulties. The first difficulty concerns the place of freedom in the coming philosophy, while the second involves the problem of formalism facing the new 'theory of orders'. Already in the 1917 essay Benjamin broaches the issue of the dissolution of the 'distinction between the realms of nature and freedom' which would seem to be required by the new concept of experience, but defers a closer analysis of this problem to a later date:

> Yet here, where we are concerned only with a programme of research and not with proof, only this much need be said: no matter how necessary and inevitable it may be to reconstruct on the basis of a new transcendental logic . . . the realm of the crossover between the theory of experience and the theory of freedom, it is just as imperative that this transformation not end up in a confounding of freedom and experience, even though the concept of experience may be changed in the metaphysical realm by the concept of freedom in a sense that is perhaps as yet unknown.
>
> (SW, 106)

Benjamin was to consider this problem more closely in the following years in his work on ethics and politics, above all in the *Critique of Violence*. The problems associated with the new concept of experience and freedom recurred throughout his subsequent work and, as will be seen, generated some novel and often ingenious solutions.

Before looking more closely at the problem of freedom and experience, it is necessary to point to some of the equally intractable problems raised by the new 'theory of orders' before analysing the theory more systematically in the following chapters. The main text of *On the Programme of the Coming Philosophy* ends with the demand that the philosophy of the future should 'create on the basis of the Kantian system a concept of knowledge to which a concept of experience corresponds, of which knowledge is the doctrine' (SW, 108). The demand is met by two incompatible options which Benjamin in his final words of the Addendum to the essay appears to elide. The first is that philosophy be 'designated' or 'subordinated' to theology, and that the new 'theory of orders' provide a universal and eternally valid framework for knowledge and experience. The second option, presented in the final sentence of the essay, is that 'Experience is the uniform and continuous multiplicity of knowledge' (SW, 110). In the first option, Benjamin makes the Platonic move of replacing the doctrine of categories with a doctrine of eternal ideas, while in

the second he is closer to the anti-Platonism of Nietzsche in dissolving the categories into the 'uniform and continuous' generation of a multiplicity of knowledges. In the first, the categories are lifted out of time, producing an unspeculative formalism of abstracted and timeless ideas, while in the second they are submerged in time, threatening to disappear in a welter of diverse and continually changing patterns and orderings of experience. The first is a formal idealism, the second a material empiricism. The philosophy of the future will have somehow to reconcile this opposition by at once deriving the categories from temporal experience while according them the dignity of being more than a by-product of experience.

Benjamin's works are riven by this characteristically Kantian tension, one which was already evident in the divergent tendencies already evident in *The Life of Students* between reading the absolute indirectly from the distortions of experience and dissolving the same distortions into a timeless, redemptive idea. The inverse of this idealist ambiguity is manifest in the often stark contrast between Benjamin's methodological prescriptions (for example the 'epistemo-critical prologue' to *The Origin of German Tragic Drama* and 'Konvolut N' to the *Arcades Project*) and his practice of immanent critique, which for many critics verges upon empiricist description.[33] However, it was precisely this tension which motivated Benjamin's speculative philosophy. Instead of redeeming spatio-temporal experience by referring it to the absolute he now traces the removal of the absolute through the warps, distortions and exclusions of a bereft experience. The balance he established between these positions was extremely unstable and continually threatened by the danger of lapsing into either a redemptive idealism or the melancholic endless task of the collector of scattered fragments.

The question of the temporal status of the ordering principles of knowledge and experience has implications for freedom, since as we saw, Benjamin warned in *On the Programme of the Coming Philosophy* that it is imperative 'not to confound freedom and experience'. This confusion can occur in two ways, both of which threaten to qualify the concept of freedom to the point of abolishing it. The first reduces freedom to empirical experience by stripping it of any of its transcendental qualities while the second removes freedom from experience by making it purely ideal and far removed from the spatio-temporal world. Again, Benjamin sought a speculative concept of freedom which would neither be continuous with, nor opposed to experience, but in which freedom at once changes and is changed by experience 'in a sense that is perhaps unknown'. The adumbrated speculative concept of freedom/experience discerns freedom in the rhythms and patterns as well as the warps and distortions of experience, or, in the terms of Benjamin's first published account of modern urban experience, the essay on Naples (1924) co-authored with Asja Lacis, in its *porosity* and *transitivity*. The alignment of freedom and experience is understood in terms of potential routes of passage which may be realised through freedom. Freedom here is less a programme than the occasion

of an unexpected transition made possible by one of the gaps, warps or breaks in the continuity of experience.

In the years immediately following the end of the First World War, Benjamin began to develop his thoughts on freedom and experience in the context of a projected treatise on 'Politics'. The *Politics* project seems initially to have been formulated as a response to Ernst Bloch's *Spirit of Utopia* for which Benjamin wrote an unpublished review. In a letter to Scholem dated 1 December 1920, Benjamin reported that the first part of *Politics* was to be a 'philosophical critique' of Paul Scheerbart's *Lesabendio*[34] (entitled, as it appears from a subsequent letter of 29 December 1920, 'The True Politician') followed by two chapters entitled 'The Dismantling of Power' and (citing Kant's *Critique of Judgement*) 'Teleology without Ultimate Goal'. The composition of the latter waited on the arrival of a 'book from France', namely George Sorel's *Reflections on Violence*. The main surviving fragment of the *Politics* project is the Sorelian essay *Critique of Violence* which was written alongside the main *Politics* project but published separately in 1921.

In the *Critique of Violence* Benjamin develops his speculative concept of freedom and experience into an anarcho-nihilist political philosophy. The argument of this essay is directed against the Kantian view of the 'crossover between the theory of experience and the theory of freedom' in which freedom consists in autonomy or self-legislation. Benjamin does not wish to 'confound' freedom and experience by dissolving them into each other but nor does he accept Kant's solution according to which a free subject gives itself the laws by which to govern experience. Instead he argues that law arises from a truce between warring parties; it does not, as for Kant, originate in a subject peacefully legislating for itself, but emerges from a violent state of war. The 'metaphysical realm' through which 'the concept of experience is changed by the concept of freedom' mentioned in *On the Programme of the Coming Philosophy* is here revealed to be a realm of violence. The laws and categories of experience issue not from an act of self-legislation, but from a decision to call a truce in a condition of violence.

Benjamin's discovery of violence in the categories of experience is consonant with his view that a transcendental philosophy makes absolute what is but a particular configuration of experience. As a consequence, other aspects of experience are excluded, or only manifest themselves in distorted forms. Lawmaking violence, as presented in the *Critique of Violence*, is an inscription which constitutes a surface which equalises otherwise irreconcilable parties:

> Where frontiers are decided, the adversary is not simply annihilated; indeed, he is accorded rights even when the victor's superiority in power is complete. And these are, in a demonically ambiguous way, 'equal' rights: for both parties to the treaty it is the same line that may not be crossed.
>
> (SW, 249)

Benjamin sees such inscription or 'the act of fixing frontiers' as the dissemblance of a violence which equalises unequal parties by a distortion through which the weak *appear* to be equal to the strong. He describes this distortion as 'mythical ambiguity of laws', one that, in order to be sustained, requires the constant exercise of 'law-preserving violence'. The latter is the all-pervasive administrative or 'police' violence required to sustain the conditions of the original truce, but which erodes the law by substituting for the line of truce or 'decision' to cease hostilities a 'nowhere tangible, all pervasive, ghostly presence' which sustains the law by acting outside of it (SW, 243). The basic argument follows the path established in the speculative concept of experience, namely, that any transcendental establishment of the conditions for the experience/exercise of freedom is inevitably partial and unable, unaided, to sustain itself. A system of categories or laws cannot legitimate itself, but must gain legitimation from without, even while claiming to be autonomous. This is not the 'heteronomy' of experience dreaded by Kant – which is defined as the opposite of autonomy – but the speculative condition of autonomy itself. This is either the violence of law-making, the drawing of a line between warring parties, or of law-preservation, the maintaining of this line even at the price of its virtual erasure.

At the same time as describing the 'dialectical rising and falling in the law-making and law-preserving formations of violence', namely the 'circumstance that all law-preserving violence, in its duration, indirectly weakens the law-making violence represented by it', Benjamin introduces a third position of 'divine', 'revolutionary' or 'sovereign' violence which is 'outside the law, as pure immediate violence' (SW, 252). Immediate, revolutionary violence is illustrated by the anarchistic 'proletarian general strike' discussed by Sorel in his *Reflections on Violence*. As opposed to a reformist, law-making exercise of violence, the proletarian general strike

> takes place not in readiness to resume work following external concessions and this or that modification to working conditions, but in the determination to resume only a wholly transformed work, no longer enforced by the state, an upheaval that this kind of strike not so much causes as consummates. For this reason the first of these undertakings is law-making but the second anarchistic.
>
> (SW, 246)

Class struggle can either dispute the frontier between the classes, or challenge the entire terrain of struggle. Yet this position collapses Benjamin's nascent speculative account of experience/freedom into an idealistic celebration of 'pure immediate violence', so abandoning the subtle insights into the complex configurations of experience in favour of a crude erasure of complexity in an absolute freedom. The 'cross-over' between the theories of 'experience' and 'freedom' seems, in the *Critique of Violence*, to incline towards an account of

freedom which is less the 'comprehension and recasting' of law than its uncompromising casting out.

While philosophically the *Critique of Violence* marks Benjamin's falling away from the level of analysis achieved in his theory of experience, it does mark an important stage in his development of his non-Hegelian speculative philosophy. It recognises that an account of freedom and politics is necessary in any philosophy of experience, but thinks the 'cross-over' between them in terms of the exercise of absolute freedom. The *Critique of Violence* remains true to the letter of *On the Programme of the Coming Philosophy* which saw that 'the concept of experience may be changed in the metaphysical realm by the concept of freedom' but does not examine the possibility of the concept of freedom being changed by the concept of experience. As a result, the admirable critique of the Kantian view of the 'cross-over' between the concepts of freedom and experience in terms of the self-legislation of a subject, which discloses the violence informing its apparent peace, quickly deteriorates into an absolute idealism of pure, divine violence. This rhetorical gesture recalls the youthful effusions of Benjamin's early youth movement writings, except that now the 'youth' have been replaced by the 'proletariat'.

Much of Benjamin's work after the *Critique of Violence* explored the mutual transformation of the concepts of freedom and speculative experience. This is the direction followed in his writings on modernity and above all on the experience of the city. While the *Critique of Violence* bears witness to Benjamin's concern with freedom under the condition of modern politics, it was only with the translation of the concept of experience into the analysis of modernity that Benjamin achieved the desired mutual transformation of the concepts of freedom and experience. In respect of the turn to a sustained analysis of modernity, *Critique of Violence* marks an important moment in Benjamin's thought, but in respect of its dissolution of the concept of experience into freedom as pure violence, it led to a dead end. By following the *Critique of Violence* with an analysis of the complexities of modern, urban experience in writings such as 'Naples' (1924) and *One Way Street* (1928), Benjamin turned back from the threatened dissolution of the theory of experience by a theory of absolute freedom, and began instead to explore the possibilities for freedom which were afforded by a concrete but nonetheless speculative analysis of modern experience.

The experience of modernity

The tension between the theoretical 'comprehension and recasting' of the modern concept of experience and the practical/political absolute rejection of it in the name of freedom characterised Benjamin's work up to and including the *Critique of Violence*. The critique of modern experience in his theoretical philosophy was in the early period more subtle and well developed than in his practical philosophy. The latter was overwhelmingly reactive and negative,

rejecting modern experience in the name of a sacrificial ideal of militant, nihilistic purity. Although he never fully overcame this tendency, the dissolution of the concept of experience in the concept of freedom pursued in the *Critique of Violence* was reversed in his subsequent writings. In these, instead of rejecting modern experience in the name of absolute freedom, Benjamin explored the new possibilities for freedom present within a decaying modern experience.

This is not to suggest that the theoretical 'comprehension and recasting' of modern experience was any less radical than its rejection at the level of practical philosophy. In *On the Programme of the Coming Philosophy*, to take one example from many, Benjamin identifies the 'lower and inferior nature of experience' which he considered to be characteristic of the Enlightenment with that of 'the entire modern era'. Yet while setting himself to comprehend the limits of modern experience through tracing its process of decay, Benjamin tried to draw out the new possibilities for freedom made possible by it. The pattern of argument that emerged in his critique of Kant, that is, of selecting what is to be rejected and developed in Kant's concept of experience, also informed his general approach to modern experience. Throughout the 1920s and 1930s Benjamin was not so much pursuing a conservative 'cultural critique' of modernity as trying both to comprehend the reactive elements of decay (Nietzsche's 'passive nihilism') in modern experience as well as recognising those elements which might be recast and transformed (Nietzsche's 'active nihilism').

This approach to modern experience is exemplified by the short essay *Experience and Poverty* (1933), published in Prague following the National Socialist seizure of power in Germany. In it Benjamin reflects retrospectively on the catastrophic experience undergone by the generation of 1914–18, gathering together both his own experience and his reflections upon experience. The article begins with the fable of the man who on his deathbed told his sons that a treasure was buried in the vineyard. The sons dug in vain after the treasure, but in the event the vineyard flourished. They realised that their father had passed on to them the experience that blessings are not to be found in gold, but in industry. Benjamin tells this story in order to show that such a sense of experience as tradition, as wisdom which 'passes like ring from generation to generation'(GS II.1, 214) has been totally devalued in the experience of the generation of 1914–18 which underwent 'one of the most monstrous experiences of world history'. This was not an experience which could be passed on through tradition, since it destroyed all received wisdom: strategic experience was shown to be untrue by the experience of 'the war of position, economic [experience] by the inflation, corporeal [experience] by hunger, and moral [experience] by the rulers':

> A generation which was still taken to school in a horse-drawn carriage
> stood under the open sky in a landscape in which nothing was left

THE PROGRAMME OF THE COMING PHILOSOPHY

unchanged but the clouds, and in the middle, in a forcefield of destructive currents and explosions, the tiny, fragile human body.

(GS II.1, 214)

Benjamin is not content to lament this destruction of experience, but affirms in it the germs of a new experience inseparable from the new conditions of experience provided by technology. This is 'a form of new barbarism' which emerges from the destruction of experience as tradition, and which Benjamin explores in order to discover the new possibilities for experience and indeed the new freedoms which it might release.

As might be expected from Benjamin's emergent speculative concept of experience, tradition is but one of a number of possible options for the organisation of space and time. Its destruction raises the possibility not of a single but of a number of possible successors. In *Experience and Poverty* Benjamin mentions four possible options, but his entire authorship of the late 1920s and 1930s may be read as an exploration of the ambiguity of the new, modern conditions of possible experience. One response to the destruction of experience is the 'oppressive wealth of ideas' represented by such 'new age' nostalgic revivals as 'astrology and yoga, Christian Science and Chiromancy, vegetarianism and gnosis, scholasticism and spiritualism' (GS II.1, 214). The meaning of this 'repulsive and chaotic renaissance' is captured for Benjamin in Ensor's paintings of masked *petit-bourgeois* crowds, which show the masking of the dissolution of experience [*Erfahrung*] by the welter of available experiences [*Erlebnisse*].

A further compensatory response is analysed later in the essay in the guise of the surpassing of technology in dreams. Benjamin gives as an example Disney's cartoons of Mickey Mouse (of whom we shall hear more in Chapter 3):

Nature and technology, primitiveness and comfort here become completely one, a way of being [*Dasein*] which appears as a relief to the eyes of people who are worn out by the endless complications of everyday life and for whom the meaning of life has disappeared in the vanishing point of an endless perspective of means. It is a way of being which always turns to the simplest and most comfortable way of contenting oneself, in which a car does not weigh more than a straw hat, and in which the fruit on the tree ripens as quickly as the gondola of a hot-air balloon.

(GS II.1, 218–19)[35]

However, this experience remains a dream, a compensation, although Benjamin is far from condemning it. Indeed, both forms of compensation for the poverty of experience are possible experiences; however, they are situated with respect to two other, barbaric responses to the destruction of experience.

One takes the destruction as an opportunity to establish a new configuration of experience, the other intensifies the destruction; one is an active affirmative nihilism, the other a reactive, passive nihilism.

Benjamin often described his work as 'nihilistic' and the celebration of an affirmative barbarism in *Experience and Poverty* illuminates his earlier nomination of a future politics informed by what he called in the *Theologico-Political Fragment* of 1921 the 'method called nihilism' (OWS, 156). His introduction of a 'new, positive concept of barbarism' required the affirmation of the new, an active nihilism exemplified for Benjamin by the work of Descartes, Einstein, Brecht, Loos and Scheerbart. His two leading examples of an affirmation of new possibilities of experience and freedom opened by the destruction of tradition are the transformation of language and of patterns of living. Drawing on his experience of the Soviet Union in the 1920s, Benjamin describes the linguistic experience of the destruction of tradition as 'Not a technical modernisation of language, but its mobilisation in the service of war or work; in any case, the transformation of reality and not its description' (GS II.1, 217). This possibility is meant to be chilling, since it is wide open to abuse. Yet Benjamin here is totally consistent with his earlier philosophy of language, which held that human language did not describe a pre-existing reality, but was a mode of transforming it. It acted thus in tradition, and would continue to do so in modernity, but with more obviously threatening consequences. For Benjamin it would be a sentimental illusion to imagine that language would not participate in the production of a new experience, that it possessed some form of immunity from the destruction of tradition.

The second affirmation concerns human habitation, and the development of glass architecture (foreseen by Scheerbart, and for Benjamin realised in the work of Loos and Le Corbusier). He writes that 'Things made of glass have no "aura". Glass is generally the enemy of secrets. It is also the enemy of possession' (GS II.1, 217). For Benjamin, glass architecture dissolves the distinction between interior and exterior, replacing it with the single, continuous concept of transparency. This form of architecture not only expresses a change in the structure of experience, but also confirms and contributes to it. Once again, this affirmative modernism is stated in disturbing terms, but for Benjamin this transformation of experience is already in train, and every option, whether compensatory, affirmative or destructive and negative expresses a decision taken with respect to it.

In many ways Benjamin's 1933 essay on experience and poverty is consistent with the programme for a critique of experience announced in *The Life of Students*. There the task given to critique was 'to point out the crisis that hitherto has lain buried in the nature of things (1915b: 36). In the later essay he does not seek an idea or redemptive absolute which will integrate a shattered experience, but looks for the intimations of new freedoms announced in the distorted, comical and even terrifying patterns of modern experience. It

also hints at the crisis inherent in modern experience, and the ambivalence which this generates. On the one side is the constructive affirmation of modern experience, on the other its destructive negation or war. *Experience and Poverty* ends with the hope that the affirmative forms of modern experience would help prepare humanity to survive the coming war. The task of the critic was to recognise the new possibilities for freedom opened by the destruction of tradition and the crisis of experience, and to call for a decision. However, that decision could not be an appeal to a redemptive idea which would unify experience, for this desire is itself now recognised as one which reduces the options for freedom. But as we shall see repeatedly, Benjamin was inconsistent on this point, and indeed two years later, in *The Work of Art in the Epoch of its Technical Reproducibility*, we find him concluding a critical analysis of the possibilities of freedom inherent to modern experience, with a call for an either/or decision: either fascism or communism.

2

SPECULATIVE CRITIQUE

> My chief interests were philosophy, German literature, and the history
> of art . . . Since the centre of gravity of my scholarly interests lies in aes-
> thetics, my philosophical and literary studies have increasingly
> converged.
>
> Walter Benjamin, *Curriculum Vitae*, 1925

Experience and immanent critique

Benjamin's elaboration of a non-Hegelian speculative philosophy of experience redefined the nature and limits of critique. The Kantian view that critique should confine itself to securing the legitimacy of judgements in terms of a cat-egorial framework applicable only within the limits of spatio-temporal experience no longer sufficed. The extension of the bounds of experience brought with it the demand for a new and extended notion of critique. Benjamin responded to this demand by returning to the concept of criticism developed by the Romantic, pre-Hegelian generation of Kant's critics, above all Friedrich Schlegel and Novalis. From their example he derived a speculative concept of criticism guided by the method of 'immanent critique'. The dis-covery of the method in his early work in literary criticism was contemporary with the elaboration of his speculative concept of experience, and both remained closely linked throughout his authorship.

It is axiomatic for immanent critique that the criteria of critical judgement be discovered or invented in the course of criticism. This followed necessarily from the extension of the bounds of experience: if the absolute is immanent to experience, then the critical judgement of experience must also be under-taken immanently. There can be no externally given and secured criteria of critical judgement such as those Kant deduced from the nature of the apper-ceptive subject. Consequently, instead of making critical judgements according to transcendentally secured criteria, immanent critique looks for its criteria in the traces of the absolute left in an experience or work. It is attentive to the dis-torted and inconspicuous ways in which the absolute manifests itself in the work or object of experience as well as open to having its 'conditions of legi-bility' transformed by the encounter with the work or object of experience. But far from being a modified form of transcendental argument such as that proposed in Kant's account of reflective judgement in *The Critique of*

Judgement, immanent critique is speculative in acknowledging that both it and the work or object being judged are transformed by their encounter.

The speculative character of immanent critique follows from Benjamin's view of the complex temporality of experience. This is already evident in the essay *The Life of Students* (1915b) where criticism is called to 'recognise and free the future from its distorted form in the present'. Criticism discovers a rule immanent to experience, but one which, because it is of the future, is in a sense 'produced' by criticism. The invention of the future through criticism binds it closely to experience, since by selecting potential futures, criticism transforms both experience and itself. Criticism is not only directed toward the future, but must also engage with previous critiques in the shape of the tradition through which experience is given. Immanent critique is ineluctably temporal and possesses no fixed laws; it is always in the process of transforming itself and its objects. This is not an automatic or inevitably favourable process, but one fraught with danger for the critic. A given doctrine of criticism, such as philosophy, is always endangered by the object of criticism exceeding the limits of critical judgement and leaving criticism speechless or condemned to prattle.

The sensitivity to the finite but speculative character of critique poses severe problems for the practice of criticism, prime among which is the extreme reflexive complexity to which it inevitably gives rise. Immanent critique is determined by the object of criticism which is in its turn transformed by the work of critique which then in turn responds reflexively to the changes both in itself and in its objects. This reflexive complexity or endless task of criticism was explored in Benjamin's critical reflections on German Romanticism, Goethe and the Baroque mourning plays. In these critiques, the textual object of criticism is dissolved into a broader concept of experience which reflexively transforms the conditions of critique itself. However, the intense sensitivity to reflexive complexity is accompanied throughout Benjamin's work by a desire to terminate the endless task of criticism by resort to an 'idea' or 'truth' which becomes its atemporal, ideal telos. The tension between a finite but speculative concept of criticism and one which dogmatically seeks timeless truths is to be found at all stages of Benjamin's authorship.

The development of immanent critique

The development of Benjamin's concept of critique is inseparable from his philosophical attempt to extend Kant's concept of experience. His early critical writings not only deploy Kantian concepts and vocabulary, but also take as their theme the Romantic response to Kant's philosophy. In many ways Benjamin's interpretation of German Romanticism may be regarded as an attempt to recover the understanding of Kant's philosophy that had been lost by academic neo-Kantianism. By restaging the encounter between Kantian critique and the Romantic extension of the limits of experience, Benjamin sought to recover that uncanny quality of Kant's thought that was capable of

shaking 'Kleist to the core' (C, 98). The critique of Romanticism was thus an intensely reflexive project which recovered the Kantian origins of Romanticism while using Kantian concepts to criticise Romanticism. The reciprocal transformation of Kant's critical concepts and early Romantic literature serves a model for Benjamin's concept of criticism, combining a recognition of temporal complexity with an intense sensitivity to the reflexive character of criticism.

The characteristics of temporal complexity and reflexive subtlety are evident in Benjamin's three most significant critical essays predating the *Origin of the German Mourning Play*: *Two Poems by Friedrich Hölderlin* (1915), his doctoral thesis *The Concept of Art Criticism in German Romanticism* (1919) and *Goethe's Elective Affinities* (1922). In each of these essays the self-reflexive practice of criticism transforms the parameters of critique. In the doctoral thesis, the main object of criticism is indeed the link between reflexivity and the temporal, transformative character of critique. The complex experience which is discovered in the course of criticism challenges the practice of critique, and leads to an unprecedented sensitivity to the surface, folds and warps of a text, whether at the thematic, semantic or rhythmic levels. The change in the character of critique is already evident in the early immanent critique of Hölderlin.

The central critical concept of *Two Poems by Friedrich Hölderlin* is the 'Poetic' or *Gedichtete*. Although this concept is discovered in the course of criticism, its basic contours are anticipated in the opening methodological paragraphs of the essay. While the critical concept of the 'Poetic' motivates the critique of the two Hölderlin poems *Dichtermut* and *Blödigkeit* it is in a sense only discovered in the course of criticising them. The reflexive derivation of the concept of the 'poetic' begins by assigning to the method of 'aesthetic commentary' the task of showing the 'inner form' or Goethean *Gehalt* or 'capacity' of a poem. The concept of 'inner form' is discussed in terms of the 'poetic task' (*dichterische Aufgabe*); this is derived immanently from the poem as well as being identified as its 'presupposition' or the 'spiritual-intuitive structure (*geistig-anschauliche Struktur*) of the world to which the poem bears witness' (1915a: 18).[1] The 'poetic task' is immanent and external to a poem, being for criticism 'both the product and object of investigation'. The 'sphere' which encompasses the 'poetic task' has a particular shape (*Gestalt*) for every poem and it is this which Benjamin designates as the 'Poetic' [*Gedichtete*].

After the derivation of the 'Poetic' as both product and object of critical investigation, Benjamin describes it speculatively as a concrete a priori or 'synthetic unity of the spiritual and intuitive orders'. The 'Poetic' is a speculative concept which synthetically unites the absolute ('spiritual order') with spatio-temporal experience ('intuitive order'). The particular shape adopted by this unity comprises the 'inner form' or shape (*Gestalt*) of the poem whose contours it is the task of critique to trace and exhibit. Benjamin insists that the 'Poetic' is immanent to the poem and beyond the 'form-content' distinction

of traditional aesthetics. As a shape of synthetic unity it 'preserves the funda-mental aesthetic unity of form and matter, and instead of separating them, stamps itself with their immanent and necessary union (*Verbindung*)' (1915a: 19). Yet even though the 'Poetic' as a synthetic union or 'concrete a priori' before and beyond the opposition of form and matter is derived from the poem, it is also, paradoxically, a condition of the poem's possibility.

While the 'Poetic' designates the particular configuration of experience which informs the poem, it does so in a different way to the 'strict, functional articulation that governs the poem'. The poem is a singular, fully determined actuality whose existence is determined by 'the actual being there of all the determinations (*aktuelle Dasein aller Bestimmungen*)'; the 'Poetic' however has the speculative property of constituting both this actual *and* one of a number of other possible configurations of intuitive and spiritual orders. The specula-tive force of immanent critique arises from this distinction between the poem as a singular actualised configuration and the 'Poetic' as its speculative princi-ple which can assume a number of possible configurations. In order to criticise the particular configuration employed in an actual poem it is necessary to speculate upon the other possible configurations of 'the Poetic'.

After formally analysing how the 'Poetic' can both be presupposed by and yet derived from the poem, but without becoming either an abstract idea or an empirical description, Benjamin takes the further step of grounding the 'Poetic' in 'life'. The actual configuration of experience or union of the spiri-tual and intuitive orders in a given poem is one of a number of possible configurations in 'life' or experience in general. Since experience is a syn-thetic unity of the absolute and the spatio-temporally limited (a synthesis to be analysed, in the case of the Hölderlin poems, through the theme of death) the particular configuration in a poem is a special case. However, Benjamin is careful to maintain that the artist does not simply choose to actualise one of the number of possible configurations represented by the 'Poetic', but rather that the 'Poetic' represents a 'limit concept' between the actual poem and life. This means that the possible configurations of 'the Poetic' are determined as much by the actual configuration of the given poem as by the potentially infi-nite number of configurations in possible experience or 'life':

> The Poetic shows itself to be the transition from the functional unity of life to that of the poem. In it life determines itself through the poem, the task through the solution. At the basis of this is not the individual sense of life of the artist, but a context of life (*Lebenszusammenhang*) determined by art.
>
> (1915a: 19–20)

The 'Poetic' is shaped by both poem and life, and yet in its turn gives shape to both: it is neither inside nor outside the poem, an indication that it is a spec-ulative rather than a transcendental condition of its possibility.

Benjamin's 'aesthetic commentary' upon Hölderlin's *Dichtermut* and *Blödigkeit* finds in the two poems a 'certain relationship' which makes it 'possible to speak of them as different versions' (1915a: 21). He regards them as elaborations of the same 'Poetic', a claim which he establishes methodologically by means of a thematic comparison of what he will subsequently call their 'material content' (*Sachgehalt*). The thematic comparison is a crucial moment in Benjamin's reading, vital if he is to meet the criticism that he has not simply assumed or imagined the 'certain relationship' or 'Poetic' common to both poems. Having established to his own satisfaction the existence of a common 'Poetic', Benjamin proceeds to judge how perfectly it is realised in each of the two versions of the poem. The critical judgement is carried out in terms of the two main characteristics of the 'Poetic' discussed earlier: its unification of the intuitive and spiritual orders and its articulation of the spheres of life and the poem.

The criticism begins with the articulation of life and poem in the 'Poetic' of *Dichtermut* and *Blödigkeit*, which Benjamin describes in terms of a mood or way of being in the world. The articulation of life and the poem in the 'Poetic' of the two poems is the mood of 'courage' (*Mut*), specifically courage in the face of death:

> The Poetic of both versions – not in their similarity, for there is none, but in their 'comparability' – shall be compared. Both poems are bound together in their 'Poetic', above all in their stance towards the world [*in einem Verhalten zur Welt*]. This is courage, which, the more deeply it is understood, becomes less a property than a relationship [*Beziehung*] of humanity to the world and of world to humanity.
>
> (1915a: 33)

The articulation of life and poem is understood in terms of courage in the face of death, and the two versions are compared in terms of their realisation of the 'Poetic' of courage. Benjamin writes of *Dichtermut* that 'The "Poetic" of the first version knows courage primarily as a property. Humanity and death oppose each other, both fixed and rigid with no intuitive world in common between them' (1915a: 33). In this version, the experience of the absolute as possible death is not integrated into the order of intuition (life or spatio-temporal experience) but is opposed to it. This initial discovery is then refined into the judgement that 'The resolute formation of intuition and figure out of a spiritual principle was avoided, and neither was permeated by the other. The danger of death in this poem was overcome by beauty' (1915a: 33). Beauty in the first version is not immanent to the poem but a poetic consolation for the rigid opposition between life and death.

The view of beauty serving as a consolation for an apparently ineluctable opposition anticipates Benjamin's later critique of the 'aestheticisation of politics' in which political oppositions are superficially overcome by an appeal to

beauty. As is well known, in *The Work of Art in the Epoch of its Technical Reproducibility* Benjamin opposes to this 'aestheticisation of politics' the enigmatic 'politicisation of art'; so too in the earlier essay Benjamin provides an alternative to beauty as consolation. This emerges in the second Hölderlin poem *Blödigkeit*, which achieves in Benjamin's judgement a more perfect realisation of the 'Poetic' of courage. In this version the intimation of the absolute in death and the intuitive order of spatio-temporal experience or 'life' are closely bound together, shaped into an 'immanently necessary union'. Beauty is no longer called upon to console in the face of death since 'in the second version beauty flows from the overcoming of danger' (1915a: 33). In this version, courage is the 'spiritual principle' which emerges out of life binding together humanity and death. Instead of courage being the response of humanity to the danger of death, it emerges in the second version as the feeling of life. It is the paradoxical articulation of the spiritual order intimated by death and the finite human world: 'the courageous undergo danger but pay no heed to it. For it would be cowardice if they heeded it, but would not be courage if they did not undergo it' (1915a: 33). With this paradox a new, speculative relationship is opened between the spiritual and intuitive orders, one in which death is not opposed to the spatio-temporal world but is everywhere present within it. The first version shapes the 'Poetic' of courage into a 'heeding' of the danger of death which remains powerless before it, while the second undergoes the danger and translates it into life, achieving the speculative union of the immanence of life and the exteriority of death.

In the first version the separation of death and experience led to a certain lack of definition and articulation within the poem. The two aspects of the 'Poetic', the articulation of world and poem and of intuitive and spiritual orders within the poem led in this case to a series of destructive oppositions in which death and the absolute were opposed to spatio-temporal life. In the first version

> Death itself is not – as it was later understood – figure in its deepest articulation, but is the extinction of the plastic, heroic being in an undetermined beauty of nature. The space and time of this death still do not emerge in the spirit of figure as unity.
>
> (1915a: 23)

In the second version, the change in the understanding of the relationship between death and the world is expressed in the 'mutual permeation of the individual forms of intuition [space and time] and their articulation in and with the spiritual, as idea, destiny, etc' (1915a: 32). Such mutual permeation breaks down the distinctions between humanity and the absolute, leading in Benjamin's eyes to the emergence of new topologies in which space, time and the absolute mutually inform and shape each other into a speculative *Verbindung* or union beyond the syntheses of form and content. Benjamin

evokes this speculative union in a strange passage, whose difficult syntax perfectly expresses the paradoxical union of absolute and intuition, exteriority and immanence which he is trying to describe:

> The figures [*Gestalten*] of the poetic world are at the same time infinite and limiting; the figure must, according to the inner law, be as much superseded [*aufgehoben*] as dissolved within the being-there of the song, just as the animating force in the living. Even the God must in the end serve the song to his best and execute its law, just as the people must be a sign of its duration. This fulfils itself in the end 'and from the heavenly ones, Bring one'. The shaping, the inner plastic principle, is so heightened that the destiny of the dead form breaks over the God so that – metaphorically speaking – plasticity is turned inside out and God becomes completely an object. Temporal form breaks through from the inside to the outside as a motion. The heavenly one *will be brought*. Here is a supreme expression of identity: the Greek God falls to his own principle, to figure.
>
> (1915a: 32)

The difficult relationship between critique and the philosophy of experience described in Chapter 1 manifests itself here in the torsions of space, time and the absolute that Benjamin discovers in Hölderlin's poems. However, the exercise of critique in *Two Poems by Friedrich Hölderlin* is not merely the application of a philosophically expanded notion of experience to literature, but an aspect of that expansion itself. The exercise of critique indeed extends the concept of experience, pointing to new topologies of space, time and the absolute which are also new ways of being-in-the-world. The critical analysis of a post-Kantian poet initially conducted in terms derived from Kant leads far beyond Kant's concept of experience. The poetic experience of Hölderlin which extended Kant's concept of experience is in Benjamin's reading reflexively turned back upon it. This experience was further developed in the doctoral dissertation and the essay on Goethe, where post-Kantian poetic reflections on death and the absolute are again used to transform Kant's concept of experience. At the same time the works of art are themselves transformed by being given a philosophical density which they always possessed but which was not explicit.

In the criticism of Hölderlin's poems Benjamin discovered a method of immanent critique which he refined but did not fundamentally change in his subsequent writings. This method begins by collecting thematic material in order to discover a locus of speculative experience (here the 'Poetic') which is then used reflexively to modify the analysis of both material and critical concepts. The *Two Poems by Friedrich Hölderlin* essay inaugurates a new relationship between philosophy and literature, one in which both philosophy and the work of art are transformed. Art comes to assume a philosophical

40

significance denied it since Hegel's *Aesthetics* subordinated art to philosophy as a means of presenting the absolute. Benjamin retrieves from the work of the early Romantics a concept of art, criticism and philosophy which had been lost in the Hegelian development of the Romantic critique of Kant.

The evidence for a close relationship between Benjamin's Bern doctoral thesis on *The Concept of Art Criticism in Early Romanticism* and his contemporary attempts to extend and enrich Kant's concept of experience is overwhelming. Benjamin originally intended to focus his thesis on Kant alone, and already in a letter to Scholen dated 7 December 1917 he mentions that he is considering a study of 'the concept of the "endless task" in Kant' or, from another letter from later in the same month, 'Kant's history of philosophy' (C, 103 & 115). By early spring of 1918 the project had taken on definitive shape as a study of the extent to which 'Kant's aesthetics constitute the underlying premise of Romantic art criticism' (C, 119). At precisely the same time, Benjamin was completing what he described in a letter to Scholem of 13 January 1918, as the 'dubious philosophical jottings' (C, 110) that were to form *On the Programme of the Coming Philosophy*. The *Concept of Art Criticism in Early Romanticism* continues the philosophical project through the analysis of the challenge posed to Kant's transcendental critique by the Romantic extension of the concept of experience.

As in the essay on Hölderlin, Benjamin reads Kant through post-Kantian writers, mainly Friedrich Schlegel but also to a lesser extent Novalis and Goethe. He introduces his thesis as a presentation of the 'concept of criticism' by means of an analysis of the 'epistemo-theoretical presuppositions' (1919: 117) of the development of Kantian critique through Romantic art criticism. The first part of the thesis on 'Reflection' reveals the 'epistemo-theoretical presuppositions' in question to be none other than the extension of the bounds of Kant's concept of experience. Towards the end of the first half of the dissertation, Benjamin concludes his analysis by showing how Romantic criticism extended Kant's critique:

> The concept of critique had received through Kant's philosophical work an as it were magical significance: in any case, for the Romantics and for speculative philosophy the term critical was explicitly not associated with a merely discriminative, unproductive spiritual attitude, but signified something objective, and productive out of reflection.
>
> (1919: 142)

Benjamin saw the Romantics extending a speculative side of critique that was latent but underdeveloped in Kant's transcendental philosophy. In this he identified the beginnings of art criticism as opposed to the judgement of art – 'it is first with the Romantics that the word art critic [*Kunstkritiker*] prevails over the older term of connoisseur [*Kunstrichter*]' (1919: 143). The new,

Romantic concept of critique occupies a position between the normative rules of neo-classicism and the unruly subjective genius of *Sturm und Drang* analogous to that of Kantian critique between dogmatism and scepticism. This position, however, could only be sustained on the basis of a thorough revision of Kant's concept of experience.

The relationship between the Romantic concept of critique and the extension of Kant's concept of experience is explored in the first part of the thesis in two ways. The first follows the distinction between Fichte and Schlegel's attempts to restore the absolute to experience by means of a philosophy of reflection, while the second develops the argument of *On the Programme of the Coming Philosophy* that Kant's concept of experience needed to be extended beyond its matrices of Euclidean geometry and Newtonian physics to include art and religion. Benjamin fuses the two lines of argument in a reading of Schlegel which discovers in art a medium of 'absolute reflection' where the infinite is immanent to experience.

Following Schlegel's fragments from the late 1790s, his correspondence with Novalis and the later 'Windischmannschen Lectures' from 1804–6, Benjamin presents the common ground and the divergences between Fichte and Schlegel's extension of Kant's concept of experience. The common ground lies in the extension of experience through a philosophy of reflection which includes within itself the experience of the absolute. For Fichte in the first *Science of Knowledge* (*Wissenschaftslehre*) of 1794, this speculative experience follows from thought's reflective thinking of itself, a process of reflection which is potentially infinite, since each reflective thought of thought becomes the subject of yet another reflection. This philosophy of reflection has the potential of becoming precisely the 'intellectual intuition' which was forbidden by Kant's critical concept of experience, one in which the content and form of thought dissolve into one another. It can also become a 'bad infinity' or endless task, in which reflection is always deferring its completion. Fichte, in Benjamin's reading, attempted to govern the process of reflection by resort to a subject or *Ich* which continually reflects upon itself and in so doing discovers its vocation as an active, practical subject in the world.

For Benjamin, the work of Schlegel and Novalis represents a radical development of Fichte's extension of Kant's concept of experience. They follow Fichte as far as admitting the absolute into thought through reflection, but refuse to locate the source of reflection in an acting subject. Focusing on Schlegel, Benjamin shows that for him reflection occurs in a *medium* and is not the product of a *subject*; what is more, this medium is identified as art:

> The thinking of thinking . . . as the primal schema [*Urschema*] of all reflection, lies at the basis of Schlegel's conception of critique. Fichte had already decisively determined this as form, but had himself interpreted this form as 'I', as the basic unit [*Urzelle*] of the intellectual

concept of the world. Friedrich Schlegel, the Romantic, had interpreted it around 1800 as aesthetic form, as the primal cell of the idea of art.

(1919: 134–135)

Schlegel's difference with Fichte on the issue of whether the unit of reflection was an acting subject or the medium of art had a number of important consequences. In the first instance, it meant the break with the concept of science which still determined Fichte's extension of Kant's concept of experience. In Benjamin's words, 'Thanks to their method, the early Romantics dissolved the image of the world [of the positive sciences] entirely into the absolute, and sought in this a different content from that of science' (1919: 131). Even more significant was Schlegel's conviction that the medium of reflection was not a subject, and could not be thought of in terms of an absolute, acting I:

Another reflection is at work in this altered notion of the absolute. The Romantic intuition of art rests on this: that in the thinking of thinking no consciousness of an I is understood. Reflection without the 'I' is a reflection in the absolute of art.

(1919: 134)

Benjamin promises that the exploration of this absolute in terms of subject-less reflection will be accomplished in the second part of the thesis on *Art Criticism*. Meanwhile he stays with the task of justifying critique in terms of its 'epistemo-theoretical presupposition,' in the concept of speculative experience developed by Schlegel in the wake of Kant and Fichte.

The notion of the objectivity of the work of art, apart from any reference to a creative subject, became axiomatic for Benjamin's concept and practice of critique. However, the speculative concept of experience on which it rested needed to be justified. The main justification offered in *The Concept of Art Criticism in German Romanticism* rested upon the notion of a 'realised infinity' of experience. This was defined against the spectre of the 'bad infinity' of reflection proposed by Fichte, in which each reflection becomes the subject of another reflection. Reading Fichte and the Romantics in the light of Hegel's critique of their bad infinity underlines again Benjamin's attempt to develop a non-Hegelian but speculative philosophy. As in his contemporary philosophical fragments, this is presented in terms of an immanent absolute:

The infinity of reflection is for Schlegel and Novalis in the first instance not an infinity of progress but an infinity of configuration . . . the infinity of reflection is understood as a realised infinity of configuration [*eine erfüllte Unendlichkeit des Zusammenhanges verstanden*].

(1919: 126)[2]

43

This infinity is formally the same as the infinity of configuration proposed in Benjamin's philosophical writings, that is, one in which the infinite is folded into the finite and manifest in the warps, tears and incongruities of experience. It is not the telos or end of an infinite process of reflection, nor is it the work of a subject, but has the character of an internally configured medium. Benjamin describes this medium in the idiom of the philosophy of reflection:

> This configuration can be grasped mediately as an infinite number of levels of reflection, in which by degrees all the remaining reflections run through from all directions. In the mediation of reflections there is no principal opposition to the immediacy of thinking comprehension because each reflection is in itself immediate. It is thus a matter of mediation through immediacies; Friedrich Schlegel knew no other and speaks in this sense of a 'transition that must always be a leap'. This principal, if not absolute yet mediated immediacy is that on which the vitality of the configuration depends.
>
> (1919: 126)

The view of experience as infinite configuration dissolves any notion of a subject able to occupy a fixed position from which to reflect, since all reflections are already infinitely mediated by other reflections. In this quasi-Leibnizian configuration of monads, each reflection contains the infinity of reflections, including its own reflection upon this infinity. As Benjamin specified some pages later, 'Reflection constitutes the absolute, and it constitutes it as a medium' (1919: 132),[3] a thought which he illustrates with a reference to Novalis's philosophy of colour, in which colours are mutual reflections within the medium of light.

The implications of this metaphysic of experience for the concept of critique are considerable, especially when art is identified as a privileged medium of reflection. Criticism in general, and art criticism in particular, discerns the traces of the infinite left in a particular reflection or work of art. Yet it is always in danger of lapsing into either the dogmatic application of a rule of discrimination between the finite and infinite or the sceptical play of differences within the finite. In his Atheneaum period Schlegel invented a new form of philosophical art criticism which 'overcomes aesthetic dogmatism . . . as well as securing art criticism against the sceptical tolerance that is traceable, in the end, to the limitless cult of creative power understood as the mere expressive force of the creator' (1919: 154). Schlegel's work seemed exemplary in maintaining the objectivity of art criticism against any submission to the dogmatically established rules of neo-classical aesthetics or the sceptical consequences of the cult of genius. This was achieved by establishing 'a different criterion for the work of art than the rule, the criterion of the determinate, immanent construction of the work of art itself' (1919: 155). The 'immanent construction' of the work cannot be reduced to an objective rule or act of

44

artistic will but is the matrix that sustains the work during its passage through time.

Benjamin follows Schlegel in identifying the 'construction' of the work of art with its form. Yet this is not form in the classical sense of a shaping principle imposed upon matter, but form understood as the configuration of a medium of expression. As with the bounded infinity of the linguistic surface described above, form is both medium of expression and that which is expressed. In the idiom of the Fichtean philosophy of reflection, form is both the *expression* and the *possibility* of reflection, it is

> the objective expression of that reflection which is proper to the work and which forms its essence. It is the possibility of reflection in the work, and informs it a priori as a principle of existence [*Daseinsprinzip*]; through its form the work of art is a living centre of reflection.
>
> (1919: 156)

As with the 'Poetic' of the Hölderlin essay, form here is not confined to the opposition of concept and intuition, but is a concrete a priori or *Daseinsprinzip*. As a locus of reflection it possesses the speculative property of being both that which is expressed and that through which there is expression; it is neither applied to content from outside the work nor simply abstracted from it. The work is understand by analogy to a bounded infinity: it possesses an a priori structure of expression which is open to, indeed derived from, an infinite number of expressions. The task of immanent critique is to unfold the formal possibilities inherent in a work of art, supplementing what was achieved in the actual work 'afflicted with a moment of chance' with other possible works that together constitute what Benjamin describes as the speculative 'idea of art'. The work as *this* particular work of art is afflicted with the chance circumstances of its birth – its heritage – but is also open to the infinite chance of its future – its critical posterity.

The second, futural sense of chance, manifest in the counterfactual possibilities of a work – anticipated in the Hölderlin essay – emphasises the speculative mission of criticism. It highlights the formal constitution of the actual work while introducing into it a moment of contingency through the possible future transformations of the work through criticism. Yet at precisely this point in Benjamin's argument critique again finds itself poised between the dogmatic and the sceptical options: it may either extinguish the 'moment of chance' by claiming to state all the formal possibilities present in a work, thus transforming them into timeless necessities, or dissolve the formal constitution of the given work by the potentially endless invention of contingent counterfactual formal possibilities.[4]

In the dissertation Benjamin traces the outline of a speculative but finite critique in which the absolute, rather than completing or dissolving the work,

introduces new contingencies into its structure. In this concept of critique the absolute is both immanent to and in excess of a work, but in terms of neither an objective rule derived from nature or reason nor the will of a subjective creator-genius. For Benjamin, the excessive moment of the work is discovered in the act of criticism which is always subsequent to it, and hence in its future. For him as for Schlegel, the form of a work requires a critical supplement and is thus incomplete at any given moment. Critique, in this view, is not only the 'negative moment' of judgement, but also the 'positive moment' of the supplement: immanent critique is thus both 'estimative' and 'inventive':

> The immanent tendency of the work and, accordingly, the standard for its immanent criticism is the reflexion which lies at its basis and is imprinted in its form. Yet this is, in truth, not so much a standard of judgement as, first and foremost, the foundation of a completely different kind of criticism which is not concerned with judging, and whose centre of gravity lies not in the estimation of the single work but in demonstrating its relations to all other works and, ultimately, to the idea of art.
>
> (1919: 159)

Critique becomes the introduction of contingency into the form of the work, a supplement which situates the work with regard to the totality of actual and possible works, so allowing the form or 'immanent construction' to emerge. Critique disturbs the identity of the work by opening it to future possibilities, but it does so without transforming its immanent possibilities into necessities nor by dissolving them into contingencies.

In the presentation of the early Romantic concept of art criticism, Benjamin changes the definition of criticism from the exercise of judgement according to a given law to the presentation of its immanent possibilities of transformation. Critique was described earlier in the dissertation as an 'experiment on the work of art, through which its reflection is woken and which can bring it to consciousness and knowledge'. The process of experimentation consists in the 'unfolding of reflection' or in the reflection 'which can bring its immanent kernel to unfold' (1919: 151). In the essay on Hölderlin, the critical experiment was conducted in terms of a comparison of two versions of the same 'Poetic' or 'immanent kernel'; in the light of Schlegel's early work Benjamin now considers it possible to accomplish the experiment with a single work, indeed he even claims that it is often accomplished within the work of art itself.

An important methodological consequence of the study of the early Romantic concept of art critique for the development of Benjamin's criticism is the view that a work of art changes over time. Such a transformation of the work was achieved through the supplementation of the work's formal possibilities by critique. This meant that the preliminary critical reflection on

a work could be conducted through a scrutiny of its after-life, or those of its possibilities which had neither been realised in the work itself nor in previous critiques. The work of art has folded within it a set of possible interpretations, a subset of which has been realised in its critical tradition. Benjamin's own practice of critique from this point was attentive to both the work of art and its critical afterlife. He expresses the same thought in a quite different idiom (i.e. Marxist) in the late methodological 'Addendum' to *The Paris of the Second Empire in Baudelaire* where he claims:

> it is an illusion of vulgar Marxism that the social function of a mate-
> rial or intellectual product can be determined without reference to the
> circumstances and the bearers of its tradition. . . . The tradition of
> Baudelaire's work is a very short one, but it already bears historical
> scars which must be of interest to critical observers.
>
> (CB, 104)

The allusion to the scars of tradition alerts us to the possibility of critique vio-lently transforming or even at the limit destroying its object; as much as it can expand and open the possibilities present in a work it can also restrict and close them. This issue was addressed in the final section of the dissertation where Benjamin compares the early Romantic theory of art with that of Goethe. For Schlegel, anticipating Hegel, critique will in time ultimately overcome the contingency present in the work by revealing all of its possibil-ities and thus converting them into necessities: 'The sublation of contingency in the torso-like character of the work is the intention of Schlegel's concept of form' (1919: 182). Benjamin contrasts this position with Goethe's view that the passage of time and the work of critique does not progressively realise the work, but reduces it first to a torso or ruin and then, in the fullness of time, to nothing.

The dissertation ends with the opposed eschatologies of art: for Schlegel the work of art is realised through its history which arrives at the abolition of con-tingency in the transformation of formal possibility into realised necessity, while for Goethe, the work of art is destroyed by its history, its formal possi-bilities reduced to pure contingencies. In the first case, at the limit we *know* the work of art, while in the second, we can only *imagine* it. Benjamin described the final section of the dissertation in a letter to Ernst Schoen of May 1919 as an 'esoteric epilogue . . . for those with whom I would have to share it as my work' (C, 141), and indeed the opposition it presents is one which continued to inform his own concept and practice of criticism. It involves the same problems as those he confronted in his concepts of truth and experience, namely: is truth the eschatological completion of experience in the realisation of an 'eternal idea' (Schlegel) or the nihilistic 'messianic cessation of happening' (Goethe), or is it rather the endless task of transformation?

The Concept of Art Criticism in German Romanticism may be read as a

programmatic statement of a philosophical criticism. Its attack upon 'subjectivism' is explicitly linked with a critique of the subjective character of contemporary criticism. The claim for the objectivity of the work of art and the related necessity of the practice of immanent critique formed the 'epistemo-theoretical presupposition' of Benjamin's own criticism, beginning with the essay on Goethe's *Wahlverwandschaften* which Benjamin wrote during the autumn of 1921. In a letter he wrote to Scholem on 8 November 1921 while at work on the essay, Benjamin described it 'as an exemplary piece of criticism . . . [and] a prolegomena to certain purely philosophical treatises' (C, 194). Following the example set by Schlegel's critique of Goethe's *Wilhelm Meister*, Benjamin's essay was as much critique as philosophical reflection. It was exemplary in countering the overwhelmingly subjective and biographical tradition of Goethe criticism with an immanent critique which sought to supplement and intensify the process of reflection already at work in the novella.

The *Wahlverwandschaften* essay gathers together the methodological procedures and thematic analyses of the essay on Hölderlin and the dissertation on early Romanticism. It is an immanent critique which strives to balance the redemptive and the mortuary tendencies of early Romantic and Goethean concepts of critique. It is also, at its most fundamental thematic level, a reflection on the place of the absolute in experience, explored, as in the Hölderlin essay, through a meditation upon the place of death in life. As in the earlier essay and dissertation, here the criticism is carried out by means of a reflection upon Kant which reflexively returns to a Kantian position in order to enrich it.

The first two parts of the essay prepare the ground for the immanent critique of *Wahlverwandschaften* pursued in the third and final part. They are in a sense attempts to revivify the form of the novel through a reflection on previous interpretations. The first part of the essay questions the interpretative assumption that *Die Wahlverwandschaften* is primarily a novella of marriage and adultery. This interpretation reads Goethe's novella as supplementing Kant's austere definition of marriage with the experience of love. However persuasive this interpretative framework, it does not for Benjamin exhaust the formal possibilities of the novella since 'The subject of *Die Wahlverwandschaften* is not marriage' (1922a: 302). In the second part of the essay he criticises the subjective, autobiographical approach to criticism prevalent during the nineteenth century and which peaked in the image of the artist-hero developed to an extreme by the disciples of Stefan George, and in the case of Goethe by Friedrich Gundolf.

Following the methodological prescriptions of the *Concept of Art Criticism in German Romanticism*, Benjamin reads *Die Wahlverwandschaften* through an immanent critique of its formal construction. Since he understood this construction as a 'basic reflection' or articulation of a fundamental experience, it was necessary to determine the character of this experience. This in turn required some reflection upon the relationship of the work of art and philos-

ophy, and so, at the beginning of the third section of the essay, Benjamin proposes that 'All genuine works have their brothers and sisters in philosophy' (1922a: 333) and that it is the task of critique to search for them, and to show the 'virtual formulability of [the work of art's] truth content [*Wahrheitsgehalt*] as that of the highest philosophical problems' (1922a: 334). These initially obscure introductory comments on philosophy and the work of art serve to introduce the main performance of the immanent critique, which focuses at length upon the *Gestalt* or figure of the character Ottilie. Benjamin regards this character as the keystone of the novella's construction, and the representation of her death as posing the work's basic formal and philosophical problem.

The decision to focus the immanent critique on the figure of Ottilie was prepared in the first part of the essay in Benjamin's discussion of the relationship between Goethe and Kant. The philosophical problem virtually enfolded in the work's 'truth content' is not marriage and the enriching of the Kantian notion of experience by love, but rather, as in the Hölderlin essay, the place of death in life. This theme – in the critical vocabulary established in the dissertation – is the 'basic reflection' which yields the form of the novel, and it is articulated more precisely by Benjamin in the question of the relationship between beauty and death. The figure of Ottilie is a point of intersection for beauty and death, making the analysis of this figure the focus of the immanent critique.

In the Hölderlin essay Benjamin criticises the limited concept of experience which opposes life and death, and which makes death an absolute danger excluded from life. Confined within this opposition, beauty serves as life's consolation before the threat of death; in the first version of the poem allying beauty with life against death. In the second version Benjamin discovered another relationship in which death is incorporated into life, and in which beauty is not a consolation for the threat of death, but a mark of its presence in life. In the *Die Wahlverwandschaften* essay the incorporation of death in life, or the absolute in experience, is introduced as the basic philosophical question formulated in the novella. However, the presentation of the form of this question requires that the critical terms of reflection themselves be transformed. For if these critical terms are already implicated in the opposition of life and death, then they will not be capable of presenting a formulation which refuses the terms of the opposition.

The analysis of the novella through the question of the relationship between beauty and death is conducted by means of a critical distinction which is itself reflexively transformed in the course of the analysis. The transformation of the critical term is initiated in the first paragraph of the essay with the opening distinction between the 'material content' [*Sachgehalt*] and the 'truth content' [*Wahrheitsgehalt*] of a work of art along with their methodological correlates of commentary and critique (1922a: 297). The opposition itself is very quickly implicated in the question of the relationship of life and death. Benjamin introduces two ways of thinking of the relationship between the material and the truth contents: one in which the material content is the mortal appearance

of an immortal truth content, and another in which the two are bound together in a complex experience which undermines any simple opposition between them. In the course of the essay, the character of the complex binding of material and truth contents, or the mortal and immortal, is elaborated in response to the novella. The work of critique thus decisively transforms the interpretative framework from which it begins and in the course of interpretation it changes both its own character and that of the novella.

The critique of the opposition between a mortal material content and an immortal truth content, revealed towards the end of the essay as the Kantian distinction between appearance and the thing in itself, is one of the main achievements of the essay. Within this opposition, appearance or material content is taken to symbolise truth, leaving critique the task of separating or abstracting truth from its symbolic form of presentation in the characters and settings of the material content. In this view 'The symbolic is that in which appears the irreducible and necessary binding of a truth to a material content.' Yet for Benjamin, Goethe's work challenges the assumption that the symbolic is the only relationship conceivable between truth and material contents; the work is a 'torso of a symbol' or the symbolic relationship subject to time. When the distinction is considered symbolically, in terms of the manifestation of a truth through a material content, then the work will be torn between the claims of finite and infinite experience. In the terms of the Hölderlin essay, finite appearance and death are opposed to each other, leaving beauty to mediate between them. Yet Benjamin, both in the Holderlin and the Goethe essays, develops a different conception of the relationship between truth and material contents, seeing it as the 'secret' or the inexpressible presence of death in life which is *marked* by beauty.

The relationship between the material and the truth content is recast in terms of the inseparability of appearance and truth. For the metaphysician or seeker of an absolute truth behind appearances this inseparability appears as an enigma or a secret. Benjamin predicts that the critic who would unveil the immortal truth behind its symbolic appearances will be defeated by Goethe's text, whose 'truth' is that the veil of appearances and the veiled truth cannot be separated from each other. This inseparability now defines beauty, which marks the mutual implication of mortal appearance and immortal truth, neither of which can exist without the other:

> Beauty is not appearance, not a veil [*Hülle*] covering something else. It itself is not an appearing, but is essence throughout, one which, admittedly, remains essentially itself only when veiled. It may be that appearance is everywhere illusion, but the beautiful appearance is the veil for that which is most necessarily veiled. For neither the veil nor the veiled object is the beautiful but the object in its veil. If uncovered it would prove itself to be infinitely insignificant.
>
> (1922a: 351)

Instead of revealing the truth behind appearances, the task of critique is rede-fined as tracing the mark delineating truth and appearance, 'not to raise the veil, but rather, through the most precise knowledge of it as veil, to raise [cri-tique] for the first time to a true intuition of the beautiful' (1922a: 351). For Benjamin in this essay, critique traces the beauty of the character Ottilie, not by treating it as a symbol for a remote, eternal truth, but as a mark of the mutual dependence of death in life and life in death:

> This appearance in which Ottilie's beauty reveals itself is perishing. It is not that external violence and necessity are leading to Ottilie's decline, but rather it is founded in her kind of appearance itself that it must be extinguished and soon.
>
> (1922a: 349)

The immanence of death in life cannot be symbolically expressed, but can only be shown; Ottilie does not *symbolise* death in life, but the shape of her character shows that it is being undergone: the absolute as death is not abstract and removed but is present and leaves its mark on finite existence.

While in the Hölderlin essay the absolute in the guise of future death is experienced in the present in terms of *courage*, which both acknowledges and undergoes its threat, the experience of the absolute in the essay on *Die Wahlverwandschaften* is located in *hope*. But this is not the eschatological hope of the early Romantics, for whom the contingency and fracture intro-duced into life by death would be redeemed at the end of time. It is rather a paradoxical hope for the hopeless, or in the final words of the essay 'Only for the sake of the hopeless is hope given us' (1922a: 256). This is a hope for the other, since 'the last hope is never for the one who cherishes it, but for those alone for whom it is cherished', a hope for the dead, which in an attenuated way becomes a hope for those who are not yet but will soon be dead. However, this hint of a dialectical reversal – in which precisely those without hope receive hope – is presented in terms of the contingency of a shooting star, an image remote from the necessity of the rising and the setting sun. The contingency of the work that nourishes critique is aligned with the specula-tive union of death in life, an experience which combines contingency and necessity.

Benjamin's critique of German Romanticism exemplifies his finite, trans-formative concept of critique. It does not begin with a philosophically secured concept of truth and value which is then applied to an object in a critical judgement, but rather philosophy itself is risked in the critical encounter. In the case of Romanticism, a movement which emerged as a response to the lim-itations of Kant's concept of critique, it is first subjected to critique in Kantian terms, but then transforms those terms in the critical encounter. The object of critique reflects the limitations of the given doctrine of criticism back upon the critic, who then approaches the object anew. In this way Benjamin repeats the

Hegelian critique of the finite character of Kantian critique – its narrow notion of experience that banished the absolute from thought – but without the collateral of a progressive philosophy of history. The absolute is folded into experience in complex and often inconspicuous ways, which it becomes the task of critique not at the outset to judge, but first to delineate and map.

Mourning and tragedy

Benjamin's most sustained and accomplished work of philosophical criticism, *The Origin of the German Mourning Play* published in 1928,[5] carries the dedication 'Conceived 1916. Written 1925. Then as now, dedicated to my Wife.' The work itself had many origins – logical and chronological – all of which left their mark on the final text. Written under the pressure of completing a *habilitation* thesis for the University of Frankfurt, the book in many ways provides a *summa* of Benjamin's early work, but one which is by no means a triumphant dialectical synthesis of its contradictions. The text marks a point of collision between the various tendencies which were working themselves through in Benjamin's thought; it raises a stage on which the aesthetic, the philosophical, the religious and the political continually interrupt each other, occasionally achieving dialogue but more often mutual destruction.

The earliest surviving trace of what was to become *The Origin of the German Mourning Play* appears in the fragments on *Mourning Play [Trauerspiel] and Tragedy* and *The Significance of Speech in Mourning Play [Trauerspiel] and Tragedy* written between June and November 1916. They are part of a series of six dense fragments written over that summer which begins with *The Happiness of Ancient Humanity, Socrates* and *On the Middle Ages* and ends with *On Language as Such and on the Language of Man*. The fundamental issues discussed in these early sketches extend the themes of the Hölderlin and Goethe essays – the representation of death, and the diverse forms this takes in mourning play and tragedy – to include those of the expression of mourning in language and lament. In a letter to Scholem of 30 March 1918 Benjamin described the fragments as clarifying for him the 'fundamental antithesis of mourning and tragedy' as well as the question 'How can language as such fulfil itself in mourning and how can it be the expression of mourning?' (C, 120–1). Informing the themes of the representation of death and the language of mourning is the same problem of representing the absolute in the finite which motivated Benjamin's speculative philosophy.

The aesthetic antithesis of tragedy and mourning play is prepared in the first three fragments of the series which, echoing Nietzsche, distinguish between the ancient Greek culture which gave birth to tragedy and the medieval Christian culture of the mourning play. In the fragment on *The Happiness of Ancient Humanity* Benjamin contrasts ancient Greek and modern conceptions of happiness according to their distinct conceptions of the relationship between humanity, nature and divinity. For modern humanity,

painfully separated from nature and divinity, happiness is understood as the absence of pain, but for the ancients, humanity, nature and divinity relate in terms of the contest or *agon*, with happiness understood as God-given victory. In the contest the absolute manifests itself in the gift of victory:

> His happiness is nothing if it is not destined by the Gods, and it is his destiny, if he wants to believe, that the Gods have given [the victory] to him and specifically to him. In this supreme hour that makes the man into a hero, in which reflection is far removed, in this hour when all the blessings pour over him, in which the victor is reconciled with his city, with the groves of the Gods, with the *eusebeia* and even with the power of the Gods themselves, Pindar sung his victory odes.
>
> (1916b: 128)

Benjamin carries over this view of the immanence of the absolute in the *agon* into his theory of tragedy and the experience of the death of the tragic hero. But the main objective of this schematic description of ancient Greece was to supply a contrast with medieval Christian culture and its modern heirs. In the fragment *On the Middle Ages* Benjamin's argument shows how the 'abyss' between divinity on the one side and humanity and nature on the other led to the representation of a profane nature and a 'potentially endless sublime [where] progress is automatic' (1916c: 133) Here there is no moment of victory in which the absolute bestows itself and glorifies life, but only an endless striving for a remote and unreachable absolute whose pursuit impoverishes life and creates a 'diminished world'.

The fragments on Greek and medieval culture provide the context for the succeeding fragments on tragedy and the mourning play. The first of these – *Mourning Play and Tragedy* – ponders the nexus of time and death in the cultures exemplified by Greek tragedy and the modern Christian mourning play. Tragedy is another form of *agon* in which the moment of death marks a point of fulfilment and completion:

> In tragedy the hero dies since no one can live in fulfilled time. The hero dies of immortality. Death is an ironic immortality, that is the origin of tragic irony.
>
> (1916d: 56)

Benjamin aligns the moment of tragic death with the realisation of fate through which the hero fulfils their decreed destiny and completes their time. Tragedy, Benjamin concludes, is not to be understood in the context of mourning, but in that of praise. The death of the hero is the completion of a fate, bearing witness to the manifestation of the Gods in the human and natural worlds. In the Christian mourning play, however, time is open-ended; God is remote, and the completion of time in the advent of the absolute has

both already happened in the birth of Christ and is eternally deferred in the Last Judgement. In the mourning play, the organising principle is not completion in and of time, but repetition; not praise but mourning:

> The law governing a higher life is valid in the limited space of earthly life, and all play, until death ends the game, in order to continue the game, in a enhanced repetition, in another world.
>
> (1916d: 57)

The new play, however, is nothing but a reflection since 'the mourning play is not the reflection of a higher life, but merely the reflection of a mirror in a mirror, and its continuation is no less shadowy than itself. The dead become spectres' (1916d: 57). The diminishing of life before an absent God condemns both living and the dead to a spectral existence, doomed to repeat but never complete their deaths, or their mourning. The banishing of death and the dead from life is a consequence of the separation of the absolute from experience – the remotion of God – and instead of provoking the rush of victory and praise gives rise to the moods of suffering and mourning.[6]

In the succeeding fragment on *The Significance of Language in Mourning Play and Tragedy* Benjamin contrasts the 'eternally full and fixed word' of the tragic dialogue with the 'word in transition of the mourning play' (1916e: 60). In tragedy the word is brought to completion in the dialogue where it receives its full meaning, while in the mourning play the arrival of meaning is perpetually deferred:

> Two metaphysical principles of repetition pervade each other in the mourning play and establish its metaphysical order: the cycle and repetition, the circle and duality. . . . The repeated play between sound and significance retains for the mourning play something spectral, fearful. . . .
>
> (1916e: 60)

The ecstatic interaction of sound and significance can lose itself in madness or break into the dimension of lament, or the 'redemptive mystery of music: the rebirth of feeling in a supernatural nature'. For Benjamin the mourning play evokes this lament for the loss of significance or the removal of the absolute through an intensified repetition of the loss. He locates this movement in the madness of the King in baroque tragic drama, anticipating one of the major themes of *The Origin of the German Mourning Play*.

The fragments of 1916 provide a clear origin for the distinction between tragedy and mourning play which informs *The Origin of the German Mourning Play*, as well as the theme of mourning and even the historical focus on German baroque drama. They also anticipate other important themes of the book, above all language (with the more elaborated account of

54

the lament of language developed in the final 1916 fragment *On Language as Such and on the Language of Man*) and what Benjamin later described in a letter to Hugo von Hofmannsthal (30 October 1926) as 'the germ of the project', namely the 'explanation of picture, text, and music' (C, 309). This theme was latent in the extremely allusive discussions in the fragments of the intensification of the textual doubling of reflections in reflections into a stream of aural lament, and was realised in the complex discussion of allegory and language which forms the second part of *The Origin of the German Mourning Play*.

An analysis of the origins of Benjamin's book is by no means exhausted by a consideration of the fragments of 1916. These themselves must be situated within the context of Benjamin's extension of the philosophical concept of experience and the elaboration of an appropriately speculative concept of criticism. Not only does *The Origin of the German Mourning Play* exemplify Benjamin's practice of immanent critique, but it is itself prefaced by an 'Epistemo-Critical Prologue' which formally presents the results of Benjamin's philosophical investigations. The 'Prologue' presents an extremely condensed statement of Benjamin's epistemological work, which develops many of his earlier themes and provides a further philosophical justification for the methodology of immanent critique.

The Origin of the German Mourning Play also bears the marks of Benjamin's growing interest in the socio-political origins and consequences of modernity. The period of cultural history analysed in the book, broadly the century following the Reformation, is crucial not only for the development of modern forms of consciousness and experience but also for modern forms of social and political organisation. Benjamin's awareness of the historical significance of this period is evident not only in his use of the political theory of violence, law and sovereignty developed in the *Critique of Violence* for interpreting the political philosophy of the period, but also in his analysis of the relationship between the emergence of the culture of Protestantism and the development of capitalism. The importance of this particular origin of the *Trauerspiel* book is manifest in Benjamin's correspondence with the Protestant theologian and politician, Florens Christian Rang, a figure who played an important but underestimated role in the composition of the book. It is also evident in his neglected meditation upon the relationship between Protestantism and capitalism in the 1921 sketch *Capitalism as Religion*.

Benjamin's correspondence with Rang during the early 1920s not only provides important evidence for the compositional history of *The Origin of the German Mourning Play* but also casts further light on the basic distinction between tragedy and mourning play. In a letter dated 7 October 1923 Benjamin described his work in progress as a 'confrontation' of the two forms of tragedy and mourning play 'concluded by deducing the form of mourning play from the theory of allegory' (C, 210). He also revealed that he had confined his sources to the second Silesian school of Protestant literature, a restriction not immediately evident in the final text. In another letter of

18 November Benjamin opens a discussion with Rang on the two issues of seventeenth-century Protestantism and its 'extremely drastic concept of death' and the theory of tragedy. The depth of the dialogue between Rang and Benjamin is evident in their subtle discussion of the derivation of tragedy from the *agon* (see the letters of 20 and 28 January 1924) which represents an intensification of Benjamin's earlier theory developed in the fragments of 1916. It is also evident in Benjamin's growing and well-informed fascination with the relationship between Protestant religiosity and modern politics and capitalism.

In the fragment *Capitalism as Religion* Benjamin extends the Nietzschean argument that the concept of a transcendent God leads to the diminishing of life already endorsed in the 1916 fragment *On the Middle Ages*. In the 1921 text, he argues against Weber and Troeltsch's thesis that Protestantism was a *factor* contributing to the emergence of capitalism by maintaining the more radical thesis that 'The Christianity of the reformation period did not favour the development of capitalism, but transformed itself into capitalism' (1921c: 290). The corollary of Christianity becoming capitalism is that capitalism becomes a religion,[7] a position Benjamin defends by identifying three characteristics of capitalism as religion. The first is that capitalism is a cultic religion without dogma or theology; the second is that it is a cult whose celebrations are permanent and incessant; and third, that it is the 'first case of a cult which does not expiate but bestows guilt' (1921c: 288). Benjamin explains these characteristics as the intensification of the separation of God from the world and humanity which leads to a collapse of transcendence, an argument which, while echoing Weber, draws quite diverse conclusions:

> God's transcendence has collapsed. But he is not dead, he has been drawn into human fate. This passage of planetary humanity through the house of despair in the path of absolute solitude is the ethos that determined Nietzsche.[8]

The collapse of transcendence does not necessarily lead to a redeeming immanence of the divine in humanity and nature – as in Nietzsche's *Übermensch* – nor to the stasis of Weber's 'house of despair' and 'Iron Cage', but can also terminate in disaster. Benjamin holds that capitalism is a nihilistic religion, and that 'What is historically unprecedented about capitalism is that religion is no longer the reform of being, but its destruction' (1921c: 289). The seventeenth-century Protestant writers studied by Benjamin in *The Origin of the German Mourning Play* are important witnesses to the early stages of the emergence of capitalism as religion; their drama is pervaded by gloomy intimations of death and disaster to which mourning is the most appropriate response.

The relationship Benjamin saw between the Reformation and capitalism not only informs his analysis of the mourning play, but also the connections he drew between baroque literature and contemporary expressionism. Towards

the end of the 'Epistemo-Critical Prologue' Benjamin explores the 'remarkable analogies to present-day German literature' which are evident in the themes and language of baroque and contemporary expressionist literature. The connecting theme is of course the development of capitalism, and this is a theme which he will analyse further in the *Arcades Project*. For this reason it is important not artificially to separate the *Origin of the German Mourning Play* from the later work on nineteenth-century capitalism. The two projects are complementary: one analyses the culture of nascent capitalism, the other the culture of high capitalism.

With the complex set of forces at play in the book, it not surprising that *The Origin of the German Mourning Play* has defeated many of its readers. The difficulties begin on the threshold of the book with the 'Epistemo-Critical Prologue' where Benjamin introduces and develops the concept of 'origin'. This concept is taken from Hermann Cohen's neo-Kantian *Logik der reinen Erkenntnis* (*Logic of Pure Knowledge*) (1902), where it serves as a means of uniting intuition and the understanding, but is given a quite different inflection by Benjamin. The notion of 'origin' is situated in terms of the traditionally Kantian refusal of the alternatives of an inductive materialism and a deductive idealism – the form of the 'mourning play' as an 'origin' cannot be inductively extracted from surviving examples of the genre, nor deduced from ideal considerations in abstraction from individual works. Instead, origin is described as a patterning of the phenomena which changes over time. Benjamin writes

> The term origin is not intended to describe the process by which the existent came into being, but rather to describe that which emerges in the process of becoming and disappearance. Origin is an eddy in the stream of the becoming, and in its rhythmic movement it swallows the material involved in the process of genesis.
>
> (1928a: 45)

Origin should not be thought temporally as a chronological beginning nor spatially as a structure or fixed form, but in terms of a rhythmic patterning. This patterning or configuration is both concrete and a priori; it is indeed the folding and the unfolding of the a priori into the concrete, an involution which, because it takes place in time, is never complete. At any moment the pattern is both emerging and withdrawing, showing different aspects and concealing others. The thought of origin is speculative – in so far as it exceeds given experience – but not simply transcendental, since it cannot be separated or distinguished as a condition of the possibility of experience.

Benjamin draws a number of methodological conclusions from the understanding of an art form as an origin or temporal patterning that is both concrete and a priori. The first is that origin can never be abstracted from a particular object at a particular place in time – 'it is never revealed in the naked and manifest existence of the factual; its rhythm is apparent only to a dual

insight' (1928a: 45). Origin is present neither in the facticity of an object nor behind it as its idea or archetype – it is a pattern that develops through time. Furthermore it is the subject of a 'dual insight' in which origin appears both as a 'process of restoration and re-establishment' and as 'something imperfect and incomplete', as a rhythm in which 'singularity and repetition [are] conditioned by one another in all essentials' (1928a: 46). Because of this unfolding of origin in time, 'philosophical history, the science of the origin' must consider both the 'past and subsequent history' of a form as well as 'the remotest extremes and apparent excesses of the process of development' (1928a: 47). Finally, the work itself is not closed to other aspects of experience surrounding its origin, and it is the task of critique to question the apparent isolation of a work from other aspects of its contemporary culture. Benjamin sums this up in the view that, with respect to history, every idea is a 'monad' which 'contains an image of the world'. The task of critique is to situate the particular patterning of the work within a broader experiential context, or to give 'an abbreviated outline of this image of the world' (1928a: 48) latent in the work.

These methodological prescriptions develop aspects of Benjamin's earlier concept of critique. The temporal character of origin means that the meaning of a work is never fully present, but also that the absolute or the a priori manifests itself at the limits of a work, limits evident in its inconspicuous details and exclusions. These may be revealed by a comparison of the same work with itself over time, as refracted through the interpretations which it has generated and solicited (as in the essay on *Die Wahlverwandschaften*), as well as with other forms and works, as in the case of the contrast of mourning play and tragedy.

The 'Epistemo-Critical Prologue' also explores a further methodological implication, which is the transformation of the criteria for analysing a work in the course of an analysis. Benjamin sums up this characteristic of critique in the lapidary statement 'Method is a digression'. This means that critique does not possess any incontestable criteria which are immune to change in the encounter with the object of critique. The objects of critique – in this case seventeenth-century German mourning plays – cannot be grasped as if they were objects of knowledge to which the appropriate criteria are to be applied, because these criteria themselves change in the encounter with the work. Such sensitivity to the transformation of both the object and the criteria informing critique is described by Benjamin in terms of digression and re-inauguration: 'Tirelessly the process of thinking makes new beginnings, returning in a roundabout way to its original object. This continual pausing for breath is the mode most proper to the process of contemplation' (1928a: 29). Truth is defined as the momentum and the movement of this contemplation which changes itself and its objects, and while it is 'bodied forth in the dance of represented ideas' (1928a: 29) it can never definitively be fixed as an object of knowledge.

The methodological prescriptions of the 'Epistemo-Critical Prologue' are realised in the two main divisions of the book. In the first part on 'Mourning Play and Tragedy' Benjamin contrasts the two forms, showing the error of

previous criticism in assuming that the German mourning play was simply an inadequate form of tragedy. By reflecting on the characters, themes and language of the mourning play, confronting them with aspects of contemporary political, religious and social culture, and citing subsequent interpretations of the plays Benjamin evokes a form or principle of construction for the mourning play quite distinct from tragedy. This distinction is then sealed through the comparison of the two forms, especially in terms of the relation of language and death. Benjamin shows how the 'empty world' of the Reformation became viewed as 'a rubbish heap of partial, inauthentic actions' (1928a: 139). In contemplating the various dramas the principle of mourning emerged as the 'origin' which informed the details and fault lines of the dramas. The origin of the German mourning play in the melancholy repetition of inchoate mourning is contrasted by Benjamin with the origin of tragedy in the forensic *agon* or the 'affinity between trial and tragedy' (1928a: 116).

The contemplation of the 'material content' [*Sachgehalt*] of the mourning play and the contrast between its formal principle and that of tragedy leads in the second part of the book on 'Allegory and the Mourning Play' to a revision of the categories of the critique. Here Benjamin reopens the critique of the concept of the 'symbol' begun in the Goethe essay, which he accuses of having tyrannised the philosophy of art for over a century. The concept of a symbol, and its philosophical baggage, was all the more tyrannous for having become almost inconspicuous. The criticism of works of art in terms of the 'relationship between appearance and essence' preceded, for Benjamin, 'the desolation of modern art criticism' (1928a: 160). Allegory emerges out of the difficult relationship between appearance and essence, and is based on the recognition that there is a discrepancy between them. This discrepancy is for Benjamin not a falling away from the symbolic, but an inevitable consequence of the experience of time and finitude; the symbol tries to make the finite participate in the infinite, to freeze the moment into an image of eternity, while allegory inscribes death into signification, making the relationship between appearance and essence one which is provisional and endangered:

> Whereas in the symbol destruction is idealised and the transfigured face of nature is fleetingly revealed in the light of redemption, in allegory the observer is confronted with the *facies hippocratia* of history as a petrified, primordial landscape.
>
> (1928a: 166)

In allegory all meanings are subject to time, a condition which is performed and mourned in the mourning play. The themes of finitude and mourning are then explored in terms of allegory, in which all claims to eternity are qualified by their being made and unmade in time.

The *Origin of the German Mourning Play* continues the experimental approach to criticism begun in the early critical essays. In it Benjamin throws

light on the form of two exemplary, Protestant and Catholic mourning plays – Shakespeare's *Hamlet* and Calderon's *Life is But a Dream* – by means of an analysis of its limited, partially realised incarnation in the German mourning play. The first part of the book on 'Drama and Tragedy' presents the thematic *Sachgehalt* of the almost forgotten German dramatists, moving between the figures of the Sovereign and the Intriguer.[9] The powerlessness in power of the Sovereign in the *Mourning Play* is figured by his inability to make a decision; the present and future of the Sovereign is drained of significance by his mourning of the past. The figure of the melancholy Sovereign embodies the meaninglessness of absolute power, for those who claim power to control signification find themselves powerless to control the train of events, and in their brutal sincerity are plunged into a stasis of melancholy.

The character of the Sovereign and the thematic complex which it embodies is complemented by the character of the Intriguer. The Intriguer figures a formal inversion of the Sovereign, for instead of claiming the power to control signification this character represents the destruction of signification. If the Sovereign is the passive nihilist who negates the world in spite of himself, the Intriguer is the active nihilist who negates everything through irony and dissemblance. The dialectical opposition of the melancholic Sovereign and the ecstatic Intriguer is the principle of construction for the mourning play. It pervades not only its themes, characters and action but also its stagecraft. The Sovereign is set aloof on the stage, issuing vain orders and reflecting in soliloquies; although in possession of absolute power, he cannot even control his own speech and appearance and becomes a martyr to his own sovereignty. The Intriguer, by contrast, thrives in the space between stage and audience, addressing the latter from the edge of the stage and taking them into his confidence. This ambiguous location inside and outside the action allows the Intriguer to dissemble and to mock the Sovereign; echoing the King's words, the Intriguer drains them but also himself of sense. In this way, the dialectical figure of Sovereign/Intriguer frames a relationship between the melancholy failure to achieve signification and the ecstatic destruction of any attempt to do so. The desire to decree meaning valid for all time is dialectically inverted by the desire to decree eternal meaningless; the first freezes the present and future through a mourning for meaning that has been forever lost while the second consumes past and present in an ecstatic destruction of any attempt to arrive at meaning.

The form or 'principle of construction' of the mourning play is the set of dialectical oppositions of Sovereign and Intriguer, legislation and anarchy, eternity and the moment, passive and active nihilism. By itself, each of these positions inverts itself: the desire to decree meaning for all time becomes melancholy immersion in the meaningless moment while that to establish total meaninglessness becomes ecstatic immersion in the moment whose meaninglessness is infinite and therefore extremely meaningful. The dogmatic extremes qualify each other in the perfect works of the mourning play, while

in lesser works one extreme prevails over the other. In the case of the German mourning play, the melancholy predicament of the Sovereign is emphasised at the expense of the Intriguer. The 'insufficiency of German baroque drama' is defined by the 'limited development of the intrigue'. This leaves the German mourning plays as ruins of unrealised possibilities; but is this a property which makes it possible for them to serve as subjects for critical experiment. Their exaggerated and underdeveloped form highlights the formal possibilities which are present, but remain inconspicuous, in the perfect examples of the genre.

Sovereignty and Intrigue are aligned by Benjamin with the philosophical and aesthetic categories of symbol and allegory: the one would decree an eternal meaning for finite objects and events, the other their eternal meaninglessness; staged together, they open other possibilities. Accordingly, towards the end of the book, after a very intricate and beautiful discussion of the relationship between melancholy, mourning, death and allegory, Benjamin performs an extra-ordinary dialectical reversal. Allegory and finitude turn upon themselves, transforming melancholy into ecstasy. The experience of finitude and the presence of death within signification are themselves made finite or allegorised: 'transitoriness is not signified or allegorically presented, so much as its own significance as allegory' (1928a: 232). When allegory turns upon itself, the occasion for mourning becomes one of affirmation, a celebration of the finitude of the thought of finitude. This is not a return to a symbolic affirmation of the presence of the eternal in the finite, but an allegory of the finitude of the finite. It is less a dogmatic statement of a relation between the finite and infinite than the staging of the question of the complex ways in which death is in life.

The *Origin of the German Mourning Play* ends with a reprise of the discussion in *On Language as Such and on the Language of Man* of the significance of the Fall from paradise. Evil is an effect of the knowledge of evil, or, in Benjamin's words, 'the triumph of subjectivity and the onset of an arbitrary rule over things'. What was described in 1916 as 'overnaming' is now presented as 'the origin of all allegorical contemplation' (1928a: 233). With this Benjamin gathers together the philosophical theology of the early fragments and the philosophical criticism of *The Origin of the German Mourning Play*. The work contains a number of latent possibilities for further development including the extension of a new concept of critique and allegory to contemporary literature, the development of the notion of capitalism as religion in the *Arcades Project*, and even the use of the concept of mourning play towards understanding the contemporary epic dramas of Berthold Brecht.

Modernism: from immanent to strategic critique

In the early to mid-1920s Benjamin's authorship took two distinct, but not unrelated directions. The first was represented by the systematic academic scholarship of *The Origin of the German Mourning Play* while the second was

the modernist exploration of urban culture in the aphorisms collected in *One Way Street* and in the translation and critique of contemporary modernist literature. Some of the affinities between the two directions have already been noted, namely the analogies between baroque and contemporary literature and the analysis of the cultures of early and high capitalism. However, during the mid- to late 1920s Benjamin established a pattern of work which was to inform his authorship until his death. In this the critique of contemporary literature stimulated, and was stimulated by, the systematic historical inquiry into the origins of modern urban experience in the high capitalism of the nineteenth century that was the *Arcades Project*. The modernist criticism of the mid- to late 1920s in many ways reasoned the need for the work of the *Arcades Project*, while that of the 1930s was decisively shaped by the provisional results of the larger work-in-progress.

In a letter to Scholem of 20 January 1930 Benjamin announced his two main publishing projects: a collection of critical essays devoted to the re-creation of 'criticism as a genre' and a book entitled *Paris Arcades*. On 25 April 1930 he reported to Scholem that the contract for the collection of essays had been finalised with the publisher Rowohlt. The contract, dated 16 April, refers to a 'volume of essays' comprising thirteen essays with the titles 'The Task of the Critic', 'Gottfried Keller', 'Hebel', 'Hessel', 'Walser', 'Kraus', 'Greene' (*sic*), 'Proust', 'Gide', 'Novelist and Storyteller', 'On Art Nouveau', 'Surrealism' and 'The Task of the Translator'.[10] The book was not published, and Benjamin later included it among the 'large-scale defeats' of his literary career.[11] However, it is possible to reconstruct the *Collected Essays on Literature* from the individual essays which were published separately elsewhere, as well as from the surviving notes for the unpublished chapters. Together they give considerable insight into Benjamin's intentions and achievements as a philosophical critic of modern literature, as well as into the origins of the *Arcades Project*, another of the self-confessed 'major defeats'. Together the two uncompleted books offer a cameo of Benjamin's immanent critique, and provide an important but unremarked nexus between the philosophical criticism of modernism and the historical genealogy of modernity.

In the same letter to Scholem of 20 January 1930 in which he announced his intention to publish a collection of his literary essays, Benjamin also declared his ambition 'to be considered the foremost critic of German literature' and, more seriously, 'to recreate criticism as a genre' (C, 359). The latter ambition was already evident in the dissertation on *The Concept of Art Criticism in German Romanticism* and informed the 'exemplary' essay on *Die Wahlverwandschaften*, the book on the mourning play, as well as Benjamin's statement of the editorial position of the critical journal *Angelus Novus* in the early 1920s (see 1922b). The close relationship between the reinvention of critique and the extension of the concept of experience evident in these works continued in the immanent critique of modern literature that emerged during the late 1920s. The *Arcades Project* was no less than a study of the

origins of the same modern experience that was articulated and given shape in modern literature. The immanent critique of literary modernism required an analysis of the experience of modernity, just as the latter provided the conditions of the possibility for immanent critique. The *Collected Essays on Literature* and the *Arcades Project* thus complement each other, the earlier critical essays resting on the account of modern experience given in *One Way Street* and driving it further in the direction of the *Arcades Project.*

One Way Street began life in the early 1920s as a 'Descriptive Analysis of the German Decline' and was concluded in 1926 as a 'first attempt to come to terms with' Paris, an effort which he intended to follow 'in a second book called *Paris Arcades*' (Letter from 8 February 1928 (C, 325)). It was between the completion of *One Way Street* and the beginning of the *Arcades Project* that Benjamin recognised his vocation as a philosophical critic of modern literature. The modernist presentation of the decay of experience in *One Way Street* provided the categories for the critical reflections on modern literature which in their turn transformed the historical categories of the analysis of modernity.

The interactive relationship between the critique of modernism and the excavation of the historical origins and the character of the experience of modernity is described in the sketches for the proposed theoretical introduction to the collection.[12] This was couched in terms of a development from immanent to strategic critique. The idea of strategic critique was introduced ironically in *One Way Street* as the first of 'The Critics Technique in Thirteen Theses' – '1. The critic is the strategist in the literary struggle' (1928b: 460), but by the late 1920s was seen as a development of the immanent critique of modernist literature. In the thirtieth and thirty-first theses of the *Programme for Literary Criticism* (1929–30) Benjamin presents the characteristics of immanent critique in the idiom of modernist criticism, as in the proposition that 'The Critique of books must be based on a programme' (1930c: 166). This is not, as it may seem, the surrender of immanent critique to a notion of critical judgement based on external criteria – a 'programme' – but an attempt to develop one of its salient features. This is the claim that the work contains latent aspects of experience – 'truth content' [*Wahrheitsgehalt*] – which determine its form and which need to be discovered in the course of critique. What was designated the 'Poetic' and 'formal construction' in the immanent critiques of Hölderlin and Goethe has become the 'programme' of the strategic critique of modern literature, and in place of the earlier mood concepts of 'courage' and 'hope' emerge those of 'modern experience'.

In an immanent critique of immanent critique itself, Benjamin noted that 'Immanent critique, as one which improvises its criteria in the work, can lead to some individual happy results' but needs to be supplemented by a 'programme' or a digression into 'materialist critique, which situates books in their relationship to their time' (1930c: 166). Immanent critique which separates its objects of criticism from experience will lead to the 'atomisation ' of critique into the unsupported intuitions and opinion of the critic. Objective

criticism requires that the work be situated with respect both to aspects of experience which are immanent to it, and to the changes which critique effects in the work, since 'critique is the form of appearance of the life of the work' (1930d: 171). This sensitivity to the continual reinvention of the work through critique has two sides: the first discerns the complex articulation of experience in the work, described as 'literary history' and the second the reflective sensitivity to the ways in which critique continually reinvents and transforms its objects.

Strategic critique shares with immanent critique the refusal to judge work according to given criteria; both make discriminations while deferring judgement: 'With a true critic, their own judgement is the last thing they bring up, not the basis of the undertaking. In the ideal case, the critic forgets to judge'(1930e, 172). This theme is consistent with immanent critique in so far as there is no position outside the work from which the critic may judge it. The critic must find the moments of externality within the work – those moments where it exceeds itself, where it abuts on experience – and to use them as a basis for discriminative judgement. Strategic critique moves between the work and its own externality, situating the work in the context of experience, and being in its turn situated by it.

What is the 'programme' informing Benjamin's strategy of criticism in the proposed *Collected Essays*? It is the search for a form capable of doing justice to modern experience, one which Benjamin will describe as 'epic' in opposition to lyrical, dramatic and novelistic forms. It is, furthermore, one which has a formal principle of citability, closely allied with 'montage' or 'allegory'. Such a form would give shape to modern experience, and serve as the 'programme' for criticism. The pursuit of this formal principle follows two broad directions in the collected essays: the first, a critique of the heritage of German Romanticism, begins with Benjamin's splendid critical essay on Gottfried Keller, written immediately after the *Trauerspiel* book and containing a close reckoning with the divergent developments of German Romanticism represented by the novels of Stifter and Keller. The second is the critique of the novels of modern urban experience through criticism of Proust, the contemporary German writers Hessel and Döblin and authors associated with the Surrealist movement. Both directions involve the analysis of the 'decay' of experience in modernity and the possibility of its transformation. These themes are further developed in the criticism of the 1930s with the reflection upon the 'epic', whether the epic theatre of Brecht and the epic novels of Victor Hugo and Döblin, or the anti-epics of Kafka and Baudelaire. The various themes are brought together in the genealogy of modern urban experience as the destruction of tradition undertaken in the *Arcades Project*.

The first of Benjamin's major critical essays after completing *The Origin of the German Mourning Play* was on the mid-nineteenth-century Swiss German writer Gottfried Keller. Benjamin on several occasions speaks of his 'love' for Keller's writings[13] and described the essay as the prolegomena to an attempt to

'make manifest in an entirely different way the unity that results from the intertwining within this man of what is limited and unloving with what is far reaching and loving' (1927c: 318). This intertwining, which Benjamin will later describe as 'epic', is contrasted with the work of another mid-nineteenth-century writer, the Austrian Adalbert Stifter. From the very beginning of his encounter with post-Romantic German language literature, Benjamin organised his critical strategy in terms of an experimental contrast between the two writers. The opening contrast in the essay between Keller and Stifter is staged in terms of the preferences of the postwar German reading public – who enjoy the auratic qualities of Stifter's descriptions of landscape, and 'who seek out the noble Stifteresque landscape more as a sanatorium than as a home' (1927c: 284). This critique develops Benjamin's earlier thoughts on Stifter written while reading Keller in 1917. The burden of the earlier criticism was that Stifter 'creates only on the basis of what is visual'; there is in his work a stasis based on the exclusion of the mutual recognition of characters through speech: the latter is but 'language used to display feelings and thoughts in dead space' (C, 131). In this space, objects, characters and actions assume an 'uncanny' and 'spectral' quality – later described as 'auratic' – by never being brought to speech: 'the summer and winter stillness of [Stifter's] landscape is not permeated by any sound from Keller's pan pipes' (1927c: 284).

After establishing the initial contrast, Benjamin conducts his critique on a number of different registers, combining the political, the linguistic and the generic. Keller's atheism and political liberalism is first situated in terms of (for Benjamin) a characteristically Swiss bourgeois, but anti-Imperial liberalism, one which has affinities with that of Nietzsche in his attacks on the 'spirit of the new Empire' (1927c: 285). As opposed to those of Stifter, Keller's writings privilege the 'revelation that must be heard' over what is seen, but not understood. For Benjamin the motile, dialogical quality of Keller's writing enlivens his descriptions, a formal feature again underlined by the contrast with Stifter, whose emphasis upon the visual freezes his dialogues. Benjamin sees in the pleasure of Keller's extraordinary description of landscape 'not so much a seeing as a describing' (1927c: 290), that is, a transformation of visual landscape into language. Benjamin describes this play of mutual recognition of the visual and the aural in terms of the 'sensual pleasure of description . . . because in it the object gives back the gaze of the viewer, and in every good description the pleasure involves the two gazes which seek and meet each other' (1927c: 290). The community of recognition involved in this crossing of gazes between the object described, the describer and the one to whom it is described is precisely not auratic, since the space of the gaze is constituted by the play of recognition. In auratic art, the space is given before recognition, and recognition experiences it as an obstacle rather than a medium.

The art of description that Benjamin evokes rests on the basis of a community of recognition which is characteristic of the 'particular stance of the epic poet' (1927c: 290). In Keller's writing, the 'mutual permeation' of narrative

(storytelling) [*erzählerischen*] and on poetic [*dichterischen*] which was the great achievement of German late Romanticism has its highest realisation. The epic description, which changes itself, its object and its community of speakers and listeners in the course of narration is generically distinguished from both the dramatic 'which makes a cross section through the structure of events' and the 'infinite concentration of existence' in the lyric. Keller's epic writing permits a mutual permeation of gaze, object and word which is based upon continual change and transformation. Thus the politics of mutual recognition characteristic of liberalism along with a complex account of the reflexive interplay of word and image unite with a redefinition of the epic as a narrative of modern experience. Benjamin's critique of Keller thus strives to be both immanent and programmatic: it is immanent in that it seeks to discover the organising formal principle of Keller's work, and programmatic in so far as it derives this principle from a politically and aesthetically mediated account of experience.

Benjamin's critical essays of the late 1920s explore the consequences of the destruction of the experience of the movement of recognition that made up the epic quality of Keller's work. The complex experience of the mutual recognition of nature and humanity was arrested in modernity and distributed across the plane of subject and object. Benjamin's subsequent critical essays examine the formal principles of modernist works in terms of the mourning of a distorted recognition, whether in memory or in 'aura' – the unreturnable gaze of the object. His finest essay on the substitution of memory for a community of recognition is *The Image of Proust* from 1929. The infinite movement of recognition discerned in Keller becomes in Proust the 'convoluted time' of memory. Benjamin locates the formal principle of this convolution as the folding into each other of narration and narrated, but this is a movement in which description melts into lyric intensity.[14] The infinite is present in this experience, but less in the movement of recognition than in the weaving and unweaving of memory: 'For an experienced event is finite – at any rate, confined to one sphere of experience; a remembered event is infinite, because it is only a key to everything that happened before and after it' (1929c: 204). But this memory is already a mourning, since for Benjamin the completeness of time is remembered *d'outre tombeau*: the movement of recognition in Keller, experienced as sensual joy, becomes the weight of an impossible recollection experienced as fear of suffocation, or as the extinction of finite experience before infinite memory. The 'Poetic' of the experience of courage and hope before death as absolute explored in the critiques of Hölderlin and Goethe becomes in the Proust essay a 'Poetic' of modern experience governed by the 'mood' of suffocation.

The convolution of memory Benjamin traced in Proust has its complement in the convolution of objects in the essay *Surrealism* (1929). Perhaps one of Benjamin's most ambivalent essays, it at once celebrates the surrealist intoxication with 'the revolutionary energies that appear in the outmoded' while

seeing them as remaining 'enmeshed in a number of pernicious Romantic prejudices' (1929a: 237). In a letter to Scholem (30 October 1928) Benjamin described his relation to surrealism as that of a 'philosophical Fortinbras' claiming the inheritance of the movement after its destruction. The surrealists' insight into how 'not only social but architectonic [destitution], the poverty of interiors, enslaved and enslaving objects – can suddenly be transformed into revolutionary energy' (1929a: 237) was very close to Benjamin's own concept of experience, but for him their insight remained auratic. In Benjamin's judgement, the surrealist object was akin to the landscape of Stifter; it was something spectral which could lead as easily to 'the humid backroom of spiritualism' as to revolution. By casting himself as a philosophical Fortinbras, Benjamin gives a negative answer to the question which he put to surrealism: 'are they successful in welding this experience of freedom to the other revolutionary experience that we have to acknowledge because it has been ours, the constructive, dictatorial side of revolution?' (1929a: 236). Just as Fortinbras takes on the heritage of a court devastated by spectres, and commences its reconstruction, so Benjamin sees himself entering into the heritage of the auratic phantasms of surrealism, and recommencing their reconstruction in epic recognition.

Benjamin sought to improve upon the surrealist heritage in two ways: the first was by an analysis of the decay of experience, a genealogy of the historical conditions which had led to the mourning of recognition whether in subjective (Proust) or objective memory (surrealism). The second was the elaboration of a 'constructive form' which would combine subjective memory with the objective memory of the 'revolutionary energy of the outmoded'. The first direction led towards the *Arcades* project, or the genealogy of aestheticised politics, the second towards a new epic form, or politicised art. A pivotal figure in both of these developments was Benjamin's co-translator of Proust, Franz Hessel. The *Arcades* project began life as a collaborative essay with Hessel, while Benjamin's concept of a modern epic form was first elaborated in a number of critiques of Hessel's Berlin writings from the late 1920s.[15]

Although Benjamin wrote three critical reviews of Hessel's work in the second half of the 1920s, the most significant appeared in 1929 under the title *The Return of the Flâneur*. Benjamin described this essay to Scholem (18 September 1929) as 'made up of a number of associations from the *Arcades*, which was occasioned by a review of Hessel's Berlin book' (C, 356). More than this, it also develops the concept of a modern epic form, elaborating on some of the themes introduced in the Keller essay. Most crucially, Hessel's account of his wanderings through Berlin are interpreted not as impressionistic descriptions, but as epic narrative constructions:

> For Hessel does not describe, he tells. What is more, he retells what he has heard. *Spazieren in Berlin* is an echo of that which was told to the child in early years about the city. A completely epic book, a

committal to memory when strolling, a book for which recollection was not the source but the muse.

(1929e: 194)

Here Benjamin combines the narrative character of the epic disclosed in the interpretation of Keller with the theme of memory developed in the Proust essay. Hessel's experience of the past and present of the city is not turned in upon itself, as in the suffocating convolutions of Proust, nor is it made up of the encounter with portentous objects and events as with the surrealists, but emerges from the mutual recognition of city and walker staged in terms of memory and narration. The city activates the memory of the *Flâneur*, which then fuses with the present *Erlebnis* of the city into a narratable experience or *Erfahrung*. The footsteps of the walker provoke an 'astounding resonance' which is fed by memory but also evokes it. Unlike the Stifteresque auratic landscape, or its surrealist equivalent in the mystical urban landscape of Paris, the city evoked by Hessel is a home (*Heimat*).[16] Yet Benjamin stresses that the meaning of being at home in the city was changing; from being a place of dwelling the home was becoming a point of transition: 'Giedion, Mendelssohn, Corbusier make the human resting place above all a transitional space for all conceivable forces and waves of light and air' (1929e: 196–7). Benjamin situates Hessel's writing between this anticipation of the future city and the memory of the past, developing a form of narrative that can contain both experiences.

The meeting of the old and the new Berlin in the constructive principle of modernism and the recollected intensity of the obsolete, is accomplished by the fusion of experience and memory. This is evoked, as in Keller, through the mutual recognition of the perceiver and perceived; citing Hessel's lapidary phrase 'We only see what sees us', Benjamin comments 'No one has more deeply understood the philosophy of the *flâneur* than has Hessel in these words' (1929e: 198). In the face of the rapid change of the city, the *flâneur* remembers, and folds this memory into the experience of the present. This changes the experience of the city, making the lived moment into a citable experience: 'The lived instant [*Erlebnis*] wants the unique and the sensation, experience [*Erfahrung*] the eternal return [*Immergleiche*]' (1929e: 198). For Benjamin the fusion of the lived moment and citable memory in Hessel's book offers a number of 'consolatory formulae of farewell' for the inhabitants of modern cities who share Baudelaire's experience of the city changing faster than the 'human heart'. It provides the conditions for an epic of modern experience which through the figure of the walker translates the *Erlebnisse* of instant experiences into the *Erfahrung* of citation.

Many of the themes of the Hessel review return for fuller exposition in the *Arcades* project, notably the *flâneur*, the experience of urban change, the distinction between the lived instant and experience, and the tension between auratic urban landscape and dwelling. The project originated in 1927 as a

joint article by Benjamin and Hessel for the magazine *Querschnitt*. By the autumn of 1927 it had become Benjamin's sole project, and began to transform itself into the matrix of the writings of the latter part of his career.[17] It developed the themes of *One Way Street*, in particular the ambition declared in a letter to Scholem (15 March 1929) 'to attain the most extreme concreteness for an era, as it occasionally manifested itself in children's games, a building, or a real life situation' (C, 384). However, the extension of the concept of experience implied by this desire to attain a concrete presentation of an era raises several difficulties, notably those of the selection of material. This problem became unmanageable when Benjamin turned to the presentation of the origins of modernity in nineteenth-century Paris.

The parameters of the *Arcades Project* were established in two programmatic fragments from the late 1920s. In the first Benjamin asks some characteristically counterfactual questions:

> What would the nineteenth century be to us if we were bound to it by tradition. How would it look if it were religion or mythology? We have no tactical relationship to it.
>
> (GS V, 998; see also 1055–6)

The destruction of tradition characteristic of modernity also acts on modernity itself. The experience of modernity does not have a tradition, does not stand in any relationship to its own origin in the nineteenth century. For Benjamin this means that the experience of modernity is oblivious to itself, even though this experience is informed by traces of its origins, development and future: 'The nineteenth century, to speak with the surrealists, is the noise that interferes with our dreams, that we interpret when we wake up' (GS V, 998). This interpretation is a way of taking up a tactical relationship to the origins of modernity, and to recognise in its past other futures and possibilities.

An example of the noise interrupting the dream is given in the very first lines of the Benjamin/Hessel 1927 draft of the short article on *Arcades*. The *Arcades Project* begins with the interruption of an evocation of the dream-like atmosphere surrounding the opening in the 1920s of the new arcades in the Avenue des Champs-Elysees with the noise of the demolition of the nineteenth-century Passage de l'Opera: 'While here a new passage is opened for fashionable Paris, one of the oldest passages in the city disappears, the Passage de l'Opera, swallowed up by the breakthrough of the Boulevard Haussmann' (1927e: 1041). The contrast between the new and the old Arcades allows the memory of the nineteenth century to interrupt the present and so to be experienced critically. The inauguration of the new Arcade suppresses the memory of the previously celebrated and in their time similarly absolutely modern arcades of the nineteenth century 'which preserve in their harsh light and gloomy corners a past which has become space [*raumgewordene Vergangenheit*]' (1927e: 1041). The retracing of the Paris Arcades is a speculative enterprise

dedicated to mapping the oblique traces of the past of modernity in its present, and to explore the unrealised futures of this past.

The oblivion of the nineteenth century in the experience of the present was for Benjamin compatible with its being fully historically researched. This was a paradox which made possible and ultimately wrecked the *Arcades Project's* pursuit of a philosophical history of the experience of modernity in Paris. Benjamin noted in *Paris Arcades II* that

> There is little in human history of which we know as much as the history of the city of Paris. Thousands and tens of thousands of volumes have been dedicated exclusively to this tiny spot of the earth.
>
> (1927g: 1056)

Benjamin sought to combine the knowledge of the city with a 'tactical relationship' to its past, one which folded the past into the experience of the present, and thus also opened its unrealised possibilities to new futures. This entailed rescuing the Paris 'landscape' from the surrealist's aura mythological and regarding it in Hessel's terms as a *Heimat*. This required a confrontation with both the history of the Revolution and of technology. In the fragment Benjamin continues with an analogy between Paris in the social landscape and Vesuvius in the geographical:

> A threatening, dangerous mountain, an ever active June of the Revolution. But just as the sides of Vesuvius thanks to its layers of lava became a paradisiacal fruit garden, so too from the lava of the revolution flowered art, the festive life, and fashion as nowhere else.
>
> (1927g: 1056)

The configurations of experience that *potentially* could have emerged from the political and technical revolutions of the nineteenth century were manifold; indeed the actual present marked but one of many possible configurations of politics and technology. In his 'immanent critique' of nineteenth-century capitalism Benjamin pursued the 'Poetic' of modern experience in the concrete details of the political heritage of the Revolution and the developments of technology.

The focus of the immanent critique of modern experience – its principle of construction – are the arcades which represent a new form of public experience, the cross between street and home, made possible by technological developments. The opening lines of the 1927 prototype of the *Arcades Project* evoke the way in which this new public space opened by the Revolution and technology eventually became a showroom for the sale of commodities. However, by a speculative re-examination of the figure of the arcade, Benjamin believed it possible to revive obsolete but citable traces of experience which adumbrated a different future for modern experience.

70

The presentation of the Paris cityscape, not as an auratic landscape of the commodity or what was described in *Paris Arcades I* as a 'primal landscape of consumption' (1927f: 993) but as a *Heimat*, points to an affinity between the *Arcades Project* and the work on the modern epic. This is underlined by Benjamin's original co-authorship of the *Paris Arcades* essay with Hessel, as well as the form of montage and citation according to which the *Arcades Project* is constructed. The Hessel review also points forward to Benjamin's concept of a modern epic, since the means by which Hessel gives form to the tension between the 'lived moment' and 'narratable experience' are thoroughly modern. In an earlier review of Hessel's *Heimliches Berlin* (1927) Benjamin identifies the proximity of its technique to 'photo-montage' and sees in this the formal principle which underlies Hessel's ability to 'pan out' or to 'extend the tiniest area of his story so enigmatically into the distance and into the past' (1927d: 82). The montage principle, closely related to the allegory analysed in *The Origin of the German Mourning Play*, becomes central to Benjamin's concept of the modern epic and its 'poetic' or formal principle of citation.

The significance of the montage technique for the invention of a modern epic form is most fully theorised in the remarkable essay on Döblin's *Berlin Alexanderplatz* which Benjamin published in 1930 under the title *The Crisis of the Novel*. This essay, which in remarkably little space develops and enriches the arguments of Lukács' *Theory of the Novel* (1916), diagnoses the crisis of the novel as terminal. It begins by distinguishing between the novel and epic forms of narrative, and moves to an immanent critique of *Berlin Alexanderplatz* in terms of a rebirth of the epic from out of the technique of montage. Following Lukacs, Benjamin maintains that the basic formal principle of the novel is 'the individual in their solitude' while the epic is communal, drawing its material from what is 'orally transmitted' and thus citable (1932a: 230). The self-referentiality of the novel, driven to the limit in the memorial convolutions of Proust, is for Benjamin 'demolished' by the revival of the epic through the use of montage. This is exemplified by the technique of Döblin's *Berlin Alexanderplatz*:

> Petit-bourgeois publications, scandal sheets, tales of misfortune, sensations of '28, folk songs, advertisements throng through this text. Montage explodes the novel, explodes its foundations, its style and opens up new, epic possibilities. Above all in terms of form. For the material of montage is by no means any old thing. True montage rests on the document.
>
> (1930a: 232)

Döblin's epic unites the collective experience of a place – *Alexanderplatz* – with the fate of an individual character, Franz Biberkopf. The place forms the locus of the epic, dissolving the solitude of the individual character into a reflex of urban experience.

Benjamin's *Collected Essays* complement the *Arcades Project* by developing the concept of a modern epic which through montage is capable of giving form to modern experience. While the *Arcades Project* charts the development and decay of modern experience, the essays explore a number of formal responses to it. Döblin's destruction of the novel and the 'restitution of the epic' exemplified for Benjamin the emergence of a tendency, 'which can be met with even in drama' (1930a: 231). The emergent epic dramatic *tendency* was exemplified in Brecht's works, which Benjamin analysed using the categories of the epic and the decay of experience developed in the *Collected Essays* and the *Arcades Project*. However, as always with Benjamin, these categories were themselves profoundly transformed in the course of the analysis.

The modern epic

After completing *The Origin of the German Mourning Play* Benjamin paid an extended visit to Moscow. His experiences in the city over the winter of 1926–7, recorded in the *Moscow Diary*, provoked a series of commentaries on contemporary Soviet literature and drama in the pages of the *Literarische Welt* which contributed fundamentally to the development of his concept of the modern epic. The epic fusion of memory and description which emerged from the critiques of Keller, Hessel and Döblin was complemented by a conception of epic which emphasised 'recognition' and 'education'. The mourning which pervades the essays in the projected *Collected Essays on Literature* – modern epic's mourning the loss of traditional community in modernity – is qualified by the expectation of the community which is yet to come. Both aspects of epic introduce a moment of excess into the experience of the present, making this experience in a sense 'speculative': in the first the supplement is retrospective and accomplished through memory, citation and narration, while in the second it is futural and accomplished through interruption, education and decision. The contours of the second aspect of epic form were most fully explored by Benjamin in his writings on Brecht's epic theatre, notably *What is Epic Theatre?* (1931) and *The Author as Producer* (1934).[18]

Although Benjamin's works on Brecht succeed chronologically the essays making up the *Collected Essays on Literature*, his appreciation of the significance of 'epic theatre' was prepared by his work throughout the late 1920s on the writings of the Soviet avant-garde. There is no evidence in Benjamin of a 'development' from a 'bourgeois' to a 'socialist' concept of epic, nor of any irreconcilable difference between the two aspects of the epic response to modern experience. What is most astonishing is the continuity not only between the two aesthetic responses to modern experience, but also between these and the critical concepts Benjamin had developed earlier in the critiques of Hölderlin, Goethe and the German mourning play. Indeed the contrast between the memorial concept of epic that Benjamin discerned in Proust and

Hessel and the ecstatic concept of epic that he discovered in Brecht itself stages the 'dialectic' of mourning and ecstasy that characterised of the baroque mourning play. Scholem's view of an irreconcilable opposition between the two directions taken by Benjamin's criticism – exemplified for him by the contemporary essays on Kafka and *The Author as Producer* – underestimates the ambition of Benjamin's criticism, which was to bring all these divergent tendencies into a common if uncomfortable space.

In *The Origin of the German Mourning Play* Benjamin noted the formal affinities between contemporary expressionism and the literature of the baroque period. In the first article which he wrote after his return from the Soviet Union – *The Political Groupings of Russian Writers* (1927) – he makes a further connection between the baroque and contemporary Russian naturalist literature. While the analogy of expressionist literature with baroque literature rested on their shared concern with the limits of form, that of Russian naturalism and the baroque rested on a shared obsession with content and detail:

> The predecessor [of recent Russian naturalism] is not only the social naturalism of the 1890s, but more strangely and strikingly, the pathetic naturalism of the baroque. The heaped up crassness of its material, the unconditioned presence of political details, and the dominance of the material can only be described as *baroque*.
> (1927a: 744)

In his study of baroque drama, Benjamin showed the compatibility of extreme formalism and naturalism; the opposition rested on the shared origin of a culture or form of experience (Protestantism) which simultaneously drained the world of meaning while making action in the world the only possible source of salvation. A similar argument held for contemporary Russian literature, with the values of the revolution ('commitment') replacing those of Protestant salvation ('conviction'). At issue was whether revolutionary commitment was best served by emphasising form or content:

> The dispute over whether revolutionary form or revolutionary content should determine the proper vocation of a new writing lasted for two years. In the absence of a properly revolutionary formal principle this conflict was recently decided exclusively in the favour of revolutionary content.
> (1927a: 745)

Benjamin's perspective on this issue followed from his own rejection of the distinction between form and content. This was already evident in the early Hölderlin essay where the concept of the 'Poetic' was beyond the opposition of form and content as a concrete a priori or 'principle of construction'.

Benjamin developed his long-standing critique of the distinction between

form and content in an essay on developments in Soviet drama (1929) entitled 'Piscator and Russia'. Departing from Piscator's decision to form a working group with the 'Moscow Association for a Proletarian Theatre' Benjamin describes the position of the association with respect to naturalism and formalism. The group rejected Stanislawski's realism because, in Benjamin's words:

> While showing the epoch as a human product, it does so statically, not dialectically. It shows the epoch as it is, not how it may be changed. It is this same deficiency of dialectic that his critics meet in his technique of establishing a scene; a realism which imitates without arguing with what is imitated.
>
> (1929b: 544)

The Association also criticised the formalism of the group around Majakowski and Tretjakoff, refusing the choice between realism and formalism and instead developing a new kind of drama dedicated to 'the intensification and illumination of the class struggle' and which is not only of

> the large Moscow stages – the Theatre of the Revolution, MGSPS, The Union Theatre, Proletkult – but of all the amateur and workers theatres scattered over Russia, the representatives of an art of theatre which has emerged from the enterprises and daily politics, something with which we are also familiar with as 'blue shirt theatre'.
>
> (1929b: 544)

Benjamin's assessment of whether amateur theatre provided a new formal principle for theatre beyond the opposition of form and content is ambiguous. While such theatre risks proving a pale imitation of metropolitan revolutionary naturalism it might also mark the transformation of the institution of theatre itself, and thus an extension of its intrinsic formal possibilities.

In the essays which were intended to make up the *Collected Essays on Literature* Benjamin saw the 'principle of construction' informing epic modernism to consist in narration/citation, or the fusion of memory and description. Narration/citation was not governed by form or content but the process of translating experience into language. In this concept of epic the individual mourns the loss of community in modern experience by re-creating a fragile tradition by means of narration/citation. By the time of the essay on Döblin's *Berlin Alexanderplatz*, this concept of narration/citation has become overlaid with the concept of montage. Montage becomes, in terms of the Hölderlin essay, the 'Poetic' or 'principle of construction' which organises the cited elements. While writing the essay on Döblin, Benjamin believed that this form of epic was in crisis, and was perhaps on the way to becoming something new. Critique, which until now had been concerned to draw out

the 'constructive principle' of a work, now becomes part of the speculative effort to discover and invent new forms.

The move to a productive conception of critique followed Benjamin's extension of his thoughts on the Soviet avant-garde to the work of Brecht. In the reflections upon the question *What is Epic Theatre?* and later in *The Author as Producer* Benjamin does not only extend the concepts of immanent critique, allegory (the relation of text and image), and the untragic hero of the mourning play to epic theatre, but also reflects upon the impact of the changing technical and political conditions of modern experience upon the work of art. The concept of epic which emerges is one in which the received opposition of form and content is succeeded by the concept or 'Poetic' of *organisation,* one in which the memorial moment of excess through recollection becomes a futurally oriented moment of education through recognition. Finally, this concept of epic embraces the 'meltdown' of traditional forms such as theatre and the novel, and looks to the invention of new arts or forms of organisation able to combine technology and politics in unprecedented ways.

Benjamin's reflections on the question *What is Epic Theatre?* begin by relocating the focus of critical attention from the play to the stage. The condition for the possibility of drama has changed with the 'filling in of the orchestra pit' and the transformation of the stage from a religious to a political platform; 'The stage is still elevated, but it no longer rises up from an immeasurable depth; it has become a public platform' (1931a: 1). The change in the structure of the stage has an effect on both the audience and the play. The space within which the audience finds itself is transformed, and the audience 'begins to differentiate itself in discussion and responsible decisions, or in attempts to discover well-founded attitudes of its own' (1931a: 10). The play itself responds and contributes to this predicament by becoming a gestural theatre which through interruption freezes moments of action, permitting an action or situation to be recognised as one of a number of distinct possibilities. Interruption here achieves what critical reflection attempted in the earlier works – the revelation that the given course of events is but one of many possible outcomes. This revelation is the experience of the untragic hero, who instead of learning through the experience of fateful reversals in the manner of the tragic hero, presents a number of counterfactual possibilities for the audience to weigh up and judge.

Benjamin draws out the philosophical implications of this form of presentation towards the end of the essay, but more emphatically in some of the studies for the essay. He describes the interruption and the astonishment it occasions in the audience as the 'dialectic at standstill' (1931a: 13). In the moment of interruption the course of time and its fateful necessity is suspended, thus showing each event to be but one of a number of possible outcomes. This suspension or 'the damming of the stream of real life, the moment when its flow comes to a standstill' momentarily frees action from necessity, 'making life spurt up high from the bed of time and, for an instant,

hover iridescent in empty space'. This experience is 'felt as reflux, this reflux is astonishment' (1931a: 13). The 'dialectical image' or moment of ecstatic suspension above time brings with it the danger of becoming an auratic spectacle. If the experience of astonishment is received auratically by an audience of 'hypnotised test subjects' who regard the stage as a 'magic circle' (1931a: 2) then the suspension of time assumes cult value as a ritualistic spectacle. At this stage of his argument, Benjamin turns back to the reconfiguration of stage and audience, in order to discover in the 'dialectic at standstill' the possibility of a transition from astonishment to recognition and education. In the Brecht studies Benjamin entertained the possible rediscovery of 'the dialectic between recognition and education. All the recognitions achieved by epic theatre have a directly educative effect; at the same time, the educative effect of epic theatre is immediately translated into recognitions' (1931a: 25).

The 'dialectic at standstill' or suspension of time performs a similar function to the involuntary memory of the Proust and Hessel essays. It allows the description to be invested with an energy which, in one case provoked mourning, in the other astonishment. But astonishment's openness to the future need not necessarily become 'educative' or politically formative; there is no necessary transition from astonishment to recognition and education. The tension between the technical changes in the status of the work of art and their political consequences thus became a pressing issue for Benjamin, explored first in *The Author as Producer* but later, as will be seen in the next chapter, in *The Work of Art in the Epoch of its Technical Reproducibility*.

In *The Author as Producer* Benjamin returns decisively to his speculative concept of experience, using it to relocate the debate around the 'commitment' of the revolutionary author. He suggests that the focus of the Soviet avant-garde debate of the 1920s on the relative virtues of revolutionary form and revolutionary content assumes a closed and ultimately conservative definition of the work of art. The work of art in this definition occupies a realm apart from experience; it imposes form on an otherwise alien content. Whether the imposition of form is understood in terms of the work of art actively shaping or passively reflecting a given content does not matter, since the definition assumes that art is something separate from society. This may be a plausable hypothesis – it is certainly one which dominated Western aesthetics and criticism for over two centuries – but it is one which Benjamin puts in question. He does so by pursuing two linked stages of argument: the first is speculatively to dissolve the boundaries of the work of art by insisting on its permeability and its finitude, the second is to replace the opposition of form and content by the concepts of organisation and 'technique'.

The speculative dissolution of 'the rigid, isolated objects (work, novel, book)' require that they be relocated 'in the context of living social relations' (1934a: 87). Benjamin hastens to emphasise that this is not merely a nod to Marxist verities, but a more radical questioning of the time and place of a work of art. Any consideration of the relationship of a work of art to

'production relations' has to be speculative, that is, it must regard an existing relation as but one of a number of possible configurations. Instead of asking 'what is a work's position *vis-à-vis* the production relations of its time?', a question which assumes the opposition of form and content, Benjamin prefers to ask 'what is its position *within* them?' (1934a: 87). The first formulation assumes that a work of art is already distinguished from production relations and that the object of research is to relate the form of the work to the content of productive relations, while the second proposes that art and production relations are already in a relation, and that the object of critique is to map its possible and actual contours. This distinction becomes particularly crucial when considering the finitude of the work of art. The axiomatic claim of *The Author as Producer* is that

> we must rethink the notions of literary forms or genres if we are to find forms appropriate to the literary energy of our time. Novels did not always exist in the past, nor must they necessarily always exist in the future . . . we are in the midst of a vast process in which literary forms are being melted down, a process in which many of the contrasts in terms of which we have been accustomed to think may lose their relevance.
>
> (1934a: 89)

If in this 'meltdown' of forms the borders of the work of art are predefined, as in the first formulation, then the finitude of art entails its disappearance or death. Yet if these borders are considered to be fluid and permeable, as in the second formulation, then the finitude of art entails its transformation into something new. Once again the choice emerges between retrospectively mourning the death of a form, and ecstatically affirming its transformation.

The 'vast process' of melting down to which Benjamin refers involves more than the dissolution of literary forms; it appears also in *The Work of Art* essay as the 'tremendous shattering of tradition which is the obverse of the contemporary crisis and renewal of humanity' (1939a: 223). At the core of this transformation lies the experience of the planetary extension of technology, which is transforming the collective and individual human *physis* and with it the character of human experience.[19] With the transformation of experience the opposition of form and content, based ultimately on a Kantian opposition of subject and object, is no longer tenable. The extension of planetary technology brings with it the permeation by technological organisation of both the body or *physis* of human beings and of nature. One consequence of this development is that there is no place outside of the technological organisation of the body from which to impose form upon a content, since both form and content are already technically organised. Consequently, the forms of art are drawn into the general 'meltdown' of all received forms which is characteristic of modernity, a predicament which for Benjamin calls for the decision

either to mourn a dying concept of art, or to affirm of a new art rooted in technology, for the latter, 'represents the dialectical starting point from which the sterile dichotomy of form and content can be surmounted' (1934a: 87–8). The 'dialectic' Benjamin refers to here follows from the view of art as a locus of organisation, fully permeated by technology, which organises not only its form and content, but also its makers and users.

This last step is crucial for Benjamin's new concept of the work of art, since it gives to art the role of negotiating with technology from within technology. Benjamin introduces an important critical distinction between 'supplying' a productive technology and transforming it. The former accepts the particular disposition of a technical apparatus, while the latter extends its limits through experimentation. Benjamin's main critical example is the 1920s leftist New Objectivity movement in both its visual and literary forms. Benjamin criticised its use of photo-montage for 'renovating the world from the inside', that is, 'by turning abject poverty itself, by handling it in a modish, technically perfect way, into an object of enjoyment' (1934a: 95). Here the organisational potential released by technology is being used as if it were a form, transforming its 'material' into an auratic object of consumption. In this, the work of art 'ceases to be a compelling motive for decision and becomes an object of comfortable consumption; it ceases to be a means of production and becomes an article of consumption' (1934a: 97). What supplies the link between the moments of decision and production in this passage is the idea of the incomplete, finite work of art. Art does not reflect reality, but proposes hypotheses; the work of art is never finished since 'the products [of an artist] must possess an organising function besides and before their character as finished works' (1934a: 98). Indeed, a finished work, one with no future, would, as Benjamin had previously noted, be a dead or 'terminated' work which had exhausted all its possible futures.

The work of art as inscribed *within* technological experience offers a moment of invention, an example of technological organisation which is finite and incomplete. What is more, this sense of the futurity of the work predicated upon its incompletion implies that any moment of completion is adventitious. Thus the moments of interruption in a work of epic theatre, the staple of the technique of montage 'familiar to you in recent years through film and radio, photography and the press' (1934a: 99) provide moments for the framing of hypotheses. They have 'an organising function' in that they 'compel the spectator to take up a position towards the action' and introduce into the action the unpredictability of the inventive 'human event' (1934a: 100). The event of the work of art is produced by the decisions it provokes, and these in turn, if the work remains alive, provoke further decisions. However, consonant with Benjamin's speculative concept of experience, these events are both immanent to technological experience, while also exceeding it. Yet, this excess is not the product of an autonomous subject or work of art, but the futurity of the work's effects in experience, one which is effected by inter-

ruptions and imaginative hypotheses, which are, again, immanent to technology. The work of art becomes a site for the framing of hypotheses rather than the creation of forms, a transformation intimated in Brecht's epic theatre which 'opposes the dramatic laboratory to the finished work of art'.

Benjamin's criticism too becomes productive at this stage, attempting to keep open as many futures as possible for the works criticised. Yet this productive critique was always implied even in the early formulations of immanent critique. The latter was rooted in a concept of experience which regarded the present as folded in complex ways with unrealised pasts and constantly changing futures. Immanent critique, sensitive to the incompleteness of a work and the negotiability of its formal limits, was dedicated to revealing the unrealised futures inherent in the work. Such critique did not apply criteria of judgement, but sought strategically to maximise the possible futures of a work. It did so by showing the restrictions of existing interpretations – the ways in which they foreclosed on the work's possible futures – and by attempting to keep open these futures for critical invention.

The modern epic thus took its place within modern experience, not only in the sense of commemorating and mourning its decay, but also in contributing to its reorganisation. Consonant with the direction taken by Benjamin's interests in the 1920s, this reorganisation was both political and technological. The often awkward fusions and confusions of the political and the technological forms of organisation became Benjamin's main area of inquiry, since they defined for him the parameters of modern experience. While recognising that this experience was presently in a process of advanced decay, Benjamin claimed that the intensification of this tendency represented only one of its many possible futures. The speculative analysis of modern experience conducted in terms of its translation into language required considerable sensitivity to the ways in which other possibilities were nested within it. It also demanded that the reflection on experience not be confined to philosophy, or to literature, but extended to visual works of art and eventually to all, to areas of culture, and above all to the culture of the modern city.

3

THE WORK OF ART

Works of art may be defined as models of a nature that awaits no day, and thus no judgement day; they are models of a nature that is neither the theatre of history nor the dwelling place of mankind. The redeemed night.

Walter Benjamin, letter to Florens Christian Rang, 1923

Image and experience

The previous chapter examined some of the implications of Benjamin's speculative concept of experience for the practice of criticism. The focus was accordingly the 'word' and the 'literary' criticism (if it can be called that) for which Benjamin is justly remembered and esteemed. The immanent critique that Benjamin practised in his critical essays was seen to be inseparable from the speculative concept of experience explored in the first chapter. The complex character of experience, its folding of time, space and the absolute in configuration, was the point of departure of Benjamin's critical methodology of tracing the folds and warps in a literary text. Yet this work of criticism returned constantly to the relationship between word and image, whether in the guise of allegory or in the dialectical image of the modern epic. The critical analysis of Keller, Hessel, Döblin and Brecht traced the tension within their work between description and narration: this might be auratic, with the image as spectacle demanding silent contemplation, or aural, as in the narrative recognitions of the epic. Moreover, Benjamin maintained that the difficult relationship between word and image in modernism is an aspect of a far broader tension within modernity between technology and politics.

Benjamin acknowledged the insistent presence of the image throughout his literary criticism in his reflections on his own work, notably in his description of the origin of the German mourning play as an exploration of the relationship between word and image. But it is clearly not a straightforward relationship, since it also involves issues of space and time, history, politics and technology. Indeed, as seen above, establishing the character of the relationship between word and image was one of the main objectives of the early writings on the speculative concept of experience. The fragment from 1917 to the effect that 'perception is reading' (see pp. 3–5 above) aligns the speculative concept of experience with the written word understood as an *image* or that

which appears on a surface. Inscription on a surface is one possible form of image, that of the graphic line, which may be supplemented by chromatic forms of configuration which exceed inscription.

The relationship between word and image is crucial to both Benjamin's concept of experience and his criticism. However, the mapping of this relationship is complicated at the outset by the necessity to situate both word and image within the contexts of arguments involving issues of political and technical organisation. Word and image represent ways of organising experience, corresponding in Kantian terms to the discursive patterns known as concepts which together comprise the logic of the understanding and the intuitive, quasi-visual patterns that comprise the aesthetic of intuitions. For Benjamin as for Kant, the discursive and the aesthetic must in some way be aligned. However, as shown in Chapter 1, the neo-Kantian option of dissolving intuition in the categories was not pursued by Benjamin. His response was closer in many ways to Kant's own attempt to bring together concept and intuition under the aegis of time, notably in the controversial section in *Critique of Pure Reason* on schematism. Here Kant attempts to align *logos* (the word) and *aesthesis* (the image) by means of schemata that accommodate otherwise heterogeneous images and words into spatio-temporal rhythmic patternings.

Benjamin's resolution of the tension between word and image is often carried through in terms of corporeal rhythms. In *The Origin of the German Mourning Play* the allegorical disjuncture of image and word is resolved into the rhythm of sobbing in lament; in *The Image of Proust* it is resolved in the rhythm of breathing while in the Baudelaire essay it is resolved into the libidinal rhythms of orgasm.[1] However, the turn to corporeal rhythms is complicated by Benjamin's speculative account of experience which introduced the infinite into experience through the argument that time is not linear but a complex formation of past, present and future. Accordingly the alignment of concept and intuition in experience was also of extreme complexity, with the patternings of word and image shot through with memories and intimations.

Benjamin's philosophy of the image is best understood through an examination of its place within the speculative philosophy of experience. Just as the critique of the word was transformed by the speculative concept of experience, so too was the critique of the image. The analysis of the image within a philosophy of speculative experience had considerable implications for the critique of the experience of images in the guise of art criticism and of art history. Benjamin argued that images should be understood as a technology for organising experience, and that visual art was a way of speculating upon limits of experience from within it. However, the technological organisation of experience through the image did not necessarily agree with the political organisation of experience through the word. Benjamin believed that the tension between word and image was related in some way to technological and

political forms of organisation, and dedicated one of his most influential (but least understood) essays – *The Work of Art in the Epoch of its Technical Reproducibility* – to exploring their relationship.

The speculative image

Benjamin's development of a speculative concept of experience in the years prior to 1920 was inseparable from his reflections on the philosophy of the image. Even his linguistic metacritique of Kant's concept of experience was based on a pattern of argument that evolved out of his reflections on colour, inscription and the image. In these early texts he developed the themes of surface, mark and configuration which were integral to his speculative concept of experience. The early texts, beginning with *The Rainbow: A Dialogue on Phantasy* (1915), continuing through the 'aesthetic fragments' and culminating in the 1917 essays on *Painting and Graphics* and *On Painting, or Signs and Marks* show Benjamin developing an astonishingly original philosophy of visual art. Yet this development cannot be understood in isolation from his contemporary critique of Kant and his development of a speculative concept of experience, for the two strands of reflection on the image and on the limits of experience are inseparable.

The Rainbow: A Dialogue on Phantasy is the common origin of Benjamin's philosophy of visual art and the speculative concept of experience. As already seen, one of the participants, Georg, is a painter who uses the occasion of Margarethe's dream of colour to reflect on the limits of both painting and experience. On hearing of her nocturnal experience of colour, he replies 'I know these images of phantasy. I believe that they are in me when I paint. I mix the colours and I see nothing but colour, I can almost say, I am colour' (1915c: 19). Margarethe agrees with his account of the dream, describing her dissolution into a colour among colours, but then asks why these colours are never experienced in painting. Georg replies that painting is confined to inscribing form on a surface. The act of painting does not begin with the phantasmal experience of colour, but with the 'spiritual and creative' experience of form. The infinite possibilities of painting are generated by marking a surface and not by the infinite number of possible chromatic combinations: the essence of painting is the 'surface' or infinite space upon which are made inscriptions, quite different from the potentially infinite combinations of surfaces of 'pure colour' (1915c: 21). The distinction between the two infinities was analysed earlier in terms of spatial and chromatic infinities, the former extensive, the latter intensive. Chromatic infinity is intensive because each colour is capable of an infinite number of possible contrasts with other colours. Benjamin describes this infinity in terms of a phantasmal colour which

is without transitions and yet plays in infinite nuances; it is moist, blurs things in the colour of its contour, a medium, pure property of

no substance, colourful but also monochromatic, a chromatic filling
out of an infinity through phantasy.

(1915c: 25)

The answer to Margarethe's question of why she has never seen the colours of
phantasy in painting is that painting obeys the graphic principles of drawing –
of inscription upon a given surface. Instead of colours generating an infinite
number of contrasts in combination with each other, marking a scattered
infinity of nuances rather than a continuous infinity of tonal transitions, they
are subordinated to the rule of inscription which rests on the distinction
between light and shade.

Speaking in the person of the painter, Benjamin points to the possibility of
there being two kinds of image: the first is graphic, resting on the single con-
trast of light and shade; the second is chromatic, emerging from multiple
configurations of colour expressed in an infinite number of possible con-
trasts. Underlying the distinction between graphic and chromatic images is the
further distinction between the extensive infinity of form and surface and the
intensive infinity of colour.

With this text Benjamin begins his critique of the dominance of the con-
cept of form in the philosophy of art, linking this critique to an extended
concept of experience. The complex linkage continues to inform his reflections
upon the distinction between the formal and the chromatic images which were
undertaken in a series of fragments culminating in the two texts on painting
and graphics of 1917. Some of the fragments from 1915 to 1917 are associ-
ated with a project on 'Phantasy and Colour' from 1915 that was closely
related to work on children's art and the illustrations in children's books.

These concerns are brought together in the short essay/fragment from
1914/15 entitled *A Child's View of Colour*, whose subtext is the replacement of
Kant's forms of intuition (space and time) with colour as a (transitive and
shifting) medium of intuition. The essay begins by distinguishing children's
experience of colour from that of adults, arguing that for children, form fol-
lows colour, while for adults, colour follows form. For the child, colour is not

the misleading coating of individual particular things in space and
time. Where colour provides the contours, objects are not reduced to
things but are constituted by an order consisting of an infinite range
of nuances: the colour is individual, but not as a dead thing fixed in
individuality, but as winged, flying from one pattern to another.

(1914b: 50)

The experience of chromatic phantasy exceeds the forms of spacio-temporal
intuition; it is the 'medium of all transformation, not its symptom' and 'can
never relate itself to form, which is a matter for law' but is always 'nuanced,
moving, and arbitrary' (1914b: 50–1). The *medium* of colour replaces the *forms*

83

of intuition as the receptive aspect of experience, but in so doing Benjamin transforms the meaning of the term intuition (*Anschauung*: seeing into). Seeing the world in the medium of colour is quite different from seeing it through the forms of spatio-temporal intuition. Chromatic intuition is intensive and 'contural' – its images are expressed not in terms of inscription but in terms of degrees of brightness and transparency. Benjamin uses the distinction between child and adult art as evidence for their distinct intuitions of the world:

> The colourism of children's drawings proceeds from brightness. The particular and highest transparency of colour is pursued, and there is no relation to form, surface or concentration of space. Pure seeing is not directed toward space and the object, but to colour, that certainly appears in the highest degree objective, but not spatially objective. . . . The objectivity of colour does not rest on form, but proceeds without intuition immediately to the spiritual object through the isolation of seeing.
>
> (1914b: 51)

By regarding colour as a medium of intuition prior to the forms of space and time Benjamin decisively transforms Kant's concept of experience. However, the significance of his claim for the distinction between the chromatic and the formal intuitions of children and adults extends beyond the limits of developmental psychology. At the end of the essay/fragment Benjamin translates the distinction into the philosophical register of reflection and intuition, concluding that children 'have no reflection [*Reflexion*], only intuition [*Schau*]' (1914b: 51).

The move into the philosophical register is extended further in the fragment on *Reflection in Art and in Colour*, also from 1914–15. Here Benjamin distinguishes between original and reflected colour, understanding the former as intensive intuition. Reflected colour on the contrary, such as in painting, 'proceeds through the spiritual as its medium of construction. Colour *remains* reflected in the spiritual as individual appearance' (1914c: 117). This means that colour is used for the purposes of formal construction and always stands in relation to form: 'Painterly colour cannot be seen for itself, it is in relation, is substantial as surface or ground, somehow shadowed and related to light and darkness' (1914c: 118). Colour is subordinated to inscription which depends on the contrasts between light and dark, the surface of inscription and the inscribed.

The paradigm of inscription informs the structure of Kant's concept of experience. Colour in its original sense, for Benjamin, is 'primally for itself, that is to say, it does not relate itself to things, nor even to their appearance in flecks of colour; rather it relates itself to the highest concentration of seeing' (1914c: 117). The concentration of seeing in colour dissolves not only the opposition between form and matter, but also the collateral distinction

between a formative subject – the one who forms and inscribes – and that which is formed or inscribed. Benjamin puts this dissolution of the subject and object opposition in several ways: '"I see" is to say I perceive and also "it looks" (mainly of colours)' and 'The look of colours and their being seen is the same: that is to say, *the colours see themselves*' (1914c: 117).

The increasingly philosophical articulation of the themes of the dialogue led directly to the project of 'Perception' and through it to the revision of Kant's concept of experience in *On the Programme of the Coming Philosophy*. But it also developed into a philosophy of painting that 'proceeded from showing that colour and form are distinct'. Benjamin was occupied with this problem in the Summer and Autumn of 1917 when he wrote the fragment *Painting and the Graphic Arts* and then the substantial essay *Painting, or Signs and Marks*. On completing the latter in October, he immediately began work on the critique of Kant in *On the Programme of the Coming Philosophy*. The reflections on painting are inseparable from the formulation of his critique of Kant's concept of experience, and provided an immediate impulse for its development.

The close relationship between the work on painting and the critique of Kant's concept of experience is evident in the extraordinary letter to Scholem from 22 October 1917. Benjamin begins by reflecting on what is essential in Kant, what from his thought must be preserved, then moves to a comparison of Judaism and Christianity ending with some reflections upon modern art which he extracts from an essay *On Painting*. In the letter he distinguishes between colour and line and the possibility of cubism being an 'unchromatic' painting moving on to some thoughts on Picasso and the distinction between geometrical inscription, philosophy and painting cast in terms of the 'relationship of painting to its sensory subject' (C, 101). A geometrical inscription, even when refined into the equations of analytical geometry, remains a mark within a given spatial configuration (for Benjamin, two- or three-dimensional space). In geometry, the configuration of space is given, while for philosophy, what is important is not the space in which an object appears, but the essence communicated through an object in space and time. Painting is distinguished from both geometry and philosophy in that it is neither the analysis of the properties of a given space nor the communication of an essence, but simply the communication of itself. It does not refer to anything outside itself, whether space or objectivity, but is a *medium* characterised by an infinite number of internal determinations.

The extension of the notion of a chromatic infinity to the philosophy of painting is conducted on the basis of Benjamin's speculative critique of Kant, and corresponds, as he himself points out, to the analysis of language as a bounded infinity which communicates only itself in *On Language as Such and on the Language of Man*.[2] The essays on painting develop the same themes and use the same vocabulary as the speculative account of experience explored earlier. The first of the essays, *Painting and the Graphic Arts*, considers the space of painting and graphics in terms of the orientation of the viewer. It begins

with a contrast between the vertical character of painting and the horizontal character of the mosaic and moves from this to a distinction between the vertical character of painting and the horizontal character of graphic art. The distinction is in its turn derived from two 'sections' or cuts of the 'World substance': 'the longitudinal section of painting and the cross-section of graphics' (1917a: 82) which are respectively 'presentative' and 'symbolic'. The first, vertical 'section' generates the image and the second the mark. The distinction is immediately qualified in the case of writing which for moderns is understood as a mark on a horizontal surface but which was originally vertical, hieratically inscribed in stone. Writing complicates the distinction between image and mark, accommodating itself to both cross and longitudinal sections.[3]

Benjamin deepens his reflection upon the distinction between the painterly mark and the graphic inscription in the essay *Painting, or Signs and Marks*. The essay is divided into two parts devoted to 'inscription' and 'mark'. The first section distributes the 'sphere of inscription' across a number of distinct areas whose characteristics are determined by the significance in each area of the *line*. Benjamin describes four areas of inscription characterised respectively by the line of geometry, writing, graphics and 'absolute inscription'.

The theme of the line has already been explored in the context of Benjamin's philosophy of experience. Here the line was shown to have the paradoxical properties first of constituting the surface upon which it was inscribed and then of configuring it by marking a limit between the inner and the outer. Both characteristics are of course linked since the surface emerges from behind and around the line while being limited in extent by it. Benjamin clarifies these thoughts in his reflections upon the graphic line, which begin with the claim that 'The graphic line is determined by its opposition to surface; this opposition does not only have a visual but also a metaphysical significance' (1917b: 83). The graphic line, he continues, 'inscribes the surface and determines that this serves as its own ground. Conversely, there can only be a graphic line on this background' (1917b: 83). This means that the relation of inscription and surface/background has precedence over the relation between the lines making up an inscription. Benjamin indeed claims that the relationship between inscribed lines is always mediated by the prior relationship of each line to its surface/background: 'in graphics two lines can only determine each other relative to their background' (1917b: 83).

Benjamin was aware that his analysis of inscription in terms of line and surface had several important visual and philosophical implications. The first is that the act of inscription both constitutes and presupposes a surface. In terms of the Kantian model of experience within which Benjamin was working, the surface of inscription, or spatial form of intuition, was both a priori and actualised by the inscription of a line, or application of schematised category. A second implication is that the line receives its significance primarily from its relationship to the surface and not to other lines. This claim too has a Kantian correlate in the argument that the categories can only gain significance

when they are related to intuition but not with respect to other categories.[4] Underlying this claim is the argument for a bounded infinity discussed earlier, since within each inaugural relation of line and surface are to be found an infinite number of possible discrete lines and surfaces. This leads to a final implication which Benjamin explores in terms of what he calls the 'absolute inscription'.

Benjamin introduces the distinction between 'absolute sign/inscription' and the 'absolute mark' as one which is of 'monstrous metaphysical significance' (1917b: 84). The 'absolute sign/inscription' is a line both inscribed *upon* and cut *into* a surface. The inscription as a cut in a surface has the capacity to separate and distinguish parts of a surface from each other. Benjamin's examples of the line which demarcates one part of a surface from another include the 'mark of Cain', which allowed the descendants of Cain to be separated from the rest of humanity, and the marks of the Passover, which allowed the Israelites to be distinguished from the Egyptians. What is crucial about these lines of demarcation is that they are inscribed upon/within a surface from without; and it is this which distinguishes them in Benjamin's eyes from 'marks' proper like stigmata or blushes, which emerge from within. The mark is distinguished generically from the graphic lines and surfaces of inscription, and forms a point of transition in Benjamin's argument from the discussion of inscription and graphics to that of the mark and painting.

The section of the essay on the mark begins with a definition of the 'absolute mark' couched in terms of what distinguishes it from the 'absolute inscription'. While the latter is 'impressed upon' a surface, thus obeying the logic of a form imposed upon a content, the 'absolute mark' 'emerges' from within; the sphere of inscription is characterised by the opposition of line and surface, while the sphere of the mark is that of a medium. From this distinction Benjamin maintains that the inscription is spatial, inscribed upon a surface, while the mark is temporal, emerging from within a medium. The inscription cuts into a surface, distinguishing one section of it from another, while the mark emerges from within a medium and gains its meaning from its relation to all the other emergent marks. In the case of the inscription there is a unique and absolute relation between line and surface/background which determines all other relations between lines; it is thus graphically figured in the contrast between line and surface (as in a black line on a white surface). The mark, however, has no relation to a surface/background, but possesses a potentially infinite number of relations to other marks; it is figured as colour, and in emerging as a mark is available for an infinite number of chromatic transformations. The infinite *transformations* of coloured marks differ radically from the infinite *permutations* of lines which may be inscribed on a given surface.

On the basis of such contrasts Benjamin formally distinguishes the image which emerges from the mutual transformation of marks from the image inscribed upon a surface:

Painting. The image has no ground. Nor does one colour ever rest upon another but at the most appears in the medium of it . . . in many paintings it is impossible to determine if a colour is of the background or foreground. This question is meaningless. There is in painting no background, and no graphic line.

(1917b: 85)

Painting construed ideally is a medium of marks from out of which emerge images which cannot be traced back to the relationship of line and surface. With this definition Benjamin returns to the contrast of the horizontal image of the mosaic and the vertical image of the painting ventured in *Painting and the Graphic Arts*, except that now he wishes generically to align the image in painting with the image of the mosaic. The line of argument he pursues moves from the chromatic medium, through 'composition' to the 'word'. Benjamin begins with the claim that painting is dialectical, but that unlike graphics, this is not a closed dialectic of line and surface. In graphics, externality is figured as the absence of surface, while in painting, externality remains within the medium of colour unless it is related to another medium such as language:

The actual problem of painting can be found in the statement that a picture is indeed a set of marks; that, conversely, the marks in the narrower sense exist only in the picture; and, further, that the picture, insofar as it is a set of marks, is only a set of marks in the picture. But on the other hand, the picture may be connected with *something that it is not* – that is to say, something that is not a set of marks – and this happens by naming the picture.

(1917b: 85)

The entry of that which is not mark into the medium of colour is accomplished by the 'composition'; this effects, says Benjamin, the entry into the medium of colour of a 'higher power' which does not subordinate the medium to inscription but is intangibly related to the medium. Benjamin describes this higher power as the 'spoken word' and proposes that the historical epochs of painting can be distinguished according to the relationship between the medium and the word.

Composition, understood as the relation of the medium of painting with that which is exterior to it, means more than simply the narrative form or linguistic content of a work of art. Indeed, the concept of composition cannot be situated within this classical opposition, for, like the concept of the 'Poetic' it is what organises both form and content. It is the means by which what is exterior to the medium of art is brought into it, whether this exteriority is thought in terms of content or in terms of form. It is a process of patterning and articulation which when viewed from the limited standpoint of form or content escapes the terms of their opposition. Thus composition is at work in

the selection of both the form and content of a painting, constituting, in the words of a 1920 fragment 'On Painting', first its content through its mimetic character (*Abbild-Charakter*), and then its form through its imaginative character (*Phantasie Charakter*) (1920: 114). It is composition which permits the translation of what is exterior into the medium of painting. With this argument Benjamin believes he can preserve the immanent character of painting as a medium – its lack of reference – while still leaving it open to the world.

At this stage Benjamin is content to hint obscurely at the sort of relationship that exists between the word and its image as given through the medium of colour. Indeed, the relationship between word and image was to occupy him in various ways for the rest of his life. However, his undeniably obscure reflections on the affinity between word and the medium of colour can be clarified by returning them to their place in his reconsideration of Kant's concept of experience. For Kant experience consisted in the union of the acroamatic 'word' of the categories with the axiomatic 'images' of intuition by means of the schema which were a 'third thing', both image and word. In the early essays on painting, Benjamin pursues two directions of argument: the first aligns inscription and mark with the spatial and temporal forms of intuition, the second dissolves the forms of intuition into a continuous medium, figured in terms of colour. Both arguments, however, still face the problem of uniting the forms or medium of intuition with the word. The sense of Benjamin's solution is to propose 'composition' as an equivalent function to the schema in uniting the word and intuition. It permits the translation of both objects of intuition (content) and abstract patterns (form) into the medium of painting.

Whatever the lack of clarity suffered by Benjamin's exposition of his concept of experience, its implications for the practice of critique are evident. His speculative concept of experience, which, however problematically, remained within Kantian parameters, allowed his concept of critique, in art as in literature, to avoid the dogmatic extremes of empiricism and formalism. By focusing upon composition as both concrete and a priori, Benjamin managed to maintain a position in which individual works of art are informed by the concept without becoming mere instantiations of a form or transcendent idea. As in literature, the focus of critique was 'immanent' to a work of art, drawing out its composition without conceding this to be either a nominal discovery of the critic or a transhistorical form embodied in the work. Equally, it was also possible to develop a conception of the relationship between the work of art and what is external to it without resorting to crude sociological analogies of 'reflection' of content or to an equally crude asociological formalism.

The critique of art

The transformation of the concept of experience was as significant for the practice of art criticism as it was for literature. The function served in

Benjamin's literary criticism by the 'Poetic' or organising principle which determined both the form and content of a work is satisfied in the work of art by the concept of 'composition'. However, his art criticism was by no means as fully developed as his literary criticism; indeed, apart from a lost essay on August Macke from the early 1920s and a short article on James Ensor from 1930, Benjamin's critique of painting was indirect, episodic and usually illustrative. It is in his critique of the methodology of art history and its relationship to cultural history that he made his most original and significant contribution. This reflected his conviction expressed in a letter to Florens Christian Rang (9 December 1923) that the fundamental problem of art criticism was the 'relationship of works of art to historical life' (C, 223), a relationship which was to be revealed not in 'art history' but through a practice of cultural interpretation which considers the work of art 'as a complete expression of the religious, metaphysical, political and economic tendencies of an epoch'.[5]

Benjamin's reflections on the methodology of art history are contained in two essays from the 1930s: *Rigorous Study of Art* (1932–3) and *Edward Fuchs, Collector and Historian* (1937). Both essays take issue with formalistic and empiricist currents in art history, and propose a closer relationship between art and cultural history. The project that emerges from these works is not simply a product of Benjamin's acquaintance with Marxist aesthetics in the late 1920s, but long predates this period. It corresponds in many respects with the influence on Benjamin of the late nineteenth-century Viennese art historian Alois Riegl, notably his masterpiece *Late Roman Art Industry*. Benjamin, in *A Berlin Chronicle*, recalls the impression this work made upon him as early as 1914 and in 1929 he described it as a 'methodological revolution' adding that 'in the last four decades no art-historical book has had such a substantive and methodologically fruitful effect' (see pp. 157–8 below).

Benjamin's enthusiasm for Riegl's writings contrasts starkly with his near contempt for the work of Wölfflin. This too dated back to the beginning of the First World War, and in particular 1915 when Benjamin attended Wölfflin's lectures in Munich. In *Rigorous Study of Art* – a review of the first volume of *Kunstwissenschaftliche Forschungen* – Benjamin claimed that Wölfflin's attempt to replace nineteenth-century historicist art history with 'formal analysis' was a failure. He saw in Riegl's work an opening beyond the opposition of a historicist empiricism which indiscriminately collected facts about works of art and artists and a historical formalism which ultimately disguised the imposition of an arbitrary judgement of taste upon works of art. What he drew from Riegl, however, was less the celebrated concept of the *Kunstwille* – or artistic will – which marks a lapse on Riegl's part into dogmatism, than Riegl's attention to 'materiality' of works of art and to what is 'inconspicuous' and excluded from the canon.[6]

There is a close link between this attention to the exclusions of art history and Benjamin's speculative concept of experience. In terms of the methodology of art history, Benjamin prizes Riegl and his school for their 'willingness

to push research forward to the point where even the "insignificant" – no pre-cisely the insignificant – become significant' (1933b: 87). Citing Hubert Grimme's work on the Sistine Madonna, Benjamin notes 'how much such an inquiry, based on the most inconspicuous data of an object, can wrest from even the most worn out things' (1933b: 87). Benjamin translates his method of literary analysis – which proceeds from the scrutiny of the 'material content' (*Sachgehalt*) of an individual work to its meaning (*Bedeutungsgehalt*) – to art history, and sees in Grimme's work the intimations of an art history that does not dissolve the work of art into an instance of a universal history or timeless progression of forms. The 'focus on materiality' inaugurated by Riegl begins with those elements which, while external to the work, are yet incorporated within it. The eye for this marginal domain is for Benjamin characteristic of the 'new type of researcher' who seeks the meaning of a work not by inserting it within historical or formal narratives, but by examining the disarticulations of form and content and thus uncovering the 'composition' or tracing the translation of what is exterior to the work into the medium of art.

Towards the end of *Rigorous Study of Art* Benjamin warns against confusing the cultural history of art which he is advocating with the sort of cultural his-tory which would provide another grand narrative of the history of art. The danger of the latter is elegantly diagnosed in the later essay on the Marxist cul-tural historian Eduard Fuchs. Fuchs's work on erotic art and political caricature would seem to exemplify the attention to materiality and the mar-ginal which Benjamin appreciated in the heirs of Riegl. It was certainly anti-classical – 'Fuchs broke right across the board with the classicist concep-tion of art, whose traces can still be recognised even in Marx' (1937: 361) – and took a definite critical stance against Wölfflin's formalism. But in its place it proposed to explain works of art in terms of a reified concept of 'cul-ture' which replaces 'the many and problematical unities embraced by intellectual history (as the history of literature and art, of law or religion) with a new and even more problematical one' (1937: 359). Against the claims of Wölfflin's formalism, Fuchs can only point to a change in 'culture' or the 'mood of the times' (1937: 364).[7] Such an abstract concept of culture threat-ens to become the support for a new historicism, one in which the history of art becomes the passive expression of a broader history of culture.[8]

With regard to Riegl, Benjamin implicitly distinguished between the insights into the materiality of individual works of art and the metaphysics of the artistic will; with regard to Fuchs he is even more explicit. He distinguishes between Fuchs's Social Democratic commitment to a progressive notion of the history of culture and his methodological innovations. He regards the latter to lie in Fuchs's sensitivity to the impact of technology of reproduction on the work of art, his analysis of popular art and his attention to iconography. Taken together these innovations 'cannot prove other than destructive to the traditional view of art' (1937: 362), since they dissolve the temporal and spa-tial boundaries of what was previously considered to constitute a work of art.

Fuchs's sensitivity to the significance of the development of technology of reproduction underwrites his insight into the historicity of meaning – the fact that the meaning of a work of art is not bestowed once and for all at the moment of its creation, but is re-created at every moment of its reception in radically changed circumstances. Thus the *original* of a work of art loses its temporal propriety: 'Attention to the technology of reproduction reveals, as does scarcely any other line of inquiry, the decisive importance of reception; it thereby allows the correction, within limits, of the process of reification undergone by a work of art' (1937: 362). The attention to reproductions as well as to what is excluded from the canon questions the distinction between high and low art, and strikes at art's self-definition and even its principles of authenticity and creative genius. Finally, the attention to iconography or the place of artistic expression within other forms of expression in its turn challenges what is considered to be proper to artistic creation.

Benjamin's final judgement of Fuchs's work holds that while it questioned the limits of the prevailing definition of art, it failed to release interpretation from a received concept of culture. The definition of the work of art is released from its temporal and spatial limits – its meaning is fixed neither in time nor with regard to other aspects of culture – only to tie this meaning down again to a progressive concept of culture. Benjamin's own work sought to question the definition of the work of art – the limits within which it found itself – by concentrating upon marginality and dislocation. Instead of inserting a work within a historical narrative, he sought to use the peculiar self-referential character of the medium of art to question the claims of historical narratives.

For Benjamin the work of art has the character of an origin – it is something which is in history, but this 'in' is not simple. Citing his own definition of origin from *The Origin of the German Mourning Play*, Benjamin states that the meaning of an original work of art is 'apparent only to a dual insight' which discerns not only the traces or 'scars' of history in a work, but also intimations of a future history which will change both the work and the traces of history already discerned in it. Fuchs's work takes the first step by recognising that history is preserved in the work (see 1937: 352) but holds back from acknowledging what is unforeseeable in the work of art's future. Benjamin's final words on Fuchs's work suggest that because it is closed to the future it must remain conservative, preserving what has been, and in doing so failing to understand it, since 'so much about which the past has vainly sought to instruct us, only the future can tell' (1937: 386).

Benjamin's intimations of the future of works of art in the Fuchs essay cluster around the threat to the definition of art posed by technology. While Fuchs recognised the significance of the technology of mechanical reproduction for challenging the definition of the work of art, he did not affirm this possibility as marking a radical change in the meaning of art. This was for Benjamin characteristic of the Social Democratic movement of the early twentieth century – 'which failed to perceive the destructive side of technology

because they were alienated from the destructive side of the dialectic' (1937: 358). Benjamin sought not merely recognition of the destructive side, but engaged nihilistically to affirm it as opening possibilities for the future. This was particularly crucial with respect to the work of art, which seemed most threatened by the development of technology. Instead of lamenting the destruction of art by technology, Benjamin sought to affirm a different future for art in the wake of its destruction.

Technology and the work of art

Benjamin analysed the relationship between art and technology in a series of seminal essays beginning in 1931 with the *Small History of Photography* and culminating in *The Work of Art in the Epoch of its Technical Reproducibility* (1935) and the *Paris Letters* of 1936. These essays, written in the margins of the *Arcades Project*, not only explored the theme of 'the fate of art in the nineteenth century' but also the aesthetic implications of fascism and communism.[9] The essays plot the 'locus of contemporaneity' informing the historical work on the *Arcades Project*, while the analysis of the transformation of the concept of art and its translation to the sphere of politics provided a means for critically assessing the present. In order to establish the connection between art, technology and politics Benjamin developed a number of new concepts such as 'aura', 'reproducibility' and the 'monumental'. At issue in all these, however, is the question 'of what constitutes a work of art', one which, Benjamin noted in a letter to Alfred Cohn (4 July 1936), apropos of *The Work of Art in the Epoch of its Technical Reproducibility*, was 'continuous with my earlier studies in spite of its new, and surely often surprising tendency' (C, 528).

There appears to be a disproportion between the question of what constitutes a work of art and the political issues of fascism and communism, one which reaches an apparently grotesque extreme in the choice posed at the end of *The Work of Art in the Epoch of its Technical Reproducibility* between fascist aestheticised politics and communist politicised art. The way the alternative is posed seems to suggest that the correct strategic response to fascism is to mount a Brecht production. However, Benjamin's argument is far more subtle and carefully developed than his concluding slogan suggests, and rests on an alignment between fascist monumental self-presentation, aura and aestheticism. For the question of what constitutes a work of art is deceptively simple; its full force is best appreciated if it is rephrased in terms of the character and place of the borders of the work of art. If the borders of the work of art are impermeable and closed, then the work is immutable, defying time and change; if they are permeable and open, then the work is constantly in a process of transformation, becoming other than itself. Benjamin sees the former definition of the work of art as characteristic of the late nineteenth-century 'Art for art's sake' movement which insulated the work of art from outside influences, and attempted to remove it from the passage of time.

Benjamin argues on several occasions that aestheticism, however fastidious or delicate, was effectively monumental in its refusal to acknowledge the passage of time within a work of art. For this movement the borders of the work of art were closed, fixed for ever at a particular time and place, making the work into an object of contemplation rather than use. The experience of such a work is contemplative, and since the borders of the work of art are inviolable, it remains the same whatever the gaze to which it is subjected. Such an experience contrasts starkly with that of a work whose borders are open or permeable, and which changes in response to use. A work whose borders are closed and impermeable is distant and unique, or to use Benjamin's concept, it is *auratic*. Aura is defined in *A Small History of Photography* as 'A strange weave of space and time: the unique semblance of distance, no matter how close the object may be', but this particular weave is monumental, conjoining 'uniqueness and duration' (1931b: 250) Yet the monumental condition of the auratic work of art is deceptive since every work of art undergoes change as a condition of its existence. The auratic work of art which pretends to be immune to the passage of time is in truth only a particular way of negotiating finitude, that is, by denying it. Such works, as monumental, literally refuse their future, since time is arrested in their claims to uniqueness and duration.

Throughout *A Small History of Photography* Benjamin refers to aura as an effect which is historically produced, but one which during the nineteenth century became paradoxical. At the very moment that technology in the guise of photography challenged the limits of art, it was also used to re-create the experience of aura. Benjamin sees in photography the possibility of creating an openness to the future which he describes in terms of an 'optical unconscious', and in which 'a space informed by human consciousness gives way to a space informed by the unconscious' (1931b: 243). A space free of consciousness is charged with contingency if it is open to the future and to becoming something other than itself:

> No matter how artful the photographer, no matter how carefully posed his subject, the beholder feels an irresistible urge to search such a picture for the tiny spark of contingency, of the Here and Now, with which reality has so to speak seared the subject, to find the inconspicuous spot where in the immediacy of that long forgotten moment the future subsists so eloquently that we, looking back, may rediscover it.

> (1931b: 243)

This sentence is a fine summation of Benjamin's concept of experience, where the future subsists in the present as a contingency which, if realised, will retrospectively change the present. The weave of space and time captured by the photograph is characterised by contingency and is anything but auratic. The

vulnerability of the present may be affirmed as fragility, or denied in the attempt to transform contingency into the auratic, monumental present.

It is in Atget's photographs that Benjamin finds the definitive 'emancipation of the object from aura' which presented the excluded and the forgotten. Benjamin wrote of Atget looking out for 'what was unremarked, forgotten, cast adrift' and producing works which 'pump the aura out of reality like water from a ship' (1931b: 250). The same photographic technology that in the hands of Atget could open itself to contingency was also capable of re-creating aura and fixing the image in a monumental present. Instead of transforming experience by making it contingent and open to future interpretation, technology may serve to monumentalise it. The works of art made possible by the new technology were capable of reflecting upon experience from within, and changing it. However, they could also be used to confirm an existing pattern of experience and to insulate it from change. Benjamin cites as an example of the technological abolition of contingency the photographic 'retouch' in which a photographic technique is used to confirm an obsolete but still dominant mode of experience. Benjamin presents this confirmation in terms of the reduction of an 'absolute continuum from brightest light to darkest shadow' to the tonal opposition, in the retouch, of light and shadow. In terms of Benjamin's underlying account of experience, the retouch reduced the possibilities of configuration opened by photographic technology (the 'optical unconscious') to the binary opposition of dark and light that characterises inscription.

Since *One Way Street* Benjamin had consistently posed the alternative between a concept of experience which responded to changes in technology, and one which used technology in order to monumentalise itself. Furthermore, he aligned this diagnosis, again even as early as 1923, with class struggle or the 'deepening degeneration of the imperialist bourgeoisie' (see 1928b: 104 & 248). The issue of what constitutes a work of art is symptomatic of the broader question of how to respond to the change in the character of experience provoked by technological progress. Technology can be used to resist the change in experience, to monumentalise the present by closing it off to any other future than the repetition of the present, or it can be used to promote the transformation of experience itself. Benjamin did not see these alternatives as options, since technology was ineluctably changing the nature of experience, and if this was not affirmed, then the attempt to freeze the present and deny a future would generate imbalances, distortions and the release of the uncontrollable violence of passive nihilism.

In a review of a collection of essays edited by Ernst Jünger, Benjamin predicted that the growing disproportion between experience and technology would lead to a 'slave revolt of technology'. He argues that 'bourgeois society cannot help but insulate everything technological as much as possible from the so-called spiritual, and it cannot help but resolutely exclude technology's right of co-determination in the social order' (1930b: 120). The inability to affirm

the technological transformation of experience means that technology, instead of serving to reorganise experience, begins to disrupt and violate it. In a sense all experience for Benjamin is technological, since the term technology designates the artificial organisation of perception; as such, experience changes with the development of technology. The slave revolt of technology may be described as the generational struggle of two technologies, or the domination of a nascent technological organisation of experience by an obsolete model which strives to perpetuate itself. This is especially clear with respect to the 'so-called spiritual' which for Benjamin is a particular way of imagining the organisation of experience. Throughout his work, Benjamin opposed the tendency to think of experience in terms of the opposition of form and content, preferring to use terms such as 'the Poetic' or 'composition' which organised experience in time. This freed Benjamin from the idealist entailments of the opposition of form and content, in which form was eternal and 'spiritual' and content transitory and material. In place of the opposition of 'the spiritual' and the technological he proposed a notion of technology as a medium of organisation which patterned experience while being reciprocally subject to change in the face of experience.

One of the consequences of the avoidance of technology was the idealist tendency to spiritualise the work of art; instead of seeing it as an open site for the discovery and anticipations of new patterns for the organisation of experience it became the closed domain of aesthetic form. The idealist perception of aesthetic form was then applied to technology as a whole: instead of challenging the sanctity of aesthetic form, technology was subordinated to it. The fascist theory of war proposed by Jünger was for Benjamin 'nothing other than an uninhibited translation of the principles for *l'art pour l'art* to war itself' (1930b: 122). The ideology of technological warfare 'wanted to recreate the heroic features of German Idealism' in an apotheosis of the distinction between spiritual form and material nature. Not only did the fascist theory of war subordinate technology to an obsolete pattern of organisation, it also failed to recognise the new possibilities of future global organisation which had been opened by it.

The relationship between fascism, technology and aestheticism is further developed in the *Paris Letters* from 1936. In these the issue of the relationship between organisation and time are central, with the organisation of experience in terms of form and content being regarded as a disavowal of time and futurity. Departing from a discussion of Andre Gide, Benjamin sees the achievement of fascist theory and practice of art to consist in bringing together 'the decadent theory of art with monumental practice' (1936a: 48). The self-contained work of art for art's sake was fused with mass self-presentation into a 'monumental design', incarnating an aestheticised philosophy of history and politics which froze history and made the present into an impermeable work of art for mass contemplation. The monumental fusion of aestheticism and the self-presentation of the mass had two salient characteristics: first, it

monumentalised existing social relations, and second, 'it put the producers as much as the recipients under a spell in which they must appear to themselves as monumental, that is, as incapable of considered and independent action' (1936a: 489). The crucial link in Benjamin's aesthetic and political argument was supplied by technology, since for Benjamin fascism was a response to a crisis which was both social and technological:

> The development of productive forces which includes, besides the proletariat, technology, has led to a crisis which pushes towards the socialisation of the means of production. This crisis is above all a function of technology.
>
> (1936: 490)

The fascist position with respect to technology 'leads in two opposed directions which are determined by the same idea, namely aestheticism' (1936: 490). In the first, the effects of technology – noise and destruction – are opposed from a nostalgic anti-technological perspective, while in the second the same effects are affirmed and celebrated. Both positions, exemplified for Benjamin by the writers Georges Duhamel and Marinetti, engage only with the superficial symptoms of technology. They both succeed in making technology itself a monumental object of contemplation. This is a position which Benjamin briefly contrasts with Majakovski's affirmation of technology, one which he regards as 'irreconcilable with the attempt to gain for technology a monumental aspect' (1936: 491). The latter does not make technology into a self-enclosed and autonomous object of contemplation to be mourned or celebrated, but considers it functionally in terms of its place within a broader experiential context.

The analysis of the relationship between technology and the work of art is central to the influential but greatly misunderstood essay *The Work of Art in the Epoch of its Technical Reproducibility*.

The work of art in the epoch of its technical reproducibility

A commentary

In a letter to Max Horkheimer of 16 October 1935 Benjamin relates the ongoing *Arcades Project* to a series of 'preliminary reflections entitled "*Das Kunstwerk im Zeitalter seiner technischen Reproduzierbarkeit*"'. These reflections were intended to 'indicate the precise point in the present to which my historical construction will orient itself, as to its vanishing point' (C, 509). *The Work of Art* joins with the *Arcades Project* in what Benjamin described elsewhere as a 'historical constellation'[10] which served both to 'telescop[e] the past through the present' and to allow 'the past to place the present in a critical condition'.[11] In this case the constellation affords an immanent critique of art

that is attentive both 'to the fate of art in the nineteenth century' and to the impact of this fate upon art and politics in the present century.[12] The essay occupies a pivotal position in Benjamin's *oeuvre* and has been justly influential, but also ill understood.

Far from being simply another exercise in the theory of art, Benjamin describes this 'short programmatic essay' as a 'telescope' pointed at a 'mirage of the nineteenth century that I am attempting to reproduce based on the characteristics it will manifest in a future state of the world liberated from magic' (C, 516). The essay brings into a constellation not only past and present, but also the future, a future not just of art, but of a world 'liberated from magic'. The latter phrase makes sense within the matrix of the theoretical relations between art, aura, magic and technology established in the essay. It can serve here to anticipate the often overlooked point that for Benjamin the 'fate of art' is *symptomatic* of a fundamental change in the structure of experience which may be traced back to broader political and technical developments.

The Work of Art in the Epoch of its Technical Reproducibility exists in three versions, the first and third of which diverge from each other in significant ways. The first version, completed during the Autumn and early Winter of 1935 preserves the form of a series of nineteen numbered and titled reflections. The French translation of this version completed in collaboration with Pierre Klossowski in the Spring of 1936 changes many of its formulations and, following the recommendations of Horkheimer and the *Institut für Sozialforschung*, blunts the political edge of the essay. The final version completed between Spring 1936 and Spring 1939 deletes some sections of the first version, changes formulations and is in many respects more allusive and indirectly argued. This is the version reprinted in Adorno's 1955 edition of Benjamin's *Schriften* and translated in the influential English collection *Illuminations*. Since the variants between the versions are often very revealing, the commentary shall move between the first and final versions, showing the process by which Benjamin refined, improved but also censored his diagnosis of the fate of art.

The first reflection or 'Foreword' to *The Work of Art in the Epoch of its Technical Reproducibility* looks back upon Marx's predictions for the future of capitalism. Benjamin's rhetorical opening echoes Marx's methodological statement in the *Contribution to a Critique of Political Economy* (1859), aligning Marx's method with immanent critique and underlining the point that it is more important to understand the developmental tendencies of capitalism than to predict the utopian future of socialism. While following Marx's distinction between economic base and cultural superstructure, Benjamin radically qualifies the schema by insisting upon their asynchronicity. There is no question of assuming that culture 'reflects' an economic base, for the main object of investigation is precisely the character of the relationship between the two. Benjamin thus begins not by adopting the distinction of base and superstructure but by establishing an analogy between Marx's focus on the

immanent critique of developmental tendencies in the sphere of the economy and his own in the sphere of culture.

Just as Marx refrained from sketching utopian blueprints of a future social-ist society, so too Benjamin refrains from speculations upon the 'art of the proletariat after its assumption of power or about the art of a classless society'; he focuses instead upon the 'developmental tendencies of art under present conditions of production' (1939a: 220). However, as with Marx in the *Contribution to the Critique of Political Economy*, this focus demands an imma-nent critique of the categories used to organise and make sense of experience. For Marx such economic concepts as 'value', 'rent', 'profit' and 'wage' both structure the capitalist economy and inform its theoretical expression in polit-ical economy. However, while acknowledging that such concepts may be outmoded and no longer serve to make sense of the experience of contempo-rary capitalism, which is one of crisis and conflict, Marx does not reject them, but subjects them to immanent critique in the light of the developmental ten-dencies of contemporary capitalism, supplementing them where necessary with new concepts such as 'surplus value' and 'rate of exploitation'. Benjamin too, maintaining the analogy between his and Marx's method, ventures an immanent critique of such 'outmoded concepts' as 'creativity and genius, eter-nal value and mystery – concepts whose uncontrolled (and at present uncontrollable) application would lead to a processing of data in the Fascist sense' (1939a: 220). His reflections on the theory of art critically rework the old concepts and where necessary introduce new concepts appropriate to the developmental tendencies of the sphere of culture.

The first section of the essay bears in the first version the title 'technical reproducibility'. The argument departs from the development of techniques of reproduction and moves to the use of these techniques for the production of works of art, specifically film. The techniques of woodcut, print and lithog-raphy are introduced as aspects of a developmental tendency in technical reproduction which break down the spatio-temporal uniqueness of a work of art. Photography is an exemplary case of the acceleration of the 'process of pic-torial reproduction' replacing the 'mechanical reproduction' by means of the hand with a technical reproduction governed by the 'eye looking into a lens' (1939a: 221). The development of technical reproduction had by 1900 caused 'the most profound change in the impact [of works of art] upon the public' by devaluing traditional categories of art while at the same time establishing 'a place of its own among the artistic processes'.

Benjamin's suggestion that innovations in technology could create a new experience of art, both in the reproduction of past and the production of future genres and works, is confirmed by his comparison of the modern with the ancient Greek epoch. In the final version of the essay, the compari-son is merely alluded to in a pair of sentences on ancient Greek techniques of reproduction, namely founding and stamping. These two sentences, however, are taken from a longer and more sustained discussion in section 8 of the first

version entitled 'Eternal Value'. Although deleted from the final version, this section spells out the latter's allusion to a relationship between technique and the experience of spatio-temporal uniqueness. After the two sentences carried over into the final version on the limitations of Greek techniques of reproduction – which meant that only bronzes, terra cottas and coins could be reproduced in quantity[13] – Benjamin continued, in the first version,

> All other works of art were unique and technically not reproducible. *Therefore* they must have been made for eternity. *The Greeks were directed by the state of their technology to produce eternal values in their art.*
>
> (1935b: 446)

The Greek aesthetic criteria of uniqueness and eternal validity compensated for the relatively underdeveloped character of their technology. This no longer held for the modern period which attained not only an unprecedented capacity technically to reproduce works of art, but also with film 'a form, whose artistic character is for the first time thoroughly determined by its reproducibility' (1935b: 446).

The suggestion that the modern period is without precedent in making reproducibility the condition for artistic production is qualified by Benjamin's comments on Greek art. These suggest that the link between artistic production and the technology of reproduction is perennial and that the Greek celebration of the artwork's unique and eternal validity expressed their technical incapacity to reproduce. However, Benjamin acknowledged that there was a political and religious aspect to the ways that the Greeks compensated for the limitations of their technology of reproduction. The Greek emphasis upon uniqueness generated a contemplative, cultic response to the work of art, making it the incarnation of eternal perfection or divinity. The relationship of the Greek work of art to time is contrasted with that of film, which does not strive for eternal perfection but is essentially 'capable of improvement'.

The technique of sculpture requires that a statue be cut from a single stone, while a film is assembled, montage-like, out of a number of takes. For Benjamin, film's 'capacity for improvement is related to its radical refusal of eternal validity' (1935b: 446). When Benjamin returns to the discussion of the use of montage in film in a later section of the essay, he describes the artwork's new relationship to time in terms of the discovery of a 'new law'. The law governing Greek art was the manifestation of the eternal in time, while the law of film is continual movement and transformation.

Already in the first section of the essay Benjamin has inverted the traditional view that the production of an original artwork is succeeded by its reproduction with the claim that the 'production' of a unique work is but a special case of the general reproducibility of works of art. Thus the first reflection begins with the claim that 'man-made articles could always be imitated by men' (1939a: 220) but implies that such imitation should not

necessarily be considered in terms of an original and its replicas. The Greeks privileged the production of the unique 'original' work because of the incapacity of their techniques of reproduction. The technical limitations of Greek culture were inverted, and made into virtues. Uniqueness was invested with an aura of eternal worth, of aesthetic excess rather than technical deficiency. Benjamin does not insist in detail on this radical assessment of Greek culture, but it is implied in his refusal to be bound by the aesthetic concepts bequeathed by the Greeks. If the modern period is no longer subject to the technical limitations of the Greeks, why should it continue to judge its artworks with the compensatory categories of uniqueness, genius and eternal validity? By pointing to a new technological structure of experience, Benjamin provokes the invention of new concepts appropriate to this experience and to the works of art which it has made possible.

The second reflection, entitled 'Authenticity' in the first version, develops some of the themes so far introduced by setting them in a fresh context. Benjamin opens with a wickedly ironic discussion of the relationship between uniqueness and authenticity, apparently conceding that 'Even the most perfect reproduction of a work of art is lacking in one element: its presence in time and space, its unique existence at the place where it happens to be' (1939a: 222). Yet at the limit, the original work of art would be like one of Benjamin's angels which exists but for the instant in which it praises God and passes away. For it is questionable whether the unique work can remain the same during its passage through time and space; its very existence depends on its being reproduced, whether here and now or there and then. The work changes through time, whether in terms of its 'physical condition', ownership, or the use to which it is put. In a footnote Benjamin notes that the 'history' of a unique work such as the Mona Lisa 'encompasses the number and kind of its copies made in the 17th, 18th, and 19th centuries' (1939a: 245). Uniqueness, in other words, demands that the meaning of a work be impervious to change, whether in its own composition or in its environment; in short, it requires that the work be outside of history.

In the second paragraph Benjamin ties the desire for an original, unique work to the need to establish a concept of authenticity. The authentic element of a work is not reproducible, but the loss of the non-reproducible may be offset by the gains of reproduction. Indeed the concept 'authenticity', he suggests in a footnote, is itself of dubious authenticity.[14] It borrows from the Greek elevation of the unique work of art, but is also a by-product of the development of techniques of reproduction. Benjamin observes that 'the intensive penetration of certain (mechanical) processes of reproduction was instrumental in differentiating and grading authenticity' (1939a: 245). Works of art such as a Madonna woodcut were made 'authentic' 'only during the succeeding centuries and perhaps most strikingly during the last one'. It was the development of the technology of reproduction which enabled the category of the authentic to emerge and lend authority to the original work.

The invention of the concept of the 'authentic' exemplifies the way in which technological developments can sustain obsolete concepts and modes of thought, in this case the Greek concept of originality. Against such regressive uses of technology Benjamin proposes that the new possibilities of organising experience released by technical developments be affirmed in new ways. In the case of the technology of reproduction, 'photographic reproduction, with the aid of certain processes, such as enlargement or slow motion, can capture images which escape natural vision' (1939a: 222). Instead of technical developments buttressing obsolete concepts of originality and uniqueness they can act as a spur to the invention of concepts and forms of expression appropriate to the change in the character of experience. In many ways, the development of the technology of reproduction transforms the works themselves, since the work seen under the condition of a photographic close-up cannot remain the same as it was before its micro-dimension was released by technology. This also holds for the dissemination of the work of art. Unless it is absolutely impermeable, unique and out of time, the work will change its character not only according to how but also to where it is received. The cathedral which when photographed 'leaves its locale to be received in the studio of a lover of art' (1939a: 223) is as far from its original as an altarpiece which leaves the church for which it was made for a art gallery.

If the concept of authenticity as the original and permanent aspect of a work of art cannot be sustained in terms of that which cannot be transmitted, perhaps it might attain eternal validity in terms of what is always transmitted regardless of circumstances? Benjamin accordingly redefines authenticity as the 'essence of all that is transmissible from its beginning, ranging from its substantive duration to its testimony to the history that it has experienced' (1939a: 223). Transmissibility is a mode of reproduction, since the tradition of an object both preserves and changes its essence. Authenticity is the record of this process of preservation and transformation, but one which privileges preservation or 'substantive duration' over transformation. The emphasis of the process of technical reproduction is the precise opposite: transformation is preferred to preservation. However, such reproduction for which 'substantive duration ceases to matter' is still a transmission or a tradition of the artwork. Retrospectively it will become a part of the original since the reproducibility of the work of art has become one of its original possibilities, or part of what Benjamin had previously defined as its 'essence'. The view that works of art are always changing with respect to their futures was an axiom of Benjamin's literary criticism from the Hölderlin essay of 1915, and is here carried over into the sphere of contemporary visual art.

Benjamin concluded this section by introducing the term 'aura' to designate what had been eliminated from a work in the epoch of its technical reproducibility: 'what withers in the epoch of technical reproducibility is the aura of the work of art' (1939a: 223). Aura is not a property but rather an effect of a particular mode of transmitting a work of art, one which privileges

its originality and uniqueness. Aura is not the predicate of a work of art but a condition, now surpassed, of its transmission. As a condition it has a cultural significance beyond the sphere of art, indeed aura describes a particular form of experience appropriate to a particular culture and stage of technological development. Benjamin insists that the 'decay of aura' is symptomatic of broader cultural change, stating plainly (but vainly) that: 'This is a symptomatic process whose significance points beyond the realm of art' (1939a: 223). What is at issue here and throughout the remainder of the essay is the nature of the broader processes manifest symptomatically in the decay of aura.

Benjamin first describes the process informing the decay of aura in terms of a local detachment of 'the reproduced object from the domain of tradition', one which is an aspect of a broader 'shattering of tradition which is the obverse of the contemporary crisis and renewal of mankind' (1939a: 223). The crisis is identified in terms of the traumatic impact upon the existing organisation of experience provoked by the technological developments; Benjamin wagers that the character of this general crisis may be traced through its specific impact upon the work of art. The latter, by realising its reproducibility through technology, 'substitutes a plurality of copies for a unique existence', losing its fixed identity and becoming completely permeable 'in permitting the reproduction to meet the beholder or listener in their own particular situation'. Such permeability can be mourned as the destruction of the established identity of art or affirmed as opening the work of art to an immense number of possible uses and identities, increasing its possible futures and thus 'reactivating the object reproduced' (1939a: 223).

Benjamin acknowledges that the technological shattering of tradition manifest symptomatically in the decay of aura is an equivocal phenomenon, engendering ambivalent affects. The crisis engendered by the dissolution of the identity of an object through the permeability of its borders can be an occasion for regression and *ressentiment* or of affirmation and renewal. For this reason, he continues, 'Both processes are intimately connected with the contemporary mass movements' (1939a: 223). Fascism marks the negative, regressive response to the dissolution of uniqueness and the permeability of borders, one which seeks to monumentalise the phantasm of a present and authentic identity and model of experience, while communism, for Benjamin, affirms the flux of identity and the permanent revolution of the organisation of experience.

Benjamin closes this line of argument with some thoughts on the equivocal impact of film on contemporary culture. This impact can be understood negatively as the destructive 'liquidation of the traditional value of the cultural heritage' (1939a: 223) although this would be to simplify the effects of the new medium. Such a diagnosis neglects the speculative character of works of art — the idea that they have wrapped within them possible futures which are invisible to their authors. In the case of film, the emergence of the new medium

does not only liquidate the objects of the cultural heritage but also releases their latent possibilities. It is in this spirit that Benjamin cites Abel Gance's claim that "'Shakespeare, Rembrandt, Beethoven will make films'" (1939a: 224). The point of this citation is not to predict filmic biographies of classic authors, but to show that the filmic potential of classical works, unknown to both their authors and to their reception prior to the invention of film, would in future be realised. The 'original essence' of their work would from now on include the possibility of their becoming films, thus allowing Shakespeare and other classical authors retrospectively to 'make films'. This possibility, unimaginable to the authors of the works, now becomes a part of the environment of their work, and, with permeable borders, part of its identity.

In the third section entitled in the first version 'The Destruction (*Zertrümmerung*) of Aura', Benjamin looks more closely at the general process of the destruction of tradition. He reveals it to be the transformation of the structure of experience, one for which the 'destruction' of aura is but a symptom. He begins with the proposition that the structure of perception responds to changes in the 'mode of being in the world' of human societies:

> Within broad historical epochs the mode of sense perception (*die Art und Weise ihrer Sinneswahrnehmung*) [in the first version *ihre Wahrnehmung*, 'perception'] changes with the overall mode of being in the world (*Daseinsweise*) of the historical collective.
>
> (1939a,224)

Benjamin underlines this claim for the epochal character of perception by adding that 'the manner in which perception is organised, the medium in which it is accomplished' is not only natural, but determined by 'historical circumstances as well'. He cites Riegl and Wickhoff's work in support of the contention that changes in art forms corresponded to changes in perception, but criticises them for restricting their research to describing the formal characteristics of the correspondence. He proposes to go further and investigate 'the social transformations expressed by these changes of perception' (1939a: 224). The decay of aura is taken as an example of this thesis, since 'changes in the medium of contemporary perception' are manifest in the decay of aura, which can thus serve to exemplify the 'social causes' of the change in perception.

Benjamin begins with an unhelpful analogy between the historical and natural concepts of aura, unhelpful because by seeming to naturalise aura he diminishes the force of his claim for its historicity. He then returns to the historical basis of the decay of aura, which is the emergence of a new form of experience 'closely related to the increasing significance of the masses in contemporary life'. This form of experience has two, familiar characteristics: it dissolves the borders of objects by bringing them '"closer" spatially and humanly', and overcomes the 'uniqueness of every reality' (1939a: 225). The

two characteristics effectively disrupt the Kantian forms of intuition – space and time – which underwrote Kant's account of experience. Space is disrupted by the technical reproduction of objects which lose their spatial definition of 'distance' whereas time is disrupted in the dissolution of uniqueness, since 'Uniqueness and permanence are as closely linked . . . as are transitoriness and reproducibility' (1939a: 225). The result is a change in the structure of experience, with implications for both subject and object: 'The adjustment of reality to the masses and of the masses to reality is a process of unlimited scope, as much for thinking as for perception' (1939a: 225). The potential for infinite transformation opened by a technologically informed experience can either be affirmed, leading to constant innovation in the subject and in reality, or refused in the regressive use of technology to restore distance, uniqueness and permanence – i.e. monumentality.

The following reflection, 'Ritual and Politics' in the first version, begins with the thought that uniqueness is a property of the environment of an object, in this case its 'being imbedded in the fabric of tradition' (1939a: 225). Uniqueness is lent the object by a 'thoroughly alive and extremely changeable' tradition. While the significance of an object changes with tradition, its uniqueness is preserved: a statue of Venus was for the Greek 'an object of veneration' and for the middle ages an 'ominous idol'; both epochs, however, preserve its 'uniqueness'. The theme of the embedded character of uniqueness is further developed with the claim that 'Originally the contextual integration of art in tradition found its expression in the cult' (1939a: 225). This is followed by the further, extremely consequential proposition locating the origin of the work of art 'in the service of a ritual – first the magical, then the religious kind'. Aura is inseparable from ritual, and is preserved in it; ritual, as Benjamin later defines the term, is a form of technology, a means of organising and controlling the environment. The ritual origin of art is preserved, until the decline and crisis of ritual in the modern period whose implications are 'sensed' in the work of art, and whose crisis 'has become evident a century later' (1939a: 226). Benjamin defines 'Art for Art's sake' as an attempt to preserve the uniqueness of the work of art after its social and technical conditions have disappeared.

From the claim that the decline of ritual coincides with the decay of aura Benjamin sketches some of the consequences of the insight that 'for the first time in world history, mechanical reproduction emancipates the work of art from its parasitical dependence upon ritual' (1939a: 226). The emancipation of art from ritual is followed by the decay of the aura and authenticity of the work of art. For Benjamin this process leads to the reversal of the 'total function of art' since 'Instead of being based on ritual, it begins to be based on another practice – politics' (1939a: 226). Unfortunately Benjamin's rhetoric cannot conceal a number of significant lacunae in his argument. At first glance the links between art and ritual and between ritual and tradition are not perspicuous. And while the theoretical breaks can be concealed by appealing

to a cultural decline in the significance of ritual and tradition which is expressed in terms of the decay of aura in art, this is not a satisfactory argument. Benjamin pulls together the argumentative threads of the destruction of tradition and the decay of aura theses in a more satisfactory way in the following reflection entitled in the first version 'Cult Value and Exhibition Value'. In this he focuses on the precise character of the relationship between ritual, tradition, technology and the work of art.

Benjamin polarises the reception and validation of works of art in terms of their cult value and exhibition value. In the former, 'what mattered was their existence, not their being on view', (1939a: 227) a 'cult value' exemplified by the prehistoric cave painting which, as an 'instrument of magic', was meant to be seen only by the spirits it would control and propitiate. The unique identity of the work of art issued from its function as an instrument of magic, its setting within the liturgically determined architecture of a temple or cathedral rather than from its being placed before the gaze of a public. Benjamin then claims that the polarity of cult and exhibition value characterises an epoch of transition. In the prehistoric era 'the situation of the work of art' was characterised by an 'absolute emphasis on its cult value; it was, first and foremost, an instrument of magic' without any exhibition value (1939a: 227). In the modern period, by contrast, there takes place a 'qualitative transformation' of the polarity towards an exclusive emphasis upon exhibition. The 'absolute emphasis' now lies on its exhibition value; the work of art has lost its value as an instrument of magic. Aura now appears as a residue of art's function as an instrument of magic, one which is increasingly replaced by 'entirely new functions'.

However suggestive Benjamin's argument, there remains an ellipsis in the account of the transition from magic to politics. The gap in the argument is filled by an extended passage on magic deleted in the final version, but which immediately follows the discussion of the work of art as an instrument of magic in the first. In this passage, magic is described as an early stage of technology. Underlying the distinction between the cult and exhibition value is an argument concerning the social place and character of technology. Magic is appropriate to the 'demands of a society whose technology only exists totally fused with ritual'. In this society art is a form of technology fused with ritual; it is quite distinct from modern societies in which technology is freed from ritual, becoming a 'second nature' itself requiring control. The subordination of technology to magic and ritual in ancient society

> presents the opposite pole to contemporary society, whose technology could not be more emancipated. This emancipated technology stands opposed to contemporary society as a second nature, and indeed, as economic crises and wars show, it is a nature no less elemental than that of ancient society.

> (1935b: 444)

Just as art served in ancient society as a technological means of mastering the elemental forces of nature, it can serve in modern societies to master the elemental forces of a technological second nature. It provides a technologically informed place for education and reflection within the epoch of technology. Benjamin continues:

> Against this second nature, which humanity has realised it no longer controls, is directed on a course of lessons like those with respect to first nature. And once again art presents itself in its service.
>
> (1935b: 444)

Art's vocation to educate is exemplified for Benjamin by film, which adapts the human body to survival in a technologically informed second nature:

> Film serves to train humans in those new apperceptions and reactions conditioned by their interaction with an apparatus whose role in their lives increases daily. To make the human [enervation] to the monstrous technological apparatus of our time is the historical vocation in which film has its true meaning.
>
> (1935b: 444–5)

Thus art serves to adapt humans to nature and nature to humans. Originally it did so by means of technology allied to ritual – magic – and directed against nature; now it does so by means of technology allied to politics – 'a creation with entirely new functions' – directed against technology as a second nature.

Benjamin takes photography and film as examples of the 'new functions' of art in the epoch of technology. Here he has to show how technology, allied to politics, can be used to master technology. Technological reproduction is affirmed by art as a means of bringing together the human and technology in the creative 'renewal' of humanity announced in *One Way Street* as the 'creation of a new *physis*' or technologically informed body and corporeally informed technology. Art in this sense serves as a site in which to explore possible futures of the relationship between technology and the human which will create unprecedented experiences of space and time, which will bring with them the dissolution of previously valid experiences of identity . . . and of politics. These experiences are for Benjamin intimated in the new, wholly technological art forms of photography and, above all, film.

The beginnings of photography in portraiture mark for Benjamin a transition from cult to exhibition value. The photographic portrait of 'loved ones, absent or dead, offers a last refuge for the cult value of the picture' (1939a: 228). Early portraits are, as a consequence, auratic, a property which is dissolved as photography moves from evoking remembrance to bearing witness. The exhibition value of photography in providing evidence of historical events 'challenges' viewers 'in a new way'. The development of a

non-auratic photography, exemplified here as in *A Small History of Photography* by the work of Atget, produces meaning not out of the 'contextual integration in tradition' but from the juxtaposition of image and caption in the case of photography, and image and surrounding images in film. The meaning of a discrete image is porous, dependent upon its contrast with other spatially or temporally distinct images or texts. The viewer is challenged to contribute to the creation of meaning, whether confronted by images juxtaposed by captions – allegory – or by film 'where the meaning of each single picture appears to be prescribed by the sequence of all preceding ones' (1939a: 228).

The reflection upon photography is followed in the first version by the contrast of Greek and modern artistic technologies already discussed. Keeping this discussion in view, however, makes more sense of the following reflection on the dispute over 'Photography and Film as Art'. Benjamin's low opinion of the nineteenth century dispute which rumbled on into twentieth-century aesthetics was consistent with his view that the concept of art being defended was the product of an obsolete stage of technical development. The epoch of technology, manifest in the domain of art as the technology of reproduction, marked 'a historical transformation the universal impact of which was not realised by either of the rivals [painting or photography]' (1939a: 228). Instead of realising that photography marked a new beginning which rendered obsolete previous categories of art and aesthetics, photography and film were defended on the terrain of 'art'. The defensive strategy employed in the defence of the new artistic technologies avoided the 'basic question' of 'whether the very invention of photography had not transformed the very nature of art' (1939a: 229). The avoidance of the question limited the potential of the medium to transform the category of art, and consequently adapted it to an obsolete, ritual conception of art.

In the wake of this critique, Benjamin proposes a defence of film according to a concept of art informed by the new values of 'exhibition' as opposed to obsolete 'cult values'. In the new medium, technical reproduction is succeeded by the technical production of reality through the use of multiple camera angles, close-ups and takes. The camera tests the subject matter by exposing it to examination and offering it to an audience for judgement. As opposed to the auratic representations of human beings in early photographs, the film, Benjamin continues in reflection IX, requires from the actor that 'they operate with their whole living person, yet foregoing its aura' (1939a: 231). The representation is never complete since the portrayal is composed of a number of partial perspectives assembled on the cutting desk. Yet Benjamin notes that the assemblage of perspectival tests that constitutes character in film agrees with modern constructions of identity according to the 'extraordinary expansion of the field of the testable brought about for the individual through economic conditions' (1939a: 248). The audience are accordingly 'experts' in the ways by which identity is constructed out of fragments.

The argument now moves from the change in the concept of performance

brought about by film – from the representation to the testing of a character – to the composition of an 'expert' audience. At the point where Benjamin seems to suggest that film has created a mode of presentation based upon exhibition value and an audience familiar with its conventions, he turns the argument round to point to another possible response to the 'withering away of the aura' of the performer. This response involves the re-creation of an 'artificial aura' through the cult of the movie star, a development paralleled by the emergence of technically sophisticated dictatorships in the political sphere. In a footnote Benjamin notes that the 'change in the method of exhibition caused by mechanical reproduction applies to politics as well. The present crisis of the bourgeois democracies constitutes a crisis of the conditions which determine the public presentation of rulers' (1939a: 249). To continue the analogy, representative politics possessed auratic traits such as the unique presence of representative before a public of other representatives (Parliament). With the new techniques of technical reproduction, construction takes the place of representation, with the consequence that 'the presentation of the man of politics before camera and recording equipment becomes paramount' (1939a: 249). The relationship between politics and technology is, once again, characteristically ambiguous, tending in two directions: it may result either in the intensification of democracy or in the use of the new technology for auratic ends, effectively subordinating politics to ritual. In the first case the distinction between author/politician and public 'becomes merely functional; it may vary from case to case'. As 'experts' the public are adept in judging the presentation of politicians and their proposals, but more radically, may use technology to achieve unprecedentedly democratic forms of self-representation. However, another possibility is the denial of the public's 'claim to be filmed' and instead of the new technology serving to facilitate the movement between political proposition and judgement, a quite different movement is effected which 'results in a new selection, a selection before the equipment from which the star and the dictator emerge victorious' (1939a: 249).

In the next section (XI), entitled 'Painter and Cameraman' in the first version, Benjamin moves from contrasting film with theatre to examine the relationship between film and painting. He begins by reflecting on the irony that 'the equipment-free aspect of reality . . . has become the height of artifice; the sight of immediate reality has become an orchid in the land of technology' (1935b: 235). Naturalism in film is the height of artifice, the result of carefully mounting a shot in the studio and later editing it in the cutting room. In both the take and the cut sophisticated techniques are employed in order to dissemble the presence of technique, with the result, in Benjamin's words, that 'in the studio the technical equipment has penetrated so deeply into reality that its pure aspect free from the foreign substance of equipment is the result of a special procedure' (1939a: 235). In a characteristic inversion, the representation of reality free of technology is the paradoxical apotheosis of technology, requiring a sophisticated technique capable of completely dissembling itself.

The permeation of reality by technology in the film studio is for Benjamin symptomatic of the change in the structure of experience taking place in the modern *physis* or social and natural body. He develops this point through a comparison between the painter and the cameraman, following an analogy between them and the magician and the surgeon. The definition of magic and its close relationship to ritual introduced in section VI of the first version is used to intensify the distinction between auratic and potentially non-auratic art. Benjamin there regarded magic as an early form of ritual technology for the organisation and control of nature. The magician/painter Benjamin explains is the 'polar opposite' of the surgeon/cameraman, just as the society which fused technology and ritual into magic was the polar opposite of modern technological societies:

> The magician heals a sick person by a laying on of hands; the surgeon cuts into the patient's body. The magician maintains the natural distance between the patient and himself; though he reduces it very slightly by the laying on of hands, he greatly increases it by virtue of his authority. The surgeon does exactly the reverse; he greatly diminishes the distance between himself and the patient by penetrating into the patient's body, and increases it but little by the caution with which his hand moves among the organs.
>
> (1939a: 235)

The theme of the viscera recalls Benjamin's description in *On the Mimetic Faculty* of a 'reading before all languages, from the entrails, the stars or dances' (1933b: 162) which follows the laws of 'mimetic production and comprehension' characteristic of magic. Reading and healing are both ancient forms of ritual technology which produce and recognise similarities on the basis of 'the magical correspondences and analogies that were familiar to ancient peoples' and which 'in the observable world of modern humanity' is in the process of 'decay' or 'transformation' (1933b: 161). The technology of the modern surgeon, like that of the cameraman, is not dedicated to producing or recognising resemblances from the interpretation of surface similarities, but to cutting into and shaping realities. In the case of magic and the magician the production of effects or 'healing' followed the diagnostic recognition of similarities, while in the case of technology and the surgeon, effects are produced by the intervention and only subsequently recognised.

Benjamin modulates the distinction of magician and surgeon into a comparison of two exemplary practitioners of auratic and non-auratic art – the painter and the cameraman. While the painter 'maintains in his work a natural distance from reality' thus preserving its aura, the cameraman 'penetrates deeply into its web' (1939a: 235). To develop the analogy further, the painter reads surfaces while the cameraman produces effects by testing and cutting into the surface; the use of auratic and non-auratic processes resulting in 'a

110

tremendous difference between the pictures they obtain' (1939a: 236). For the painter, the law of composition informing the spatio-temporal relations of the surface of representation is already given and is in a sense 'read off' from reality; consequently, for Benjamin, the picture obtained 'is a total one'. By contrast, the law of composition informing the tests of the cameraman is not given prior to the intervention, but has to be produced, and the resulting image 'consists of multiple fragments which are assembled under a new law' (1939a: 236). The invention of a 'new law' by means of the montage of test results is precisely the task facing the epoch of technology, and it is for this reason that

> for contemporary humanity the representation of reality by the film is incomparably more significant than that of the painter, since it offers, precisely because of the thoroughgoing permeation of reality with technological equipment, an aspect of reality which is free of all equipment.
>
> (1939a: 236)

The space for the invention of a new law capable of gathering together the fragmented results produced by technical interventions while being free of technology is another manifestation of the immanent absolute theorised in Benjamin's speculative account of experience. It opens a space within the 'second nature' of technology from which, in the words of section VI, humanity can commence its process of adapting itself to, and exceeding, the new technological *physis*. The opening of such a space within the epoch of technology, Benjamin concludes, 'is what one is entitled to ask from a work of art' (1939a: 236).

The comparison between film and painting is extended in section XII, but this time from the point of view of the audience. The audience can adopt either a 'critical' or a 'receptive' attitude towards a work of art, largely dependent upon the way in which the art form is presented to them. Painting, for example, 'simply is in no position to present an object for simultaneous collective experience', for in spite of its history of public display in galleries from the nineteenth century, 'there was no way for the masses to control themselves in their reception' (1939a: 236–7). In film, on the other hand, the collective experience of the 'expert audience' contained the possibility of a fusion of enjoyment and criticism. At this point, Benjamin suggests that film should aspire to the 'simultaneous collective experience' of architecture whose 'audience' both enjoys and criticises. Architecture is lived and critically adapted by its 'audience' or users, providing the model of a critical reception which produces the 'direct, intimate fusion of visual and emotional enjoyment with the orientation of the expert' (1939a: 236). In this context Benjamin introduces the claim that however radical the form and content of painting it remains an obsolete art, a claim vigorously rebutted by Adorno in his defence of avant-garde art.

The following reflection (XIII) develops the argument that film is more likely to provoke a 'progressive' response in the audience than is avant-garde painting. This claim is supported by an analysis of the extension of bounds of experience made possible by film technology, and in particular in its revelation of an 'optical unconscious'. The argument is presented with interesting differences of emphasis in the first and final versions. The first version, entitled 'Micky Mouse' opens with the proposition that 'One of the most important social functions of film is to re-invent the equilibrium between humanity and the [technical] apparatus' (1935b: 460). In the first version the reflection analyses the conditions of equilibrium and disequilibrium between technology and humanity in terms of the 'optical unconscious', elaborating the latter concept in the final version with the help of a reference to psychoanalysis, specifically Freud's *Psychopathology of Everyday Life*. In both versions Benjamin describes the extension of the 'optical unconscious' as both an effect of technology and as a factor in expanding the limits of experience. In a passage common to both versions Benjamin claims that the film camera

> extends our comprehension of the necessities which rule our lives . . . [and] manages to assure us of an immense and unexpected field of action. Our taverns and our metropolitan streets, our offices and furnished rooms, our railroad stations and our factories appeared to have locked us up hopelessly. Then came the film and burst this prison world asunder by the dynamite of the tenth of a second, so that now, in the midst of its far flung ruins and debris, we calmly and adventurously go travelling. With the close-up, space expands; with slow motion movement is extended. The enlargement of a snapshot does not simply render more precise what in any case was visible, though unclear: it reveals entirely new structural formations of the subject.
>
> (1939a: 238)

The technology of the camera allows the 'new' inconspicuously folded into the everyday life of modern technological societies to be brought to view and activated. Space and time – the intuitive conditions of experience in Kant's account – are themselves destroyed, opening the space for new possibilities of experience. The camera, in other words, performs the same critical explosion of experience which Benjamin ventured in his criticism of literary texts: it reveals the absolute which is immanent to experience but which manifests itself in inconspicuous and indirect ways.

In the final version the account of the optical unconscious is broadly positive; Benjamin affirms the extension of experience and the possibility of consciously mastering the technological second nature that it brings with it. The technological destruction of experience raises the prospect of a 'different nature' in which 'an unconsciously penetrated space is replaced by a space

consciously explored by humanity' (1939a: 238). By contrast, the first version focuses more on the difficult necessity of achieving equilibrium between humanity and technology, and points to the possibility, indeed likelihood, of a disequilibrium between them. In the latter case, the destruction of existing patterns of experience, the demolition of measures of space and time, provokes a crisis whose outcome is more likely to be catastrophic than transformative. Benjamin sees film as a staging of the psychosis of the optical unconscious provoked by technology, but one which can serve as an 'inoculation' against its effects. The reality revealed by technology is to a great extent 'beyond the *normal* spectrum of perception' and its representation in film shows the same disregard for the rules of logic as the Freudian unconscious.

Benjamin makes the further claim that the optical unconscious not only pursues a logic peculiar to itself, but also that this logic is potentially psychotic:

> Many of the deformations and stereotypes, the transformations and catastrophes that the world can find in the visual perception in films can also be found in psychoses, hallucinations and dreams. And in this way the procedures and techniques of the camera have claimed for the collective perception of the public the individual perceptions of the psychotic or dreamer.
>
> (1935b: 462)

Yet in becoming public property, the logic of the dream or psychosis is changed, and becomes a means for the cathartic discharge of the energies produced by a technological civilisation. Benjamin regards 'American grotesque films and the films of Disney as producing a therapeutic explosion of the unconscious' (1935b: 462). Art in general, and film in particular, is now understood in terms of an economy of drives which need to be channelled or discharged, for

> When one considers what dangerous tensions have been created in the masses by technological development and its consequences – tensions that in their critical stages adopt a psychotic character – one soon realises that this same technical development has created the possibility of a psychical inoculation against such mass psychoses through certain films, in which the forced development of sadistic fantasies or masochistic delusions hinder their natural and dangerous emergence in the masses. Collective laughter presents the timely and healing escape from such mass psychoses.
>
> (1935b: 462)

The potential of film to provide a cathartic release from the tensions generated by technology through collective laughter contrasts with its auratic use as a spectacle for generating rather than discharging energy in its audience. With

this theory Benjamin provides a third perspective on the nature of the 'work of art' in the epoch of technology. The first regarded the work as a site for experimentation and the invention of new modes of experience while the second saw it as an occasion for tactile critical enjoyment by analogy with architecture; to these is now added the view that the work of art is a form of cathartic inoculation against the psychotic development of the energies generated by technology. In the remaining reflections of *The Work of Art in the Epoch of its Technical Reproducibility* Benjamin draws out the relationship between the three definitions of the work of art and relates them to the conflict between the two 'contemporary mass movements' of fascism and communism.

In section XIV – 'Dadaism' in the first version – Benjamin presents Dada as the attempt 'to produce by means of painting (and relatedly literature) the effect that the public now seeks in film' (1935b: 463). Benjamin prized Dada for its openness to the future in providing a site for invention which anticipated film through its 'creation of a demand which could be fully satisfied only later'. Benjamin identified in the self-conscious destructive barbarism of Dada a staging of the imminent obsolescence of art before technology, which, he observed parenthetically in a footnote, paradoxically 'works towards a certain form of art' (1939a: 251). The artists associated with Dada strove to redefine the limits of the work of art in the epoch of technology through 'the relentless destruction of the aura of their creations' while remaining within the compass of the traditional definition of art. The effect of their work went beyond the visual to the tactile: 'It hit the spectator like a bullet, it happened to them, thus acquiring a tactile quality' (1939a: 240). Yet for Benjamin this shock, while anticipating the effect of film, did not share its cathartic potential. This is because Dada, like cubism and futurism, remained within the 'wrappers' or confines of art. All of these 'art' movements were judged by Benjamin to be the 'deficient attempts of art to accommodate the pervasion of reality by the [technical] apparatus' (1939a: 253). They were deficient in his judgement because, unlike film and before it photography, 'these schools did not try to use the apparatus as such for the artistic presentation of reality' but tried instead to represent, within art, the effects of the transformation of experience by technology, namely 'shock' in the case of Dada, the transformation of space in cubism and 'speed' in futurism.

In the penultimate reflection (XV) – 'Tactile and Optical Reception' in the first version – Benjamin describes the task of art in the epoch of technology as relocating itself with respect to the new conditions of experience. The model for the future art of the technological epoch is architecture, the art which responds most readily to changes in the structure of experience. The architectural setting of the experience of technology had already been established in a footnote to reflection XIV, where Benjamin presented film as the 'art form that is in keeping with the increased threat to life which modern humanity has to face'; it is through film that humanity can 'expose itself to shock effects' and

to learn to 'adjust to the dangers threatening it' (1939a: 252). Yet this aspect of film had already been anticipated by architecture, whose form cannot easily be separated from technique and which is for this reason close to the structure of technological experience. Indeed, Benjamin goes as far as to say that film merely 'corresponds to profound changes in the apperceptive apparatus' which are structured by the architecture of the city, or 'changes that are experienced on an individual scale by a person in the street in big city traffic, and on a historical scale by every present day citizen' (1939a: 252). Yet the experience of film remains optical, and even though its cathartic effect is tactile it lacks the overwhelmingly tactile character of architecture. On the basis of modern experience the mass audience does not contemplate or enter into but rather 'absorbs the work of art' (1939a: 241). The absorption of the work can take place either through an 'inoculation' as in the case of film, or, through 'tactile appropriation' in the case of architecture (1939a: 242).

Benjamin regards architecture as the perennial art, the one which is in many respects the most porous and sensitive to change from outside, whether in technology or in its 'relationship to the masses'. He reads a litany of 'art forms [which] have developed and perished' – 'tragedy', 'epic', 'panel painting' while architecture adapted and survived. The key to its survival lies not only in its porosity, but also (and relatedly) in the 'canonical value' of its 'mode of appropriation' (1939a: 242). This is both 'tactile' and 'optical' based in 'use and perception'. Against the attentive, conscious contemplation of the viewer of paintings Benjamin poses the distracted, habitual use of architecture. By 'distracted' he does not mean a lack of attention, but rather a different, more flexible mode of perception. This form of perception is a response to the effects of the technological transformation of the space and time of experience:

> For the tasks which face the human apparatus of perception at the turning points of history cannot be solved by optical means, that is, by contemplation, alone. They are mastered gradually by habit, under the guidance of tactile appropriation.
>
> (1939a: 242)

These habits are, furthermore, developed and practised collectively; tactile appropriation proceeds by collective testing and communication of results. This context of tactile appropriation proper to architecture, which is constantly being transformed by use, its boundaries renegotiated by changes in habits, is the basis of the potential impact of film, the sole visual art which 'with its shock effect meets this [tactile] mode of appropriation halfway' (1939a: 242). Film is thus an anomalous, transitional medium, one poised between tactile and optical forms of perception and which thus possesses immense potential either for negotiating between the two forms of perception, or for subordinating one to the other.

115

Architecture provides the main site for the interaction of technology and the human, a negotiation conducted in terms of touch and use. It is both a condition and an object of experience, the speculative site for the emergence of the 'technological *physis*'. However, the speculative status of architecture for Benjamin is not defined in terms of transcendence, but in terms of porosity and flexibility. As the locus of modern experience, architecture both establishes the parameters of perception in space and time while being itself subject to constant transformation. For this reason Benjamin ends his essay *The Work of Art in the Epoch of its Technical Reproducibility* by identifying architecture as the 'concrete a priori' or canonical art form. But this conclusion is not surprising given the amount of attention Benjamin had already devoted to architecture and the city at all stages of his authorship. Indeed, the names Berlin, Naples, Moscow and Paris signified for him new forms of possible experience, cast ambivalently as both promise and threat. But before turning to the experience of the city it is necessary to close the commentary on *The Work of Art in the Epoch of its Technical Reproducibility* by considering its Epilogue, entitled in the first version 'The Aesthetics of War'.

Throughout the essay Benjamin presented the possibility of changes in the character of experience leading either to transformation or catastrophe. Transformation for Benjamin, we have seen, is always associated with permeable boundaries open to influence from outside and thus in a state of constant change. This is especially important in the modern epoch given the tremendous energy released by technology; if this energy is contained within fixed borders, then it will become destructive. It will not only destroy the limits of experience, which for Benjamin is a condition of their transformation, but also the very conditions of experience themselves. In the Epilogue Benjamin returns to the 'contemporary mass movements' which have emerged in response to the epoch of technology. One movement is dedicated to transforming all existing structures and identities, while the other attempts to fix the same by investing them with 'ritual values' and aura.

The Epilogue begins by evoking the process which manifests itself in the 'proletarianisation of modern man and the increasing formation of the masses' (1939a: 243). These are identified as effects of the development of productive forces, a dynamic movement which increasingly assumes its own momentum through technology. If the social structure is not adapted to the development of productive forces, then the discrepancy between the energy released and the structures available for its expenditure will tend towards a destructive solution. Benjamin sees this 'solution' expressed in two forms, both of which introduce 'aesthetics into political life'. The first is the 'violation of the masses, whom Fascism, with its *Führer* cult, forces to their knees' and in which society itself becomes a mass auratic artwork that contemplates its self-destructive mobilisation for war: 'War and only war can set a goal for mass movements on the largest scale while respecting the traditional property system'. The second is 'the violation of a [technological] apparatus

which is pressed into the production of ritual values' in the destructive expenditure of war, which again is 'the only way to mobilise all of today's technical resources while maintaining the property system' (1939a: 243). Benjamin brings the two violations together in the claim that

> If the natural utilisation of productive forces is impeded by the property system, the increase in technical devices, in speed, and in the sources of energy will press for an unnatural utilisation, and this is found in war. The destructiveness of war furnishes proof that society has not been mature enough to incorporate technology as its organ, that technology has not been sufficiently developed to cope with the elemental forces of society.
>
> (1939a: 244)

The conditions for a balance between technology and social organisation have yet to be discovered, although as Benjamin hints in this passage, this will require a mutual adaptation of technology and social organisation to which no structure or law will be excepted.

Art can provide a point of experimentation for future adaptation of humanity and technology, a service intimated in the developmental tendencies of film which provide a cathartic discharge for the tensions produced by the development of productive forces. However, another conceivable future is that of warfare which is also able 'to supply the artistic gratification of a sense perception that has been changed by technology' (1939a: 244). The change in sense perception and the character of experience is ineluctable, as is also the decision on how to respond to this change. One response is the passive nihilist appeal to aura in establishing a new aesthetic distance within which the change in experience can be dangerously maintained and denied within existing structures. The other is the active nihilist response of revolutionising all structures and redirecting the energies released by war into constructive channels: the necessity for choosing between passive and active nihilism 'is the situation of politics which Fascism is rendering aesthetic. Communism responds by politicising art' (1939a: 244).

Benjamin's understanding of politics and technology as ways of organising experience made them the focus for his critique of modern experience during the late 1920s and 1930s. He gathered the two themes together around the study of urban experience, regarding the city and its architecture as the place where technology and politics meet to produce modern experience. Benjamin's analysis of the experience of the city was characteristically double-edged, regarding it as both home and alienated visual spectacle. His studies of urban experience, beginning with Naples and moving through Moscow and Berlin to Paris, were implied in his work on the philosophy of experience, literary and art criticism, but also developed it further, producing a new form of philosophy which united epistemological reflection, history and criticism.

4

THE EXPERIENCE OF THE CITY

For two hours I walked the streets in solitude. Never again have I seen
them so. From every gate a flame darted; each cornerstone sprayed
sparks, and every tram came toward me like a fire engine.

Walter Benjamin, *One Way Street* (1928b)

Speculative cities

The range of Benjamin's writings on urban experience spans the series of
short city portraits – *Naples* (1924), *Moscow* (1927), *Weimar* (1928), *Marseilles*
and *San Gimignano* (1929) – and the remains of the massive study of Paris
known under its working title of the *Arcades Project* [*Passagenwerk*]. In
between, and tangentially part of the same genre, is the modernist evocation
of the experience of Berlin and Paris in *One Way Street* and the 'autobio-
graphical' narrations of a child's experience of Berlin in *A Berlin Chronicle* and
A Berlin Childhood around 1900. Although identifiable by their focus, the city
writings should not be read as a discrete and identifiably separate part of
Benjamin's authorship but as a development and intensification of the specu-
lative concept of experience informing his philosophical, critical and aesthetic
writings. As the locus of modern experience, the city is central to Benjamin's
reflections on contemporary culture and his writings on urban experience
traverse, and are traversed by his broader philosophical and aesthetic analyses
of experience.

Benjamin oriented his cities geographically and temporally around his home
city of Berlin. The experience of Naples highlights what is inconspicuously
peculiar about the cities of Northern Europe, while that of snow-bound
Moscow lends insight into central European Berlin: 'More quickly than
Moscow itself, one gets to know Berlin through Moscow' (1927b: 167). The
character of Berlin is recognisable not only through the mirror of the experience
of Moscow, but also of Paris, and vice versa: *One Way Street* stages an encounter
of Paris and Berlin which exposes the elements of experience common and
peculiar to the two cities. The reflexive knowledge of a city through the expe-
rience of other cities is not only geographical but also chronological. Moscow,
for example, as the capital of the socialist revolutionary movement indicated a
possible (not terribly attractive) future for urban experience which served to
illuminate the present experience of capitalist and pre-capitalist cities.

Benjamin's city writings exemplify his speculative method: the city in question, whether Naples, Moscow, Berlin or Paris can only become an object of knowledge indirectly, obliquely reflected through the experience of other cities, each of which is its own infinite surface. From within the experience of a given urban environment, as within the experience of a particular language, it is difficult to see what is peculiar, what is unsaid, what is excluded without the shifting points of vantage offered by other cities or languages. And these cities need not necessarily exist, but may be imaginary, as in the science fiction of Paul Scheerbart, or the nostalgically imagined Paris of Baudelaire, the Vienna of Karl Kraus or the Prague of Kafka. Benjamin would certainly have appreciated Italo Calvino's attempt to understand Venice through the imagination and narration of other, unreal cities in *Imagined Cities*. Once again, this reflexive experience of the city is not only geographical, but also temporal. The memories of a Berlin childhood of around 1900 frame the adult's experience of Berlin and Paris, while the study of the cultural history of nineteenth-century Paris is both made possible by the experience of the Paris of the 1930s while providing a number of counterfactual perspectives within which to understand contemporary experience.

The understanding of urban experience through the use of spatio-temporal contrasts and counterfactuals is not only an epistemological device for gaining knowledge of urban experience, but itself a feature of modern urban experience. The experience of a city is shot through with allusions to other cities,[1] in street names, buildings, and spatial typologies, but more obviously in the pasts that are embodied in a city. The experience of a city is made up of a constant negotiation with the ghosts and residues of previous experiences, most notably in Paris, with the ghosts of insurrection and revolution, but also in Berlin which for Benjamin was above all a city of ghosts. For Benjamin, the field of such negotiation is not exhausted by actual past experiences of the city, but also of those experiences which did not ever happen. The experience of the city includes the lost chances and the missed encounters – such as the 'love at last sight' of Baudelaire's *A une passante*. The forfeiture of an experience itself leave traces which persist and shape the experience of the present. The surrealists were the masters of the experience of the city that might have been, but not for us. Finally Benjamin insists that the experience of the city is ecstatic and futural, haunted by intimations of the future, whether as the city ecstatically fusing into an epic unity of its past, present and future citizens as in the Paris of Victor Hugo, or in the melancholy of the allegorical city which lives on without us, in repetitive change, as in the Paris of Baudelaire's anti-epic poetry.

More than exemplifying the speculative method of setting a particular surface (such as the experience of Paris in 1928) within a set of possible surfaces defined spatially and temporally (the experience of other cities or the same city at other times), Benjamin's writings on the experience of the city disturb the philosophical articulation of the concept of experience. Benjamin's speculative

understanding of urban experience depends upon his extended philosophical concept of experience, while at the same time challenging its limits. This is evident in the emergence of the same philosophical concept of experience from the destruction of tradition and the emergence of new forms of urban modernity. The experience of space and time bequeathed by tradition no longer held for the new urban environment, which made unprecedented demands not only upon philosophical but also upon literary and visual forms of reflection. Modern urban experience provoked not only the demand for a 'coming philosophy' but also for 'modernism' in literature and art. In its turn, such philosophical, literary and visual modernism did not simply refract, but also gave shape and direction to this experience.

Philosophy in the cities

The 'recasting' of Kant's concept of experience anticipated in *On the Programme of the Coming Philosophy* opened the vista of a philosophising beyond philosophy. The new concept of experience required a new transcendental logic or doctrine of the categories – Benjamin's 'theory of orders' – which in turn entailed a renegotiation of the concept of freedom. An essential feature of the new concept of experience was its speculative character, its sensitivity to the indirect manifestations of the absolute in space and time. One tendency evident in Benjamin's early work was the projection of the absolute out of time and space – whether as 'Platonic idea' or as 'divine violence' – while another, which prevailed throughout Benjamin's work of the 1920s and 1930s, traced the complex, often digressive and tortuous routes by which the absolute manifested itself in concrete experience. A key factor contributing to Benjamin's later philosophy of experience was his work on the experience of the city, which became for him a prime site for the new philosophising beyond philosophy.

Benjamin's writings on the experience of the city weave together a number of discrete threads of argument. On the one hand the experience of the city evokes a categorical framework or 'theory of orders' which stresses movement and complexity. Instead of establishing a doctrine of categories on the basis of substance or the subject in the way of the philosophical tradition, the experience of the city replaces substance and subject with *transitivity*. In place of a Kantian transcendental deduction of the categories of quantity, quality, relation and modality from the pure unity of the apperceptive I, Benjamin derived such categories of modern experience as 'porosity', 'threshold' and 'shock' from the impure dispersal of anonymous transitivity. The experience of the modern city thus not only transformed the basic orientation of the categories, moving from fixed states to transitivity, but also fundamentally challenged the character of the doctrine of categories itself. Instead of being conceived as a finite number of forms which anticipate and govern the shape of experience, the categories are now seen as intricately woven into the weft of everyday life.

This change had considerable implications not only for the understanding of the speculative character of experience, but also for its philosophical presentation in a 'theory of orders'. The emphasis upon transitive categories not only made the elements of experience temporal and concrete, but also transformed philosophy into speculative cultural history.

Although the concrete categories of urban experience are potentially infinite, they are not simply the empirical data of historical events. As speculative categories they contain excessive moments which, whether oriented to the future or the past, whether directly or indirectly, mark the involvement of the absolute within experience. The philosophical presentation of this involvement of the absolute – the immanent totality discussed in Chapter 1 – could only be achieved in terms of an immanent critique which discerned its presence within concrete, historically specific experience. Philosophical presentation for Benjamin increasingly became a matter of the presentation of such concrete categories, which could not be achieved by philosophical abstraction, but instead required a speculatively informed cultural history. The categories of urban experience could not be abstracted from the concrete historical data in which they were set, but had to be presented in its terms. What is more, this presentation of the speculative experience of the city, with its sensitivity to the interweaving of past, present and future in the concrete fact, also required a sensitivity to the issue of freedom. For the speculative experience was one of an indirect freedom, a freedom of movement or transitivity rather than the positional freedom of a subject or 'I'.

Benjamin's first city portrait, the magnificent essay on Naples signed with Asja Lacis, provides a 'transcendental deduction' of the categories of modern urban experience from the principle of 'transitivity' as opposed to those of the 'subject' or 'substance' informing the philosophical tradition. The basic principle of the essay – that 'everything transitive is joyful' – combines the ontological principle of transitivity with the practical principle of joy (as opposed to 'freedom'). Benjamin discovers the basic categories informing the possible experience of 'Naples' to be temporal transition and spatial porosity. Although strictly speaking they are neither categories nor forms of intuition, transition and porosity indirectly govern the experience of the dissolution of the fixed boundaries of substance and subject into a welter of sudden transitions, interminglings and improvisations. In the description of the city there is no distinction between what is fixed and permanent and (its feared opposite) what is transitory – rather, everything is in a continual process of discontinuous transformation.

The essay begins with a description of one such discontinuous transition: a procession publically reviling a priest suddenly falls to its knees when the priest stands up to bless a passing wedding procession. The disruption of the procession in a sudden theatrical reversal defines the experience which the inhabitants of Naples have of their city, one which Benjamin describes in terms of the categories of transition and porosity. As is the case with all of Benjamin's categories (and here he is very close to Hegel's reflective concepts

of the logic of essence) transition and porosity are linked, and may even be said to describe the same experience of transitivity, but with, respectively, a temporal and a spatial accent. Temporal transition is experienced in terms of transitivity, while spatial transition is experienced in terms of porosity: 'Porosity is the inexhaustible law of life in this city, reappearing everywhere' (1924: 417). The two categories are related in so far as the porosity of the structures of the city is the condition for unexpected transitions, thus undermining any distinction between the space of the city and the temporal activities of its citizens:

> As porous as the stone is the architecture. Building and action inter-penetrate in the courtyards, arcades and stairways. In everything they preserve the scope to become a theatre of new, unforseen constellations. The stamp of the definitive is avoided.
>
> (1924: 416)

The avoidance of the definitive has implications for both the spatial and the temporal experience of the city, with ambiguity being figured in terms of courtyards, stairways and, most significantly, arcades. Spatially the city is described as 'anarchical, embroiled, village-like' while temporally action is conducted under the sign of masquerade and theatre in which 'the festival penetrates each and every working day' ensuring that 'each private attitude or act is permeated by streams of communal life'. Yet this description is far from a nostalgic celebration of a 'traditional' city, since for Benjamin this experience of transitivity is ambiguous: it is not only the condition for the experience of joy, but also for poverty, violence and the criminal association of the *Camorra*.

The spatial form of intuition informing urban experience is provided by the city's architecture, which in the case of Naples is socially and stylistically porous. For Benjamin this is the outcome of

> the passion for improvisation, which demands that space and opportunity be at any price preserved. Buildings are used as a popular stage. They are all divided into innumerable, simultaneously animated theatres. Balcony, courtyard, window gateway, staircase, roof are at the same time stage and boxes.
>
> (1924: 417)

From within this space there is no place from which to gain an inclusive experience of the city, or to represent it, since every box is also a stage, every viewer a viewed. In this understanding of spatial experience (which may be described as 'speculative') every position is in a process of negotiating its relations with other positions; there is no fixed spatial form which governs the location of participants in the way of Haussmann's boulevards in Paris. Transitions between different parts of urban space are not smooth and continuous, but multifarious,

sudden and abrupt, precisely the experience of shock that the violent imposition of Haussmann's boulevards was meant to abolish. The classic forms of spatial routing such as arcades, streets and staircases do not obey the urbanistic laws of smooth and visible transition, but are discontinuous, offering possibilities for sudden passages through undisclosed routes.

In Benjamin and Lacis's essay the building type which exemplifies the discontinuous character of urban experience is the Neapolitan staircase, although it is also in Naples that Benjamin first recognised the significance of the Arcade. Writing of the staircases of the Spanish Quarter, Benjamin and Lacis describe a form of routing that defied the usual expectations: 'The stairs, never entirely exposed, but still less enclosed in the gloomy box of the Nordic house, erupt fragmentarily from the building, make an angular turn, and disappear, only to burst out again' (1924: 417). The experience of such space cannot be contained within the Kantian forms of spatio-temporal intuition, which stress continuity, nor in the categories of quantity, quality, relation and modality. Indeed, the Neapolitan staircase walks all over the *Critique of Pure Reason*, disobeying all the rules which would qualify it to be an object of a possible experience. It does not conform to the quantitative rules for the continuity of appearances: it 'erupts' and 'bursts out' discontinuously into appearance. Nor is it clear, in terms of quality, that the staircase obeys the principle of continuous reality, since there is no evidence to support the assumption that it is the same staircase at different levels. These stairs pose a problem for the categories of relation, since they are neither consistently enclosed nor exposed; and finally, in terms of modality, the concrete a priori staircase steps beyond the modal categories of possibility and impossibility since, although they exist, they are to all appearances impossible. In the final analysis, the experience of climbing the stairs in Naples cannot be captured by the classical table of the categories of experience, but demands description in its own, concrete terms.

Along with its spatial porosity Benjamin and Lacis point to the indeterminate temporality of Neapolitan architecture. The architecture of Naples does not occupy a monumental present since 'one can scarcely discern where building is still in progress and where dilapidation has already set in' (1924: 417). Within this temporally and spatially porous architecture Benjamin and Lacis also discover social porosity, between families, neighbours and strangers, in piazzas, in churches and in cafés. Yet even though this evocation of the continuous festival of Neapolitan life can on occasions seem like a travelogue, it does not underplay the poverty and misery of the inhabitants of the city. The experience of this city is ambiguous, porous, with joy succeeded by sudden misery. The ambiguity is captured in the claim that 'Poverty has brought about a stretching of frontiers that mirrors the most radiant freedom of thought' (1924: 420). This is not a Romantic celebration of poverty in the style of Murrillo, but a recognition that poverty is not only privative, does not only deprive its victims of initiative, but can also provide a spur for innovation,

even if, as Benjamin and Lacis recognise, this innovation can take the form of crime.

The importance of the essay on Naples in Benjamin's *oeuvre* is largely due to way in which it inconspicuously puts into operation, extends and inverts, many of the abstract prescriptions of his philosophy of experience. First of all, it extends the bounds of philosophy by taking the city as an object of philosophical reflection, replacing the customary philosophical topoi of melting wax, unpaid deposits, and brains in vats. It forces philosophy to recognise that the experience of the city perpetually challenges and undermines the categories that are applied to it – even those of porosity and transitivity. In addition, while the authorial voice throughout *Naples* seems detached, it is constantly being qualified, shocked and even silenced by its 'object'. Questions are continually posed by appearances, and the interpretative criteria modified or abandoned in the face of what is observed.

Another aspect of the philosophy of experience evident in *Naples* is the conviction that space and time are not fixed and continuous forms of intuition but are in the process of continual but discontinuous transformation. In 'Naples' spatial and temporal differences are wrapped into each other; they do not form horizons within which objects and events take place, but routes and intersections where things unpredictably appear and disappear. In the formal terms established in Benjamin's philosophy of experience, Naples is a sphere of configuration rather than a surface of inscription – its porosity and continual transformation does not provide a site on which a monumental inscription can be sustained. It is a place where the spatial and temporal limits of experience are in a process of continual transformation, not according to a plan but according to improvisations whose motivation remains inscrutable and whose consequences are unforeseeable.

The comparison between *Naples* and the next city portrait *Moscow* is instructive.[2] The extreme contrast between the summer heat of the southern Catholic and the winter cold of the northern Socialist city barely concealing the traces of Orthodox Christianity does not detract from the similarities which distinguish both cities from Berlin. While Berlin 'is a deserted city' whose 'princely solitude' is born of its wide pavements, the urban spaces of Moscow and Naples are densely populated. 'In Moscow', Benjamin observes, 'there are three or four places where it is possible to make headway without that strategy of shoving and weaving that one learns in the first week' (1927b: 178). And like Naples, the streets of New Economic Policy Moscow are full of small traders:

> Shoe polish and writing materials, handkerchiefs, dolls' sleighs, swings for children, underwear, stuffed birds, clothes-hangers – all this sprawls on the open streets, as if it were not twenty-five degrees below but high Neapolitan summer.
>
> (1927b: 180–1)

Yet, crucially, 'all this goes on silently; calls like those of every trader in the South are unknown' since street trading under the NEP was tolerated but not legal, a form of policing whose fascinating ambiguity Benjamin had already diagnosed in *Critique of Violence*.

The context of deferred repression indicated by the silence of the traders leads to a number of contrasts with the festive urban experience of Naples. The transitivity of urban experience expressed in terms of the spatio-temporal categories of 'porosity' and 'transitivity' in the case of Naples is succeeded in Benjamin's account of Moscow by that of 'mobilisation': 'The country is mobilised day and night, most of all, of course, the party' (1927b: 186). Unlike Neapolitan transitivity, which is an improvised response to the immediate demands of the social and built environment, Soviet mobilisation is imposed from above. The dissolution of private life in Naples by architectural and social porosity is in Moscow imposed upon the city by the party-state.

Benjamin describes the experience of socialist Moscow in terms of the control of personal space and time; he notes that 'Bolshevism has abolished private life. The bureaucracy, political activity, the press are so powerful that no time remains for interests that do not converge with them. Nor any space' (1927b: 187). The intrusion of the state into private life changes the experience of time, which becomes a continuous present of response to the demands of the moment. However, this is not a festive experience of a superabundance in which each moment contains a lifetime, but the inverse: the conditions of mobilisation make 'each hour superabundant, each day exhausting, each life a moment' (1927b: 190). In terms of Nietzsche's *Gay Science* and *Thus Spoke Zarathustra*, the experience of the moment in Moscow is that of the passive nihilism of the dwarf who spoke to Zarathustra of the eternal return. The moment is replete, but experienced as a burden rather than as a joy or liberation.[3]

In the case of Naples, the experience of the city was governed by the temporal ambiguity of its buildings, poised between construction and ruin. In Moscow, temporal dislocation was far more extreme. Benjamin considered Moscow to be less a proletarian city than a combination of a vastly expanded peasant village with the gargantuan monumentality of modern technology. This combination marked the experience of time in the socialist city: its 'curious tempo' emerging from the juxtaposition of the 'rhythm of its peasant population' with the rhythms of modern technology. The urban experience of Moscow was marked by 'the complete interpenetration of technological and primitive modes of life' (1927b: 190) which mobilised the population in an attempt to modify old habits by imposing technological and bureaucratic forms of control. The party-state ruled the population by means of constant mobilisation, and unlike the experience of Naples – where 'everything transitive is joyful' – the mobilisation of Moscow was catastrophic and threatening – the 'greatest weight' – producing extreme depression and apathy among its citizens.

Benjamin saw the main difference between the mobilisations of Naples and Moscow to lie in the medium and character of the movement. In Naples, mobility was oriented towards locality and was experienced in terms of an improvised response to the demands of a hostile urban environment, while in Moscow mobility was oriented by the party-state and was experienced as a constant demand to anticipate the ever-changing party-line. In the case of Naples, local anarchy created a form of criminal self-regulation in the *Camorra* who 'are dispersed over the city and the suburbs' (1924: 414) and become a spectral figure of porosity. The *Camorra* exists in an inconspicuous network of communication and the transmission of power which threads itself through both the neighbourhoods of the city and through its institutional structures. Benjamin hints at a complicity between police and *Camorra*, and indeed attributes to the criminal organisation precisely those characteristics which he had previously ascribed to the police in the *Critique of Violence*: 'Its power is formless, like its nowhere tangible, all-pervasive, ghostly presence in the life of civilised states' (1924: 243). While in Naples the *Camorra* increasingly assumes the police role of law preserving violence, in Moscow the party police is in the process of assuming the characteristics of a criminal organisation, all the way to the NKVD's code of honour. Benjamin describes the Soviet Union under NEP as a client or 'caste state' in which 'the social status of a citizen is determined not by the visible exterior of their existence – their clothes or living place – but exclusively by their relations to the party' (1927b: 194). These relations are in their turn 'policed' by obscure networks of power and influence which, because occult, call for the furious mobilisation of public professions of loyalty to the regime and an allusive reticence when expressing an opinion. Porosity in the socialist city functions through networks of informers, and the response to the exigencies of urban life is anything but improvised: 'A judgement is weighed innumerable times before being uttered to more distant contacts.' The police are again present as a ghostly presence, subject only to the inscrutable decrees of the party, which can 'casually, unobtrusively change its line'. Since uncertainty is the only certainty in this state, the citizens have to act the role of furious, continual loyalty, minimising any risk of unintentionally crossing the limits drawn by the party-line. Here the party-line is discontinuous and perversely futural, subject to sudden change and reverses, calling for the continual expression of loyalty.

In the *Critique of Violence* Benjamin described the formal, law-preserving violence of the police as:

> less devastating where they represent, in absolute monarchy, the power of a ruler in which legislative and executive supremacy are united, than in democracies where their existence, elevated by no such relation, bears witness to the greatest conceivable degeneration of violence.

> (1921a: 243)

After his short experience of life under the conditions of the degeneration of revolutionary violence into a one-party 'absolutist' state in Moscow, Benjamin introduces a number of important nuances into the argument set out in the *Critique of Violence*. He maintains an analogical form of the earlier distinction between democracy and absolutism in the distinction between capitalism and the Soviet state, showing how in the Soviet Union of the NEP the distinction between a capitalist economy and a socialist polity was systematically blurred. The resulting ambiguity encouraged the worst features of both systems, namely corruption and clientage. In the capitalist state, money and power are convertible qualities:

> Any given amount of money may be converted into a specific power, and the market value of all power can be calculated. So things stand on a large scale. We can only speak of corruption where the process is handled too quickly.
>
> (1927b: 194)

In the Soviet state under NEP the convertibility of money and power has been suspended; the state 'reserves power to the party, and leaves money to the NEP man'. In this unstable condition the only barrier to the creation of a mafioso state was the incorruptibility of the ruling party, and in particular the police through which it exercises its law-preserving violence. However, Benjamin notes that this depends on the rigorous separation of money and power, and the prevention of the development of a 'black market of power' in which the limits between the market and politics lose their definition.

In terms of Benjamin's philosophy of experience, such blurring of the line between money and power is inevitable since all fixed limits are in the process of changing over time. It is when this is handled 'too quickly' that corruption emerges. However, in the case of the Soviet state, the party is the sole judge of the limits between market and power relations, which makes it the sole arbiter of corruption or 'the degeneration of violence'. Because of its absolutist political claims, the Soviet state, Benjamin implies, is in the process of converting itself into a criminal organisation and its police into gangsters accountable only in terms of the honour or 'revolutionary morality' of the organisation/party. The public functions of the state bureaucracy are shadowed by the workings of the spectral party police, whose identity and channels of influence remain unknown and obscure.

The future of the Soviet state intimated throughout 'Moscow' is one of a degeneration of violence far more threatening than that of the 'democratic states' where the porosity of power and money is at least checked by notionally democratic institutions. The juxtaposition of an absolute party-state and a black market in power promised a political future which would be neither democratic nor communist but the rule of a mafioso party-state that governed by means of clientage and intimidation. Benjamin predicted that

'Should the European correlation of power and money penetrate Russia, too, then, perhaps not the country, perhaps not even the Party, but Communism in Russia would be lost' (1927b: 196). The essay on Moscow brings together the political analysis of the 'degeneration of violence' from the *Critique of Violence* and the analysis of the decay of experience developed in the philosophical writings. The phenomenological descriptions of everyday life in Moscow are informed by the spectral presence of the party police which 'makes life so heavy with content' (1927b: 195). This joyless mobilisation leaves no room for improvisation, but allows only a reactive response to 'the countless constellations that here confront the individual in the course of a month' (1927b: 195). The ambiguous relationship between wealth and power in capitalist democracies is here fused into a modern form of absolutist state, one which Benjamin would later in the mid-1930s describe with fascism/Nazism as 'totalitarian'.

The essay on Moscow ends with some reflections on the growing cult of Lenin in the Soviet Union of the mid-1920s. The Lenin cult is tangentially related to the technocratic aspects of the consolidation of the October Revolution. In establishing this linkage Benjamin anticipates his later discussion of the relationship between technology and the production of 'cult values' in totalitarian regimes. The experience of Moscow combines the threat of a 'black market' of power regulated by an unaccountable and unlocatable political police with a rhythm of life set by the juxtaposition of technology and a primitive mode of life, a constellation presided over by an emergent cult of the dead leader. Many of these features would recur in Benjamin's analysis of fascism, which also instituted a political dictatorship which preserved market relations, fostered technological development and, of course, established a cult of leadership.

The totalitarian forms of experience which Benjamin saw emerging in Moscow contrast strongly with Naples itself at this time under the fascist regime), which was characterised by a highly dispersed form of economic and political corruption in the *Camorra*. Each city represents a different experience of movement in time and space: in Moscow, experience is frozen at a point of stasis between peasant past and a technological communist future. And although the mobilisation is fast and furious it leads nowhere; it represents a one-way street in which the experience of past, present and future is arrested in a monumental present summed up by the cult of the dead leader. In Naples, the character of experience is more ambiguous, and offers an improvised and extremely provisional weaving together of past and future in the transitive present. Yet both the traditional city of Naples and the fusion of modernity and primitivism detected in Moscow differ significantly from the experiences of the modern cities of Berlin and Paris described in *One Way Street*. It was only through the analysis of these other urban experiences that Benjamin was able to understand his own.

One Way Street brings together a number of reflections on contemporary

experience dating from the mid-1920s, a period contemporary with the essays on Naples and Moscow and the composition of the *Origin of the German Mourning Play*. The reflections can be divided into two groups corresponding to two phases of composition. The first, mentioned to Scholem in a letter from Capri dated 16 September 1924, comprises the *Descriptive Analysis of the German Decline* which, in revised form, made up the single largest section of *One Way Street* entitled 'Imperial Panorama: A Tour of the German Inflation'. The second group of texts comprises the collection of 'aphorisms, witticisms, and dreams' which Benjamin mentioned in a letter to Scholem dated 22 December 1924 and which he intended to publish as *Plaquette für Freunde* (*Brochure for Friends*). The two parts were collected together with a number of aphorisms on Paris, making this book, as Benjamin later confided to Hofmannsthal, 'my first attempt to come to terms with this city,' a project which he intended to continue 'in a second book called *Paris Arcades*' (C, 325).

In the same letter to Hofmannsthal Benjamin described *One Way Street* as an attempt 'to grasp topicality as the reverse of the eternal in history and to make an impression of this, the side of the medallion hidden from view' (C, 325). As such it represents a development of the speculative extension of the concept of experience proposed in Benjamin's earlier critique of Kant. Not only does the book give precedence to the topical over the eternal and the concrete over the abstract, but it does so in terms of an analysis of the decay of modern experience under the conditions of a money economy. It represents a development of the philosophical account of experience, as well as a confrontation between the diverse experiences of Berlin and Paris which Benjamin himself identified as one of the 'origins' of the *Arcades Project*.

The early stages of *One Way Street* were written immediately after Benjamin had read Georg Lukács' *History And Class Consciousness* (1923), a text which attempted to bring together Marx's account of commodity fetishism in *Capital*, Georg Simmel's account of reification and culture in *The Philosophy of Money*, and Max Weber's genealogy of rationalisation in *The Protestant Ethic and the Spirit of Capitalism*.[4] It thus addressed a similar set of ideas to those informing Benjamin's own fragment *Capitalism as Religion* discussed earlier. In the light of the latter it is not too surprising that Benjamin found in Lukács' book 'principles [which] resonate for me or validate my own thinking' although he continued (in the above mentioned letter to Scholem which announced the composition of the *Descriptive Analysis of the German Decline*) that he 'would be surprised if the foundations of my nihilism were not to manifest themselves against communism in an antagonistic confrontation with the concepts and assertions of Hegelian dialectic' (C, 248). Benjamin prized Lukács' attempt to develop a speculative critique of the decay of modern experience, but not the Hegelian auspices under which he pursued it.

In a manner similar to Benjamin's own development of a speculative concept of experience, Lukács in the central essay of *History and Class Consciousness* – 'Reification and the Consciousness of the Proletariat' – starts

from a critique of Kant. Both writers find Kant's concept of experience limited, and attempt to supplement it with a speculative concept. However, Lukacs finds his speculative concept of experience in the Hegelian dialectic, notably in a clash between the reified experience of the market and capitalist relations of production, and the speculative experience of the 'class-conscious' proletariat. The 'substance' of a reified culture is transformed by the self-conscious 'subject' of the proletariat, promising a communist future through which, in the speculative sentence of Hegel, 'subject is substance'. Benjamin agreed with the diagnosis of the reduction of experience by the commodity form under capitalism, but not with the view that it could be superseded by a class-conscious subject. Instead he looks for moments of excess within the experience of reification; not an excessive subject, but speculative moments within reified culture which exceed the limits of the monetary form assumed by the exchange of commodities.

The early section of One Way Street – 'Imperial Panorama' – explicitly makes the transition from the experience of commodification to that of the city, first Berlin and then Paris. It presents the 'decay of experience' occasioned first by the commodification of social relationships – in which 'money stands ruinously at the centre of every vital interest' and then in the commodification of the experience of objects, which Benjamin calls 'the degeneration of things'. Benjamin gives Simmel and Lukács' theory of reification a subjective twist, focusing not on the thing-like character of persons and objects, but on the experience of their resistance. In the case of social relationships 'Bus conductors, officials, workmen, salesmen – they all feel themselves to be the representatives of a refractory matter whose menace they take pains to demonstrate through their own surliness' (1928b: 454). In the case of things 'the objects of daily use gently but insistently repel us' (1928b: 453).

In One Way Street modern urban experience is no longer considered in terms of the concept of substance, nor yet by that of transitivity, but by the intermediate concept of the experience of resistance. In the first case, that of pre-modern experience, 'human movement, whether it springs from an intellectual or even a natural impulse, is impeded in its unfolding by the boundless resistance of the outside world' (1928b: 454). In this experience, the 'outside world' is a substantial entity which resists movement, while modern urban experience is characterised by resistance without a substantial entity that can be identified as its cause. The experience of resistance does not rest on there being something – a substance – which resists us, but is a symptom of an intangible obstacle to our movement.

On the basis of the experience of intangible resistance Benjamin makes his first statement of what will become the thesis of the 'decay of aura'. This is closely related to the experience of the modern city in which porosity again assumes the character of 'the greatest weight'. In a passage which relates the 'degeneration of things' and the 'opaque and truly dreadful situation' in which modern city dwellers find themselves, Benjamin writes 'Just as all things, in a

perpetual process of mingling and contamination, are losing their intrinsic character while ambiguity displaces authenticity, so is the city' (1928b: 454). The experience of resistance is here linked with the porosity of things; there is no longer a substantial entity which resists our movement, but an ambiguous and inauthentic experience of blockage which resists our comprehension. This sense of the inscrutable obstacle to movement can be experienced by the city dweller as a source of threat and insecurity, or as the occasion for an inventive response. In the early sections of 'Imperial Panorama' Benjamin criticises the passive nihilism of the 'helpless fixation on notions of security and property deriving from past decades' which creates 'enervating amazement' at the loss of stability, rather than provoking change. The refusal to take an actively nihilist, inventive response to ambiguity underlines the fact that 'society's attachment to its familiar and long-since-forfeited life is so rigid as to nullify the genuinely human application of intellect, forethought, even in dire peril' (1928b: 451). Benjamin thus presents two possible responses to the experience of ambiguity and resistance: the first is to persist with, defend and insist upon fixed identities while the other is to embrace ambiguity in an innovative and inventive way. The first option defends a given identity to the point of psychosis, while the second risks identity for the sake of its transformation.

In addition to relating the commodity and the experience of the city, *One Way Street* introduces the further factor of technology. 'Imperial Panorama' ends with a warning of the ecological consequences of the exploitation of nature for profit, a theme which returns at the end of the book in the final section 'To the Planetarium'. There Benjamin speaks of technology in terms of a new *physis* or body for both humanity and nature. The subordination of technology to obsolete forms of identity such as 'nations and families', along with private property and the pursuit of profit, leads to the 'revolt of technology'. The postwar communist revolutions are described as 'the first attempt by humanity to bring the new body under its control' (1928b: 487). The city is increasingly the technological site of human habitation, the place where the collision of technology and human tradition is most marked. In *One Way Street* Benjamin shows how relations to nature and to other humans are given limited expression by the commodity form (money), a key symptom of which is the subordination of technology to profit. His subsequent work on the experience of the city criticises the relationship between commodification and technology, showing how the possibility of a new experience of space and time opened by technology is reduced by the commodity form. The contents of the *Arcades Project* are organised around the tension between technology and the order of the market and private property which was the heritage of the French Revolution. The commodity form provides the transcendental surface for inscription which is exceeded by the speculative configurations offered by technology.

The complex set of relationships between modern experience, the city and technology were exemplified by the architectural form of the arcade. The

arcade offered a figure or concrete a priori through which to 'test the extent to which it is possible to be "concrete" in the philosophy of history' or 'to attain the most extreme concreteness for an era'.[5] It formed the point of departure of the speculative analysis of the cultural history of nineteenth-century Paris in the *Arcades Project*. This was intended to be a self-conscious intensification of the presentation of urban experience attempted in *One Way Street*, an attempt to deliver the sustained presentation of concrete experience which was only achieved episodically in the earlier book. Although the beginnings of the project were inseparable from Benjamin's work on and with Franz Hessel, surrealism and the 'modern epic', it soon gathered its own momentum, or perhaps more accurately, its own inertia.[6]

Hints of the uncontrollable expansion of the project are already evident in Benjamin's correspondence of Spring 1928, where optimistic claims soon to finish the 'essay' (30 January) and then 'book' (8 February) are soon tempered by despondency at the increasingly demanding task which was 'taking on an ever more mysterious and insistent mien and howls into my nights like a small beast if I have failed to water it at the most distant springs during the day' (24 May, C, 335). One of the reasons for the disturbed nights was the figure of the Arcade itself; as a place of spatial and temporal transition it could only be presented by means of what Benjamin had called in the *Origin of the German Mourning Play* 'method as digression'. Benjamin followed the paths to the distant springs intermittently for more than a decade, collecting them under the alphabetically organised titles of the project, and using them as the points of departure for digressions into other, independent works such as *The Author as Producer* and *The Work of Art in the Epoch of its Technical Reproducibility* as well as those writings more closely linked to the project such as *Paris, the Capital of the Nineteenth Century* or to the drafts of the ill-starred Baudelaire book such as *Paris of the Second Empire in Baudelaire* and *On Some Motifs in Baudelaire*.[7]

The Arcade served as one of the main figures for the concept of porosity in 'Naples' where Benjamin likens the main street of the city to an arcade.[8] The Paris arcade, however, is characterised by a spatial and historical complexity which effectively raises the concept of porosity by several powers. In all his discussions of the spatial character of the arcade Benjamin stresses how its status as a threshold or point of passage contributed to its sense of disquieting ambiguity.[9] Built during the first half of the nineteenth century and clustering in the vicinity of the notorious Palais Royale, the iron and glass arcades were not only pedestrian passages between main thoroughfares but also points of transition between inside and outside as well as between the private and the public. As 'passages' it was unclear whether the arcades were a place where one could tarry, to look or to shop or both, or a route or short cut to elsewhere. The passage did not possess a fixed meaning, did not define a place, but was parasitic upon the other places to which it led and the purposes for which it was used. Natural light poured into these glass-covered interiors, bringing

with it – in an exemplary moment of porosity – the outside. As an already ambiguous interior, the arcade provided the further equivocation of a private space which was public: all of which make it the counter-categorical equivalent of the Neapolitan staircase.

Benjamin described the space of the arcade as a 'residue of a dreamworld' in which the natural constraints of weather and the social constrains of public and private were suspended. This space, made possible by iron and glass technology, opened for a moment the possibility of forms of experience based upon a new relation to nature and new social relations. However, Benjamin dedicated his *Arcades Project* to showing how this moment was lost, whether in the transformation of the arcade into a defined space or a simple route. In later stages of work on the project, this loss was attributed to the bourgeoisie surrendering its revolutionary future. Benjamin considers the surrender of the possible futures of the arcade in terms of the transformation of its spatial ambiguity, a change which took place in two ways. The first was the transformation of the arcade into the space of the department store – a place defined by its function of retailing commodities. The second was the imaginary transformation of the arcade into the interior of the home in Fourier's phalanstery, a 'reactionary transformation' in which the arcades surrendered their originally ambiguous 'social ends' and 'became dwelling places' (1935c: 193, 160). Whether as places of selling, dwelling or mere passage, the arcades lost the speculative challenge they originally posed to the opposition of public and private and the artificial and the natural.

The discussion of the reduction of the arcade points to the importance of its temporal and historical significance for Benjamin. Indeed, writing from the late 1920s and 1930s, it was the residues of the dream world still contained in the arcades that most interested him. He read this prematurely archaic form of architecture speculatively, that is, as containing latent, unrealised futures. Indeed, in the methodological 'Convolut N' of the *Arcades Project* it is the temporal/historical aspect of the arcades that is emphasised above all others. In a fascinating allusion to the links between the *Origin of the German Mourning Play* and the *Arcades Project*, Benjamin describes the arcade as an 'origin' and his work on the project as an excavation of origin:

> In the Arcades project I am also involved in fathoming origin. That is to say, I am pursuing the origin of the construction and transformation of the Paris arcades from their rise to their fall, and laying hold of this origin through economic facts.[10]

As an origin, the arcade is an 'eddy in the stream of becoming' or a concrete a priori which can only be understood temporally as a rhythmic pattern or an unfolding which 'in the process of becoming and disappearance' discloses and conceals aspects of itself. As an origin, the arcade does not possess a fixed character, but reveals different aspects of itself through the passage of time.

Thus the *Arcades Project* is a speculative enterprise which counterfactually compares what the arcade became with what it might potentially have become. Benjamin's presentation of the temporal aspect of the arcade considers it according to the closely interrelated aspects of technology and political economy.

Urban poetics

With the *Arcades Project* the mutual relationship between a speculatively enriched concept of experience and the description of modern urban experience reaches its apogee. In the absence of the philosophical concept of experience developed earlier, Benjamin would not have been able to conceive a historical project such as the study of the Paris arcades. This is not to overlook that the philosophy of experience was in its turn decisively transformed by the cultural history of urban experience. Yet this project was more than an urban history of Paris, since it also explored the ways in which the experience of the city shaped and was shaped by its literary and visual expressions. Just as the philosophy of experience informing Benjamin's criticism was transformed by its encounter with works of literature and art, so were all three transformed by the analysis of urban experience. Philologically this is evident in the close relationship between the *Arcades Project* and the other critical writings of the 1930s, such as *The Work of Art in the Epoch of its Technical Reproducibility* discussed above and Benjamin's final work of criticism, the fragments of a book on Baudelaire from 1938 to 1939.[11]

In 1923 Benjamin published a rhymed translation of Baudelaire's *Tableaux parisiens*, prefaced by the celebrated essay *The Task of the Translator*. This translation was the result of over ten years' work on *Les Fleurs du mal*, and was intended to be a critique of Stefan Georg's translation. It also marks a stage in Benjamin's use of Baudelaire's poetry as an exemplary case of a modernist poetic which takes the experience of the city as its 'poetic principle' or *Gedichtete*. The term 'poetic principle', introduced in Chapter 2, designates the speculative configuration of experience, or the binding together (*Verbindung*) of the absolute and the spatio-temporal. The shape of a particular poem (its thematic and rhythmical patterning) actualises one of many possible configurations of the Poetic, usually through a particular relation to the world or 'mood' such as courage in the case of Hölderlin, or hope in the case of Goethe. Read in these terms, Baudelaire's poetry gives shape to the experience of the city by actualising such moods and experiences as shock, repetition, revulsion, fear and melancholy.

The preoccupation with the work of Baudelaire is a feature common to all phases of Benjamin's authorship and an important source of motivation for the work on the *Arcades Project*. Section V of the 1935 *exposé: Paris, the Capital of the Nineteenth Century* was dedicated to Baudelaire and the theme of the 'Streets of Paris' and was headed by an epigraph from *Le cygne* – one of the poems from the *Tableaux parisiens* – 'Tout pour moi devient allegorie' ('All

THE EXPERIENCE OF THE CITY

becomes allegory for me'). In this section Benjamin describes Baudelaire as an allegorical poet of the allegorical city, and sketches out some of the implications of this claim. Baudelaire's poems present the experience of the marginal bohemian, *flâneur* and conspirator; they present the experience of the 'prehistoric' in the 'modern' and the 'dialectic at a standstill' of the repetitious novelty of fashion and the commodity.

The pivotal position occupied by Baudelaire in the *Arcades Project* is reflected in the plans from 1938 to write a 'Baudelaire book' which would serve as a 'scale-model' for the Paris project as a whole. Benjamin described his plans for the 'scale model' in a letter to Max Horkheimer, written in Paris and dated 16 April 1938:

> The work will be in three parts. Their projected titles are: Idea and Image; Antiquity and Modernity; the New and the Ever-the-Same [*Immergleiche*]. The first part will show the prominent significance of allegory in *Les Fleurs du mal*. It presents the construction of Baudelaire's allegorical intuition which reveals the fundamental paradox of his theory of art – the contradiction between the theory of natural correspondences and the renunciation of nature . . . The second part develops *Überblendung* as a formal element of allegorical intuition, the power that brings to view the antiquity in the modern and the modernity of the antique. This procedure applies equally to the poetic *Tableaux parisiens* as to the prosaic *Le Spleen du Paris*. . . . The third part treats of the commodity as the fulfilment of Baudelaire's allegorical intuition.[12]

In a later letter to Horkheimer (from Copenhagen, dated 28 September 1938) Benjamin enclosed the three essays which make up the second part of the Baudelaire triptych, renaming 'Idea and Image' as 'Baudelaire the Allegorist' and the 'New and the Ever-the-Same' as 'The Commodity as Object of Poetry'. The second part, then, marks the transition from a characterisation of Baudelaire's 'allegorical intuition' to a recognition of the commodity as the poetic object. In terms of Benjamin's methodology of analysing the *Gedichtete* or 'Poetic', the movement between the three parts proceeds from an intuition of the principle through commentary to a critique of the pattern and form in which it is actualised.

It is important to stress the place of 'Paris of the Second Empire in Baudelaire' within the overall architecture of the Baudelaire book in order to avoid misunderstanding the surviving text. Adorno, in correspondence with Benjamin, criticised it for not being sufficiently 'speculative' by which he meant that it lacked mediation. He located it 'at the crossroads of magic and positivism. That spot is bewitched. Only theory could break the spell – your own resolute, salutarily speculative theory'.[13] The speculative theory however structures the entire work; it is to be found in the 'speculative construction' of

the whole. In his reply to Adorno, Benjamin claimed that the speculative demands of the three parts governed the choice of strategy pursued in the second, realised section of the work.[14] At stake between him and his critic was the definition of the speculative; by focusing on the shortage of mediation Adorno was implicitly criticising him for not being sufficiently Hegelian, so missing the entire point of Benjamin's speculative method and its roots in his own peculiar account of speculative experience.

The speculative method pursued throughout the surviving plans and sketches of the Baudelaire book may be inferred from the *Arcades Project*. In the first section on 'Idea and Image' or 'Baudelaire as Allegorist' Benjamin intended to present the results of his analysis of Paris as an allegorical city and its refraction in Baudelaire's 'poetic intuition'. This part is organised around Marx's theory of value, and stresses the theme of the exchange of equivalents in the market or 'fetish commodity'. As seen in the third section of Chapter 2 above, Benjamin had already entertained the view of capitalism as a religion in the early 1920s, but now he takes the apparently equal exchange of commodities to be the sacred, animating principle of modernity. The 'fetish commodity' of the market animates the allegorical and marginal figures which populate this part of the *Arcades Project* – the *Flâneur*, the Prostitute, the Bohemian, the Crowd and the Poet.[15] It provides the basic structure of experience, which may be responded to in terms of a number of possible intuitions ranging from the empathic intoxication of the *flâneur* to the despairing allegories of Baudelaire. In the first case, the *flâneur*'s pleasure in the contemplation of the crowd at its shopping is transformed into an empathy with the 'fetish commodity'; in Benjamin's words 'The intoxication to which the *flâneur* surrenders is the intoxication of the commodity around which surges the stream of customers' (CB, 55). Benjamin charts how the *flâneur* sheds his individual distance and is rapturously received among the faithful of the fetish commodity, being transformed into a floorwalker, or salesman in a department store, that is to say, a commodity whose use value lies in the sale of commodities.

Benjamin characterises Baudelaire's response to the fetish commodity as an allegorical intuition, one that is intoxicated but not empathic:

> He let the spectacle of the crowd act upon him. The deepest fascination of this spectacle lay in the fact that as it intoxicated him, it did not blind him to the horrible social reality. He remained conscious of it, though only in the way in which intoxicated people are 'still' aware of reality.
>
> (CB, 59)

This consciousness formed Baudelaire's 'allegorical intuition' which structured his actualisation of the poetic principle of modernity, namely the fetish commodity. As in his earlier exercises in literary criticism, Benjamin establishes the limits of Baudelaire's working through of the modern Poetic by means of a

comparison, in this case with the work of Victor Hugo. The peculiar character-
istics of Baudelaire's modernism are established through a contrast with Victor
Hugo's very different but complementary version of the modern poetic. The
second part of the projected Baudelaire book builds on the characterisation of
modern experience as the experience of the 'fetish commodity'. This experience
and its poetic working through can assume a number of different forms, duly
analysed in the second part. On the basis of these it becomes possible to proceed,
in the projected third part of the book, towards a critique of Baudelaire as one
possible (and thus by definition limited) realisation of the Poetic of modernity.

Benjamin's delineation of Baudelaire by means of a contrast with Hugo is
evident throughout the surviving fragment of part two of the projected book.
His deployment of the comparative method as well as some of the links
between the *Arcades Project* and the earlier work on *Trauerspiel* and the modern
epic may be exemplified by an analysis of Benjamin's view of the modern hero.
The 'allegorical intuition' that was conscious of the horrors of Parisian life
required heroic virtue in order to be sustained, and indeed, Benjamin notes,
'Baudelaire patterned his image of the artist after an image of the hero' (CB,
67). The Baudelairian hero differed utterly from the hero of Victor Hugo,
which was none other than the inspired crowd. Hugo elevated the crowd to
the heroic stature of the protagonist of progress and radical republican virtue
against the 'forces of darkness':

> The masses of the big city could not disconcert him [Hugo]. He
> recognised the crowd of people in them and wanted to be flesh of
> their flesh. Laicism, Progress, and Democracy were inscribed on the
> banner which he waved over their heads. The banner transfigured
> existence. It shaded a threshold which separated the individual from
> the crowd.
>
> (CB, 66)

The Baudelairean hero did not completely surrender to the intoxication of
progress and the crowd, but maintained an ironic distance from both the
forces of good and evil. The experience of modernity expressed by Hugo in the
form of a heroic epic of the crowd is worked through by Baudelaire into the
form of the lyric:

> When Victor Hugo was celebrating the crowd in a modern epic,
> Baudelaire was looking for a refuge for the hero among the masses of
> the big city. Hugo placed himself in the crowd as a *citoyen*; Baudelaire
> sundered himself from it as a hero.
>
> (CB, 66)

Benjamin derives the two personae of the hero from the same experience of
the urban modernity of Paris; both are configurations of the same 'Poetic'. The

one hero incarnates the crowd while the other seeks distance from it; the first gives rise to an epic of progress, the other to a lyric of dissolution. Hugo and Baudelaire, in other words, perform the opposition of tragedy and mourning play already rehearsed in *The Origin of the German Mourning Play*.

According to Benjamin, Hugo attempted to write the epic of the nineteenth century with the crowd cast as hero; but just as the hero of Benjamin's theory of tragedy could not escape the confines of myth (see 1928a: 107), nor could Hugo's crowd – the commodity incarnate – step outside of the 'mythical' forms of the market and realise the bourgeois utopia. Although driven by the wind of progress, Hugo's heroic crowd could not realise the liberty, equality and fraternity proclaimed by the Revolution. Against this tragedy Benjamin advanced the claims of the allegorical mourning play, with its fragmented hero tortured at the hands of the world. For him Baudelaire's lyric is best under-stood as a form of mourning play, driven by a lyrical mood of despair before transience. If the baroque mourning play was an elaboration of sadness and lament, so too was Baudelaire's poetry a working-through of the mood of despair before inevitable loss. Its lyrical hero, like the Christian martyr of the baroque mourning play, was in but not of the world; Baudelaire's modern hero lived the ironic distance of the actor:

> For the modern hero is no hero; he acts heroes. Heroic modernism turns out to be a mourning play [*Trauerspiel*] in which the hero's part is available.
>
> (CB, 97)

For Benjamin the origin of Baudelaire's 'allegorical intuition' was his para-doxical location within and without the experience of the modern city. On the one hand 'this poetry is no local folklore, the allegorist's gaze which falls upon the city is rather the gaze of the alienated man' (CB, 170), while on the other it is a view from inside urban experience: 'Baroque allegory only saw the corpse from the outside; Baudelaire also saw it from the inside' (CB, 180). The paradoxical location with respect to urban experience was sustained by the formal juxtaposition in Baudelaire's poetry of the language of immediate lived experience [*Erlebnis*] with that bequeathed by the lyric tradition. Contemporary idioms – 'the phantom crowd of words, the fragments, the beginnings of lines from which the poet wrests his poetic booty'[16] – are both presented through and contemplated under the forms bequeathed by tradi-tion, and in being so framed by classical forms, the modern is wrenched from its immediacy and raised to the level of experience [*Erfahrung*].

With the transformation of *Erlebnis* into *Erfahrung* Benjamin achieves the passage from the first and second methodological stages of 'allegorical intu-ition' – from the commentary upon the materials [*Sachgehalt*] of 'lived experience' – to a critique of its working-through in poetic form. Summing up this transition, Benjamin wrote that

Of all the experiences which made his life what it was, Baudelaire sin-
gled out his having been jostled by the crowd as the decisive, unique
experience. . . . This is the nature of something lived through
(*Erlebnis*) to which Baudelaire has given the weight of an experience
(*Erfahrung*).[17]

The poetically elaborated experience of shock took the form of a mournful,
asymptotic classicism – a working-through of loss and dereliction impossible
to complete. The fusion of the antique and the modern sets the glories of nine-
teenth-century Paris in a line of past glories such as those of Athens and
Rome. The contemporary myths of progress, justice in the harmony of equal
exchange, and the 'ever-new' turnover of commodities are tainted by remem-
brance; optimistic *Erlebnis* becomes desolate *Erfahrung*. The lived experience
of the Capital of the Nineteenth Century is framed by remembrance and by
the evocation of the marginalised and excluded. In Baudelaire's allegorical
poems the blossoms of progress and the modern are blighted by remembrance
of their transience and by the summoning forth of the excluded.

Benjamin's commentary and critique of Baudelaire is best illustrated by his
analysis of *Le Cygne*, for him one of the most significant poems of the
Tableaux parisiens and indeed of *Les Fleurs du mal.* In this poem, dedicated to
Hugo, Baudelaire establishes his distance from his contemporary author as
well as from contemporary Paris.

The Swan (to Victor Hugo)

I

Andromache, I think of you! That little stream,
Poor, sad mirror once swollen with
The majestic griefs of your widowhood;
This cheat Simois which has risen with your tears

Has suddenly milted my fertile memory,
Just as I passed the new *Carrousel.*
Old Paris is finished (what mortal
Heart can keep up with this city!)

But its image lives on in me – those stalls
Those heaps of blocked-out capitals and pillars,
Weeds and cornerstones vegetating in slimy pools
And the random junk glinting in crates.

Over there was once a menagerie,
And there, at clocking-in time one
Crisp and clear morning, when sweepers
Kick up a storm of dust in the still air,

I saw a swan who had slipped his cage,
Webbed feet flapping on the dry cobbles,
White plumage trailing along the rough ground;
He stopped by a parched gutter, opened his beak

Then neurotically bathing his wings in the dust,
Sang out, his heart full of his noble birthlake:
'Water, why won't you rain, send your storm?'
I see the wretch, a strange and fatal myth,

Sometimes against the sky, like Ovid's man,
Against the ironic and cruel blue sky,
Stretch up his yearning head on a gulping neck,
As if addressing reproaches unto God!

II

Paris changes, but my melancholy is stubborn.
New palaces, scaffolding, prisons and
Old quarters all become allegory for me;
My fondest memories weigh upon me like rocks.

And in front of the Louvre an image depresses me:
I think of my noble swan and his crazy dance,
Ridiculous and sublime like all exiles,
Drained by an infinite thirst, and then of you

Andromache, fallen from a husband's arms,
Subdued beneath the fist of proud Pyrrhus,
Crouching high before an empty tomb,
Hector's widow but now wife to Helenus!

I think of the black woman, wasted and chesty,
Grovelling in the filth, her wild eyes
Searching out the absent palms of proud Africa
From behind a prison wall of fog;

Of all who have lost and cannot go back,
Never, never, of those who gulp down tears
And wean themselves off vixen sorrow!
All the wasted orphans wilting like flowers!

Then in the forest of my exiled spirit
An old remember-me blasts like a horn.
I think of the shipwrecked and marooned,
The captive, the hopeless! . . . and so many more!

In this poem, the *flâneur* strolling through Paris suddenly stops and begins an
'invocation of the Louvre' which 'immediately changes, in mid verse to a

lament over the frailty of the city'.[18] This 'immediate change' constitutes for Benjamin the allegorical 'dialectical image' of the poem: '*Le Cygne* has the movement of a cradle rocking between modernity and antiquity.[19] It is manifest in the series of exiles who are evoked, beginning with Andromache and moving through the swan, the victim of colonialism, the orphans and of course to Victor Hugo himself, weaving together classical and modern predicaments of exile. The movement can also be discerned in the apposition of the Imperial poet Virgil and the exiled Ovid, and then both with the modern poets Baudelaire and Hugo (an ironic analogy which remains in question throughout the poem).

Benjamin opens his commentary on the poem in *Paris of the Second Empire in Baudelaire* by indicating the allegorical condition of the poem. Not only is the poem a lyric of the 'allegorical intuition' – an evocation of the allegorical mood – but moreover, its subject is allegory itself. The allegorical mood is evoked by the pensive reminiscence of the collapse of antiquity and the fragility of the modern. Allegory as mood and as subject approach each other yet resist contact. The remembrance of the poem is accordingly twofold: the poet's memory of Paris – 'old Paris is finished', 'Paris changes' – and the poetic memory of impermanence, exile and hopeless suffering embedded in the poetic tradition. The first edition of *Le Cygne* carried an epigraph from Virgil: 'Falsi Simoentis ad undam' (*Aeneid* III, 301), a recognition of loss emerging at the heart of the Imperial epic:

> Just then, as it chanced, in a grove near the city,
> Where flowed
> A make believe
> Simois, was Andromache performing the sad and solemn
> Rites of the Dead, with wine for the ashes and invocations
> To the spirit, at Hector's cenotaph – an empty mound of
> Green turf
> And twin altars the widow had consecrated to grief.[20]

Le Cygne's opening apostrophe to Andromache and her tearfully imagined Simois invokes the tradition's memory of grief, but from within lyric rather than epic. Baudelaire's citation of this passage echoes Virgil's own echo of the fate of Hector's wife after the fall of Troy; and the echo of one lost city chimes but does not harmonise with Baudelaire's own experience of a lost Paris.

The shock produced by the encounter of traditional and personal memory and of both with the spectacle of the building (in)activity of the new Paris results in stasis; time freezes into space forming what Benjamin variously described as an allegorical or dialectical image: 'The city which is in constant flux grows rigid. It becomes as brittle and as transparent as glass' (CB, 82). At this moment of stasis the image of the city gathers to it an ensemble of allegorical emblems of the lost and the excluded: 'The stature of Paris is fragile; it

is surrounded by symbols of fragility. . . . Their common feature is sadness about what was and lack of hope for what is to come.' The emblematic images fall into two classes: those of the regretful consolations of the imagination in exile, and those of futile, utopian rebellion. The poet is arrested between a regret for a lost Paris and a taking up of arms against the new city which would exclude him. Andromache, the echo of the poetic tradition and poetic memory, is already bitter and broken; she and her ersatz Simois are an image of grief serving to emblematise the thought that contentment in captivity is impossible. Even escape from prison is but the vanity of the swan, who grovelling in the urban filth is driven by the memory of a lost birth lake to rebel against fate and to conjure the remote heavens for a storm.

The rocking back and forth between the memory of the poetic tradition of exile and remembrance, the memory of Paris and the spectacle of contemporary Paris persists through the poem. The phantasmal procession of misery passes before the arrested *flâneur* gazing at a building site: Andromache, hopeless but pursuing consolation in make-believe rivers and tombs; the optimistic swan, reduced but also ennobled by hopes of return and vengeance; the exiled black woman dreaming of Africa; Ovid on the Black sea, the exiles in the forest of Arden . . . The procession of images stretches out into infinity and collapses upon itself in a lament: 'The Captives and the hopeless . . . and so many more.' The procession of spectres evoked by this collision of memory, present and future seems to be over, but not without a final twist. Benjamin's commentary simply states:

> The poem 'Le Cygne', too, is dedicated to Hugo, one of the few men whose work, it seemed to Baudelaire, produced a new antiquity. To the extent that one can speak of a source of inspiration in Hugo's case, it was fundamentally different from Baudelaire's. Hugo did not know the capacity to become rigid which – if a biological term may be used – manifests itself a hundredfold in Baudelaire's writings as a kind of mimesis of death.
>
> (1938: 82)

The poem about the predicament of exile assumes another dimension with the dedication to Hugo, exiled in the Channel Islands since the *coup d'etat* of Napoleon III. The poem achieves the status of a reflection upon the art and politics of Hugo. As Baudelaire wrote when sending the poem to Hugo, it is intended for 'those who are absent and who suffer' and was recognised by the recipient as a profound and true 'idea'. In the paralysed indecision of the allegorist the futility of hope and regret are placed beside each other as debilitating illusions. Both the philosophy of history which is driven by a redemptive hope for the future and the philosophy of history which despairs of redemption are belied in the poem – a poem which exceeds both its author and its dedicatee.

The 'strange myth' of the swan figures the predicament of Hugo, but the latter in turn figured for Benjamin a particular response to the reconfiguration

of modern experience. In the *Arcades Project* Hugo stands for a philosophy of history which sought, through Republican progress, to establish a bridge between the memory of a classless society and the future. He stands for the Social Democratic 'progressive' philosophy of history castigated in the *Theses of the Philosophy of History* (another parerga of the *Arcades Project*) for appealing to the inevitability of progress in the face of the triumph of fascism. Yet the figure of the swan is ambiguous, praying for a redemptive storm, the same which, in the 'Theses' caught the wings of the Angelus Novus and 'irresistibly propels him into the future to which his back is turned, while the pile of debris before him grows skyward. The storm is what we call progress' (1940: 260). Progress is catastrophic, but as with the storm in the fable of Noah's Ark, it is not simply the occasion for despair, but also for the witnessing of a new covenant. For Benjamin, the critical limits of Baudelaire's poetry are established by despair, but also by the admission of other possible futures.

Baudelaire and Hugo, the poets of modern urban experience, form a constellation of hope and despair out of which emerges a further possibility. This is not just a possibility within poetic language, but within the experience of the contemporary city itself. The *Arcades Project* proper draws the loci of these experiences through concrete categories. Repetition, shock and claustrophobia are not abstract categories, but are embodied in the data of cultural history. In the case of the Baudelaire book, the focus of the data and its speculative presentation was supplied by *Les Fleurs du mal*, while in the case of the *Arcades Project* the organising framework for the wide range of materials was the modern city as a site of spectacle and alienation.

The image of the city

The Baudelaire studies identified the lived experience [*Erlebnis*] of 'shock' as the modern 'poetic principle' informing Baudelaire's poetry. The experience of shock was located in the expansion of the laws of the exchange of commodities to all aspects of metropolitan life. This characteristic of urban experience, which plays a structural role in the Baudelaire fragments, was explored more fully in the *Arcades Project* itself. However, Benjamin's understanding of the experience of commodification did not consist in adding to an orthodox Marxist account of the extension of commodity relations under conditions of high capitalism the subjective ('superstructural') correlates of the lived experience of capitalism. If this had been the case, then Adorno's critique that his work 'lacked mediation' would have been entirely justified. On the contrary, his exploration of the experience of Parisian modernity was conducted under the auspices of his speculative account of experience. Accordingly, the presentation of the conditions for the possible experience of urban modernity in the *Arcades Project* entails an account of the reorganisation of spatio-temporal experience that took place during the epoch of high capitalism. This in turn, according to Benjamin's method, could not take the form of an abstract

theoretical deduction, but had to begin from the *doxa* provided by concrete historical evidence.

The beginnings of a deduction of the categories of urban experience are to be found in the earlier city portraits, but in the *Arcades Project* the exercise is conducted at a far higher level of philosophical and historical analysis. In it Benjamin attempts to develop a speculative cultural history, one that traces the changes in the patterns of urban experience by a description of historical data at once counterfactual and located within a narrative of the development of capitalist modernity. The two forms of analysis are complementary, since the specificity of the historical record may better be appreciated in the light of an analysis of what might have happened. Benjamin's historical narrative is accordingly qualified continually by counterfactual imaginations of other possible outcomes, a method exemplified by his treatment of the arcade.

The 'decay of aura' thesis provides the basic plot of the *Arcades Project,* but it is one which is complicated by a large number of subplots and digressions. The most significant of these include the ambiguous possibilities for liberation or repression released by the development of technology, the equivocal relationship between 'ritual' and 'politics', the expansion of the market to all areas of modern urban life, and the fate of art under conditions of modernity. These themes recur throughout Benjamin's work since the 1920s; what is novel is the attempt to bring them together under the auspices of a single project. They all entail a consideration of the possible decay and/or reinvention of experience in modernity, in other words, the question: will technology be used to promote 'ritual values' in the aestheticisation of politics or will it be used to invent new values in the politicisation of art? In the *Arcades Project* Benjamin presents both possibilities, continually confronting the historical evidence for the former with the intimations of the latter. Throughout the *Arcades Project* he shows how the possibilities of technology were limited by capitalism, how (again echoing the fragment *Capitalism as Religion*) capitalism assumed ritual values as the 'fetish commodity' and furthermore how in the face of these developments art was simultaneously relegated to insignificance and elevated into a religion.

The complex weaving together of these themes into a speculative account of modern experience is best illustrated by the 1935 *exposé* of the *Arcades Project, Paris, the Capital of the Nineteenth Century.* This conspectus of the entire *Arcades Project* consists of six short headed sections which between them sketch a speculative account of modern experience, departing, in each case, from the symptomatically ambiguous place of art in modernity. Common to them all is an analysis of the relationship between technology, art and politics/ritual, but one which gains a speculative dimension through its focus upon the temporality of experience (at once past, present and future), and its search for latent possibilities through the exploration of counterfactuals. Each section departs from a speculative reflection on the fate of art in the context of the changing technical and political conditions

of nineteenth-century Paris and each in its turn is organised around the conjunction of an exemplary historical figure and an architectural event.

In the first section of *Paris, the Capital of the Nineteenth Century* – 'Fourier or the Arcades' – Benjamin juxtaposes an architectural history of the arcade with an assessment of the utopian socialist Fourier. The architecture of the arcade was made possible by developments in iron construction techniques, and its early examples from the 1820s and 1830s pioneered a novel, modern form of glass and iron architecture. For Benjamin the arcade marked a technical development that anticipated by almost a century the social conditions for its full utilisation. It was accordingly a form which possessed possibilities far in excess of its actual use as a shopping mall for the luxurious end of the textile trade. One of these possibilities was explored by Fourier's communistic phalanstery, which Benjamin describes as a 'city of arcades' (1935c: 160). The social ends to which Fourier applied the possibilities opened by the technological development of iron and glass architecture were in Benjamin's judgement 'reactionary' since they reduced the arcade to a 'dwelling place' as opposed to transforming the very concept of 'dwelling' in the way Paul Scheerbart had done in his *Glass Architecture*. The arcade also challenged the concept of 'art', by using art within them 'in the service of the salesman' and in reinterpreting the use of art in architectural adornment. Benjamin stresses the nascent challenge posed to the concept of art and artist by the engineers who were developing their own functional forms out of the new building materials. In the 'struggles between builder and decorator, *Ecole Polytechnique* and *Ecole des Beaux Arts*' (1935c: 158), art was increasingly confined to the decoration of surfaces.

The relegation of art to surface decoration by architectural engineering is followed in the second section – 'Daguerre or the Dioramas' – by the attrition of the mimetic function of visual art by the dioramas, photography and then film. The diorama, which illusionistically reproduced natural and historical scenes for a viewing public, signalled a 'revolution in the relationship of art to technology' (1935c: 162). The revolution consisted in the technological reproduction of appearances, anticipating the development of photography. The threat to art posed by photography lay not so much in replacing traditional forms of representation, such as miniature portraiture, as in pioneering new forms of representation such as Nadar's embryonic photo-reportage of the Paris sewers. This development, along with the increase and intensification of communications and 'the new technical and social reality', reduced the 'informational importance of painting' and put into question its 'subjective contribution to painted and graphic information'. While photography created a mass market for the image through reproduction, the exploration of new subjects and the development of new techniques, painting began to consolidate a marginal position, emphasizing first 'the coloured elements of the image' and then the formal exploration of the limits of representation in impressionism and cubism respectively.

The character of the new 'technical and social reality' of modern life was further explored in the third section 'Grandeville or the World Exhibitions', dedicated to the world exhibitions and the 'fetish commodity'. The commodification of the world brought together the market for consumer goods with the market for images described in the previous section. The world fairs were expanded dioramas in which commodities were enjoyed as a spectacle: 'they opened up a phantasmagoria into which people entered in order to be distracted' (1935c: 165). Under the distracted gaze made possible by the development of technologies of visual reproduction, the world became a spectacle; a transformation satirically refracted in the drawings of Grandeville. Throughout this section Benjamin alludes to the new 'social reality' accompanying the spectacle of the commodity. The 'phantasmagoria of capitalist culture' excluded the proletariat and the question of the class struggle between proletariat and bourgeoisie. In this struggle art was confined to irony – whether the savage irony of Grandeville's etchings or the frivolous operettas of Offenbach.

The public face of the capitalist phantasmagoria presented in the World Fairs was complemented by its private aspect in the 'interior' of the home. Benjamin traces the social and technical conditions for the development of the modern, private dwelling in 'Louis-Philippe or the Interior'. The revolution in dwelling consisted in the separation of 'living space' from the 'place of work'; the living space was a sphere of illusion or 'phantasmagorias of the interior' while the place of work was the site of reality. There was no place between the interior and the workplace for politics or 'social preoccupations' – the former were the business of the citizen monarch Louis-Philippe while the latter were excluded from consideration. By excluding social and political questions from those of everyday life, the dwelling was 'de-realised'.

The consequences of the de-realisation of dwelling for art were twofold, echoing those that followed from the invention of the arcades. On the one hand, art shared the evacuation of reality and significance which was characteristic of the interior; objects of art were hoarded in the interior, and while this redeemed them from the measure of exchange value it was only to give them a 'fancier's value, rather than use value' (1935c: 168). On the other hand, since the interior was 'not only the private citizens' universe' but also 'his casing' art could serve to decorate the shell of the dwelling. Such was the ambiguous achievement of art nouveau which applied the new methods of construction to the expression of the individual personality of the dweller but at the same time exposed the interior upon the exterior, thus 'shattering' its casing. It posed, in a frail way, new possibilities for uniting the public and the private under the aegis of technical development and stood as 'the last attempt at a sortie on the part of art imprisoned by technical advance within her ivory tower' (1935c: 168). However, the attempt to fuse an idyllic image of nature in the sinuous plant-like lines of art nouveau with construction in iron and concrete was at best probational and ultimately condemned to ornament. For while the forms of art nouveau exposed the individuality of the inhabitant of

the interior, they were not sufficiently strong to reorganise the distinction between public and private space into a new conception of dwelling.

The fifth section – 'Baudelaire or the Streets of Paris' – leaves the interior to survey the fate of the public space that fell between the home and the place of work. The street too became a phantasmagoria before the gaze of the *flâneur*, transfigured from the familiar to the extraordinary through the crowd thronging to the market. The city as phantasmagoria was alternately landscape and interior – in both cases an object of spectacle. Benjamin presents two responses on the part of art to this condition: the first is represented by Baudelaire's poetry, the second by the movement of *l'art pour l'art*. In Benjamin's interpretation, Baudelaire's poetry disengages itself from the city of the fetish commodity and its human incarnation in the crowd and resorts to a 'dialectical image' of prehistory located outside of contemporary life. His poetry confronts the condemned image with poetic material drawn from the contemporary city, producing an ambiguous result that is both modern and the refusal of the modern. Benjamin suggests that the condemned is vulnerable to being transformed into the 'new', for that which is removed from contemporary life will assume the aspect of novelty.

In the case of art, the refusal of the contemporary city can be mobilised into a novel, marketable position, something which Benjamin regards as characteristic of aestheticism. Avant-garde art makes novelty its highest value, and attempts to isolate art not only from the contemporary world and the market, but also from the development of technology. Instead of art aligning itself with changes in contemporary political and technical organisation, and thus transforming itself into something new, it adopts a ritualistic detachment from contemporary life in order to protect its traditional boundaries. However, in so doing it becomes the 'counterpart of the distractions which transfigure the commodity'. By stressing novelty, the work of art becomes complicit with fashion and the constant stimulation of imagination vital to the turnover of commodities.

In the final section – 'Haussmann or the Barricades' – Benjamin reflects on the default of art before technology and politics. The reconstruction of the city under the Prefecture of Haussmann during the Second Empire exemplified for Benjamin 'the tendency which was noticeable again and again during the nineteenth century, to ennoble technical exigencies with artistic aims' (1935c: 174). The boulevards did not owe their existence solely to technical but also to political exigencies, namely the securing of the city from insurrection through the eviction of the proletarian population of the inner city *quartiers* and the attempt to render impossible the building of barricades through the breadth of the boulevards, and strategically to link them with barracks. The excluded proletariat returned with the barricades in the commune; and the burning of Paris during the last days of the commune for Benjamin marked a fittingly destructive end to 'Haussmann's work of destruction' and his reshaping of the city as an alienated *Gesamtkunstwerk*.

Benjamin closes the section on Haussmann and the *exposé* as a whole by suggesting some links between surrealism and *Paris, the Capital of the Nineteenth Century*, so returning to the origins of the *Arcades Project* in his late 1920s critique of surrealism and to his appreciation of the speculative power of ruins and the outmoded in *The Origin of the German Mourning Play* and *One Way Street*. He speaks of the liberation of 'the forms of creation from art' which was the achievement of the technical and social developments of the nineteenth century. However, he then shows very summarily that the moment of the liberation of creativity was short-lived, and the possibilities of social and technical innovation were soon restricted by their exploitation in the market: 'The fantasy creations prepare themselves to become practical as commercial art. . . . All these products are on the point of entering the market as commodities' (1935c: 176). Benjamin lingers on the moment of transition, before the socio-technical imagination becomes governed by the framework of the market and the bourgeois dictatorship of Napoleon III. He continues, speaking about the historical data from the moment of transition, that 'they still linger on the threshold. From this epoch spring the arcades and the interiors, the exhibition halls and the dioramas. They are residues of a dream world' (1935: 176). What is important for him is that they *still* linger, arrested on the threshold of any number of possible futures.

Benjamin ends the *exposé* with a reference to the 'upheavals of the market economy' in which the monuments of the bourgeoisie are 'recognised' 'as ruins even before they have crumbled'. The particular possibility realised by the bourgeoisie has exhausted its future, making it possible to return to the earlier point of transition and 're-awaken' other possible futures which remained latent and unrealised. Benjamin describes this movement of recognition and return as a 'textbook example of dialectical thought' and gives the last word of the projected *Arcades Project* to Hegel. But this is the speculative Hegel of the ruse of reason, the Hegel of the rose and the cross who strove to recognise the absolute in the finitude of experience, the understanding that every epoch 'dreams the next' and 'bears its end within itself'. This speculative but finite thought, which informs the entire *Arcades Project*, is neither a historical empiricism nor a transcendent idealism; rather it insists on the presence of the absolute in concrete experience, and not only in actual, but also in possible experience. Each epoch is on the threshold of its possible futures, which remain nested within it in a latent state. The recognition of the traces of these futures in the past is the hallmark both of Benjamin's 'transcendental but speculative philosophy' and the experience of possible modernities to which the incomplete *Arcades Project* bears witness.

AFTERWORD:
THE COLOUR OF EXPERIENCE

A reading of Walter Benjamin would not be complete without some mention of the Messianic, not that completeness is necessarily a virtue. Some explanation is due for the apparent relegation of the Messianic theme in this interpretation of Benjamin's concept of experience. In many respects the arrival of the Messianic theme alleviates the bleak rigour of Benjamin's thought; it invariably appears in the context of some argument for 'redemption'. The Messiah would restore what has been lost, mend what has been broken; this redemptive strand is present at all stages of Benjamin's authorship and signifies the proximity of a lapse into dogmatism. It is not essential to Benjamin's concept of experience that the intimations of the future be figured Messianically, and indeed to do so in a superficial way compromises its rigour.

To question the overwhelming significance attributed to the Messianic theme by some of Benjamin's renders is not however to underestimate the importance of eschatology in his thought. His work is certainly full of intimations of last things, but not necessarily in the sense of a Messianic completeness. A better biblical precedent for his thought is the appearance of the rainbow to Noah after the flood, marking the advent of a new covenant between Divinity, Nature and Humanity. Benjamin's last word, in the *Theses on the Philosophy of History*, has usually been read in terms of a Messianic rhetoric, but it can be more plausibly interpreted eschatologically as what happens after 'the storm called progress' that is blowing from paradise. The Angelus Novus bears witness to ruination, but not necessarily in the expectation of redemption, but in expectation of a new covenant or law.

The ambiguous storm rages throughout Benjamin's authorship, appearing already in the *Metaphysics of Youth*. There the 'landscape of time' in which the 'I' is threatened with dissolution is beset with a storm which produces the same bodily and spatial torsions experienced by the Angelus Novus:

> Dispatched in the shape of time, things storm on within it, responding to it in their humble, distancing movement towards the centre of the interval, towards the womb of time, whence the self radiates outward.
>
> (1914a: 15)

The catastrophic storm of time has a double movement: while it engulfs everything in it, consigning it to darkness and ruin it also irradiates the future, for 'the rejuvenated enemy will confront us with his boundless love'.

The creative destruction of the storm is described in the eschatological fragment *The Meaning of Time in the Moral Universe* (1921d) where time is identified with the storm blowing from paradise – 'the tempestuous storm of forgiveness which precedes the onrush of the Last Judgement' (1921d: 286) – which annihilates the world for the sake of the new covenant:

> time not only extinguishes the traces of all misdeeds but also – by virtue of its duration, beyond all remembering and forgetting – helps, in ways that are wholly mysterious, to complete the process of forgiveness, though never of reconciliation.
>
> (1921d: 287)

Benjamin's eschatology is one of the new covenant following the destructive storm, one which does not reconcile or redeem, but forgives through the 'obliteration' or 'extinguishing' of the 'traces of all misdeeds'. This state 'beyond all memory and forgetting' is described in another fragment from 1921 *Notes for a Study of the Beauty of Coloured Illustrations in Children's Books* which Benjamin begins with the reference 'Compare the dialogue on the rainbow' (1921e: 264). There the 'home of memory without yearning' is described as 'the fantastic play of colour' which is distinguished from 'Platonic anamnesis'. The latter remains within time, oriented to the past and thus 'not without yearning and regret' and distinguished from the colours of the rainbow of the new covenant which are futural and in this sense Messianic.

Art may either suspend itself between past and future, or approach the paradisiacal duration 'beyond all remembering and forgetting'. In the words of the fragment it may either be in 'tension with the Messianic' suspended between past and future, its 'yearning for paradise' being the passively nihilistic 'yearning to be without yearning' or it can be paradisiacal, where 'Paradise is as far removed from the apocalypse (though this apocalypse is a hesitant one) as the latter is from art' (1921e: 265). The first art yields the 'grey Elysium of the imagination', the cessation of happening before the apocalyptic storm announced in 'the wall of cloud on the horizon of [the artist's] vision', while the second art sees beyond the storm to the paradisiacal rainbow, with the wall of cloud opening up and showing the ' more brightly coloured walls [that] can be glimpsed behind it' (1921e: 265)

For Benjamin the colour of experience intimates the advent of a new law beyond the socio-technological catastrophe of modernity, one announced in the speculative excess of colour over the forms of experience in which it finds itself. Yet this excess is not transcendent, but immanent to experience. Not to recognise this marks for Benjamin the limit of Baudelaire's poetry. The swan conjures the storm from a dry wasteland, not seeing that the storm is already

upon it; the storm it desires is one that would satisfy its thirst for vengeance, not for forgiveness. The swan is still full of yearning for its lost paradise, not seeing the paradisiacal colours intimated in the catastrophic storm that already engulfs it.

Benjamin ends *On Some Motifs in Baudelaire* with a reference to a prose piece entitled 'A Lost Halo' that had been excluded from the canon of the poet's works. For Benjamin, the fable of the modern poet shedding his halo signifies the price paid by poetry for the sensation of the modern age, namely 'the disintegration of aura in the experience of shock' (1939c: 154). The association between the loss of the halo and the disintegration of aura recalls the link Benjamin had established in his early writings between the halo of Grünewald's angel and the chromatic immanence of the absolute. Aura consists in the 'ability of the [object] to look at us in return', which is a property ascribed to colour in the early fragments. The rainbow of colour in the haloes of Grünewald's angels marked for Benjamin the promise of an immanent absolute, one which was refused by Baudelaire. In Benjamin's reading of Baudelaire's 'correspondences', the commingled 'perfumes, colours, and sounds' are removed from history and placed anterior to experience as 'data of prehistory'. This marks an attempt to secure experience 'in crisis-proof form', to place the absolute beyond historical experience and to make it an object of ritual.

The securing of the absolute outside of the data of historical experience was not the only way to bear witness to the 'disintegration' of aura. The removal of the absolute from history results in its abolition: the experience of the absolute becomes spectral, as in the bells of Baudelaire Spleen which 'are like the poor souls that wander restlessly, but outside of history' (1938: 144). The destruction of experience follows from such days of recollection 'not marked by any experience'. The correlate of the prehistoric correspondences is the posthistoric Messiah – both mark the exteriority of the absolute to spatio-temporal experience, and both entail the reintroduction of ritual into politics.

Another possible witness to the decay of aura is not the Messianic end of history but the recognition of the absolute in the decaying ruins of modern experience. Here the fragments from the catastrophic destruction of aura are, in the words of *The Work of Art in the Epoch of its Technical Reproducibility*, gathered 'under a new law'. Art provides a witness to the new law, one in which the colour of modern experience both 'reflects' its decay and bears the promise of the new covenant. The act of aesthetic witness is exemplified by a contrast Benjamin draws between two responses to the 'lustre of a crowd', that of Baudelaire and that of impressionist painting. Baudelaire rejects the 'glitter' of the crowd, and retreats to a realm of happiness outside of history, condemning experience to a play of mourning for what has been lost. Impressionist painting, by contrast, explores the possibilities for happiness released by the colour of the crowd and the experience of modernity.

151

Benjamin describes the impressionist exploration of the absolute through the decayed forms of modern experience in a footnote to *On Some Motifs in Baudelaire*. The footnote departs from a short story by Hoffman, 'The Cousin's Corner Window', which tells of a man who watches the crowd in the marketplace below in order to enjoy 'the changing play of the colours' (1939c: 130). Benjamin identifies the happiness enjoyed in this experience with the reorganisation of the structure of experience carried out in impressionist painting. This experience was certainly decayed, but maintained within it the possibility of a new law, of a reorganisation of experience through colour:

> the technique of Impressionist painting, whereby the picture is garnered in a riot of dabs of colour, would be a reflection of experiences with which the eyes of a big-city dweller have become familiar. A picture like Monet's 'Cathedral of Chartres' which is like an ant-heap of stone, would be an illustration of this hypothesis.
>
> (1938c: 130)

The witness to this reorganisation is inconspicuous; the new experience does not come in a Messianic wave of power and light, but in the nuances of riotous colour. The 'multiple fragments assembled under a new law' remain fragments of colour, but, to use one of Benjamin's preferred metaphors, they together generate the image of a mosaic.

The destruction of traditional experience does not inaugurate an 'age of absolute sinfulness' which only the Messiah can redeem. It is certainly catastrophic, but the technical and social disruption of tradition bears with it the seeds of new forms of organisation, many of which may not be immediately or ever realised. Benjamin's speculative philosophy at its strongest moments does not seek truth in completeness, but in the neglected detail and the small nuance. The speculative power of the excluded is episodic and unpredictable, and it is this frangibility, as of a rainbow, which makes it an occasion for hope, which is, after all, even if not for him and not for us, only another way of saying 'future'

NOTES

INTRODUCTION

1 C, 322. The book referred to is *Der Ursprung des deutschen Trauerspiels* written 1924–5 and published in 1928. Throughout I have translated *Trauerspiel* as 'Mourning Play' rather than its more usual but inaccurate translation 'Tragic Drama'.

2 C, 359. Benjamin proposed to seal his claim for critical premiership by publishing a collection of critical essays. See Chapter 2, below.

3 Friedrich Nietzsche, *The Will to Power*, trs. Walter Kaufman and R.J. Hollingdale, New York: Vintage Books, 1968, p. 319.

4 See R.G. Smith's *J.G. Hamann: A Study in Christian Existence*, London: Collins, 1960, esp. pp. 209–21.

1 THE PROGRAMME OF THE COMING PHILOSOPHY

1 See Benjamin's autobiographical *Lebenslauf* II in GS VI, 216.

2 In *On Perception* Benjamin rests his claim for a speculative philosophy on the basis of the neo-Kantian abolition of the distinction between intuition and understanding: 'with the elimination of that distinction we begin to discern the outlines of a development of the transcendental philosophy of experience into a transcendental or speculative philosophy' (SW, 95).

3 These include the sizeable 1916 fragment *On Language as Such and on the Language of Man* and the 1921 preface to the translation of Baudelaire's *Tableaux Parisiens*, *The Task of the Translator*; the aesthetic fragments from 1916 on tragedy and the mourning play which formed the 'conception' of *The Origin of German Tragic Drama*, and the 1919 doctoral dissertation *The Concept of Art Criticism in German Romanticism*; and the 1921 *Critique of Violence*.

4 These fragments are collected in GS VI and VII, with a selection translated in SW.

5 For Benjamin's detailed account of this see *On Perception* (SW, 93–6).

6 See SW, 95 with explicit reference to 'speculative metaphysics before Kant'. It was Adorno's misunderstanding of Benjamin's speculative philosophy that led to their differences in the 1930s, when Adorno attempted to reorient Benjamin's concept of experience in terms of the neo-Hegelian concepts of totality and mediation.

7 'Wahrnehmung ist lesen/Lesbar ist nur in der Fläche [E]rscheinendes . . ./Fläche die Configuration ist-absoluter Zusammenhang' (GS VI, 32).

8 Gershom Scholem, *Walter Benjamin: The Story of a Friendship*, tr. Harry Zohn, Philadelphia: The Jewish Publication Society of America, 1981, p. 61.

9 There have been several attempts to map the distinction between a 'mystical' and a 'materialist' orientation in Benjamin's thought upon the two versions of this text; unfortunately,

the preferred candidate for the 'materialist' version – *On the Mimetic Faculty* – is in many respects more uncompromisingly occult than the 'mystical'.

10 The transcendental surface may be understood according to the analogy of the projection of an object (sphere) three-dimensional space onto a two-dimensional surface. In this projection information is lost which cannot be retrieved by an inverse operation, but whose loss nevertheless leaves discernible traces in the distortion and warping of the two-dimensional figure.

11 At one point Benjamin considered writing his doctoral thesis on Kant's concept of the 'endless task'; for his drafts towards this project, which are clearly of significance for his philosophy of history, see GS VI, 51–3.

12 It should be noted here that 'Hegelian speculative philosophy' refers to Benjamin's interpretation of it as a totalising metaphysics; for a divergent reading see Gillian Rose, *Hegel: Contra Sociology*, London: Athlone, 1995.

13 In a fascinating text preceding the dialogue – *A Child's View of Colour* (1914b) – Benjamin prepares this distinction between chromatic configuration and inscription. This will be discussed below, but it might be helpful to anticipate by citing two sentences which underline the differences between configuration and inscription: 'Where colour provides the contours, objects are not reduced to things but are constituted by an order consisting of an infinite range of nuances' (1914b: 50) and 'For a pure vision is concerned not with space and objects but with colour, which must indeed be concerned with objects but not with spatially organised objects' (1914b: 51).

14 In the dialogue Georg likens this experience to a 'rush' (*Rausch*) of intoxication. At this point the rush is induced by alcohol, but later Benjamin would experiment with hashish and at least considered opiates.

15 Benjamin writes of this, 'To create directly out of phantasy means to be divine. It means to create directly from the laws, immediately and free from the relation to form'. Divine creation does not proceed by means of the inscriptions of form, or the demarcations of human law. This argument will recur in the form of God's creative word in *On Language as Such and on the Language of Man* and as divine violence in *The Critique of Violence*. What is perhaps more interesting in this allusion to divine creation (supported by reference to Neo-platonism) is the fact the immanent infinity is informed by laws which do not take the form of human inscription.

16 This perhaps marks the beginning of Benjamin's research into children's perception and their experience of colour. For many years Benjamin considered writing a study of the use of colour in children's literature.

17 Benjamin visited the Altarpiece in Colmar in 1912 and 1913 (see C, 42); he refers to it again in his 1917 article *Dostoyevsky's The Idiot*.

18 This interpretative position draws support not only from the argument of the 1916 essay, but also from Benjamin's references to the work of Hamann, a contemporary of Kant in Königsberg who as early as 1781 proposed a mystical/linguistic metacritique of the *Critique of Pure Reason*.

19 Benjamin refers twice to the 'elimination' or the 'crystal pure elimination of the ineffable'. His insistence underlines the need to maintain a place for the absolute within experience.

20 In the language of set theory, which Benjamin was studying at this time, the infinite set is one which can be put into one-to-one correspondence with a proper subset of itself.

21 Benjamin's continuing interest in the philosophy of mathematics is evident even in his announcement two years later to Scholem in a letter dated 30 March 1918 that he will have to 'put off' 'Mathematics and any further grappling with Kant and Cohen' in order to concentrate on his dissertation.

22 See GS VI, 9–11.

23 This thought informs the celebrated essay *The Task of the Translator* which is precisely to translate the designations of linguistic intention.

24 The reflexive *sich* of *sich mitteilen* is not necessarily the defined entity suggested by its translation as 'itself'.

25 The crucial term *geistige Wesen* is borrowed directly from the philosophy of colour, and precisely from that part which argues that colour is not a medium of expression for discrete contents, but a condition for their appearance as such: 'Seen in itself, [colour] projects either, in painting – the space in things – or, in its own domain – concerns itself with the spiritual essence [*geistige Wesen*] of things, and not their substance' (GS VI, 118). Its psychologistic translation as 'contents of the mind' and 'mental content' is wholly inappropriate and misleading.

26 Effectively the second case collapses into the first – all that can be communicated is language as such, anything outside of its limits cannot be communicated.

27 Benjamin did not consider language to be a uniquely human achievement, defining it generically as any system of expression.

28 With this Benjamin establishes a link between his philosophy and his critical work on the genre of the mourning play, which he was preparing at the same time. For a discussion of the relationship between this text and the contemporary fragments on the mourning play see below, pp. 52–5.

29 At one point Benjamin illustrates the distinction between a particular linguistic surface and the source of the configuration of linguistic surfaces in terms of a distinction between the identity of all 'that *appears* most clearly in its language' and that which signifies 'the *capacity* for communication'. The former denotes language as an infinite surface of expression, the latter as an infinite capacity for configuring surfaces of expression.

30 For the reference to Hegel, rare in Benjamin's *oeuvre*, see C, 113; it is also noteworthy that Benjamin begins, after 1917, to follow Cohen in eliding Kant and Plato's versions of the metaphysics of experience.

31 See among others the fragments on 'The Endless Task' and 'On Kantian Ethics' in GS VI, 51 & 54; at various stages Benjamin considered writing his doctoral thesis on an aspect of Kant, whether on his notion of history (see his letter to Scholem, 22 October 1917, C, 98) or the 'endless task' (letter to Scholem, 7 December 1917, C, 103). Even the eventual thesis topic – romantic art criticism – was chosen because of its 'historically and fundamentally important congruence with Kant' (Letter to Ernst Schoen, May 1918 (C, 125)).

32 Letter to Schoen, May 1918 (C, 125).

33 See for example Adorno's critique of the *exposé* of the Arcades Project *Aesthetics and Politics* ed. Ronald Taylor, London: NLB, 1977, pp. 110–20.

34 Benjamin had an abiding fascination for this work of (what might now be described as) 'science fiction'. He wrote an initial critique of it in 1919, and in 'The True Politician' apparently undertook to prove that 'Pallas is the best of all worlds' (C, 151).

35 The air balloon might swell like a fruit, but surely not the gondola . . .

2 SPECULATIVE CRITIQUE

1 GS II.1, 105.

2 The ellipsis omits a fascinating reference to Hölderlin and Benjamin's approbation of his thought of an 'infinite (precise) composition'.

3 Benjamin intensifies this thought of the absolute as a medium to the extent of saying later 'there is in fact no knowledge of an object by a subject. Every instance of knowing is an immanent connection in the absolute' (1919: 146).

4 The two options were pursued by two of Schlegel's closest readers: the first in Hegel's philosophy of art – which translated artistic contingency into philosophical necessity – the second in Erwin Solger's philosophy of irony.

5 *Ursprung des deutschen Trauerspiels*, GS I.1.

6 These moods are comparable with those of courage and hope which informed the Hölderlin and Goethe essays.

7 Indeed, capitalism is present in Protestantism as one of its excessive futures – initially it 'developed as a parasite of Christianity in the West . . . until it reached the point where Christianity's history is essentially that of its parasite – that is to say, capitalism' (1921c: 289).

8 This passage is followed by a fascinating discussion of Nietzsche, Marx and Freud which focuses on Nietzsche's *Übermensch* as the type of the post-Christian human, who does not seek expiation but intensified movement which results in the 'demolition of heaven by an intensified humanity' (1921c: 289).

9 For a more detailed analysis of the themes of *The Origin of the German Mourning Play* see my article 'The Significance of Allegory in Benjamin's *Origin of German Tragic-Drama*, in F. Barker *et al.* (eds), *1642: Proceedings of the Essex Conference in the Sociology of Literature*, Colchester (no publisher), 1982.

10 The contract is reproduced in Brodersen 1996: 183. With the exception of major essays on Gide and Art Nouveau, all of the intended essays were completed by Benjamin and published separately elsewhere. According to the contract this collection superseded a previous volume (1928) of three essays including two on Kafka and Proust.

11 He wrote of it: 'And though many – or a sizable number – of my works have been small-scale victories, they are offset by large-scale defeats. I do not want to speak of the projects that had to remain unfinished, or even untouched, but rather to name here the four books that mark the real site of ruin or catastrophe, whose furthest boundary I am still unable to survey when I let my eyes wander over the next years of my life. They include the *Paris Arcades*, the *Collected Essays on Literature*, the *Letters* [subsequently published in 1936 as *Deutsche Menschen*], and a truly exceptional book about hashish.' Letter to Scholem, 26 July 1932 (C, 396).

12 These comprise fragments 132–42 in GS VI, including such titles as *Programm der literarischen Kritik, Tip fur Mazene*, and *Die Aufgabe des Kritikers* and *Falsche Kritik*.

13 See the Letters to Hofmannsthal, 16 August 1927 (C, 317), and to Horkheimer, 24 December 1936 (C, 536).

14 Benjamin offers the example of the stocking which, folded into itself is both 'bag' and 'present' (1929c: 206). This recalls the theme of the Goethe essay – wrapping of the veil and the veiled – if unwrapped the enigma becomes just a sock.

15 In a letter to Scholem of 30 October 1928 Benjamin referred to this work as a 'new theory of the novel that lays claim to your highest approval and a place beside Lukacs' (C, 342).

16 Benjamin goes on to describe the Paris of the *flâneur* as split between two dialectical poles of landscape and home: 'It offers itself to him as landscape, it embraces him like a room.'

17 In a letter to Scholem of 30 January 1928 Benjamin still considered the essay – with the working title 'Paris Arcades: A Dialectical Fairy Play' – to be the work of a few weeks.

18 Benjamin considered these writings as complementary, see his letters to Brecht (21 May 1934 (C, 443)) and Adorno (28 April 1934 (GS II.3, 1380)).

19 See *One Way Street* (1928b: 486–7).

3 THE WORK OF ART

1 At the end of *One Way Street* the relationship of technology and nature can be resolved either in the convulsive rhythms of epilepsy – 'In the nights of annihilation of the last war the frame of mankind was shaken by a feeling that resembled the bliss of the epileptic' – or the orgasmic rhythms of 'the ecstasy of procreation' (1928b: 487).

2 See C, 101; in the essay on language Benjamin insisted that language was a bounded infinity which communicated only itself.

3 Benjamin returns to this distinction in *One Way Street*: 'Script – having found, in the book, a refuge in which it can lead an autonomous existence – is pitilessly dragged out into the street by advertisments and subjected to the brutal heternomies of economic chaos. This

is the hard schooling of its new form. If centuries ago it began gradually to lie down, passing from the upright inscription to the manuscript resting on sloping desks before finally taking itself to bed in the printed book, it can now begin just as slowly to rise again from the ground. The newspaper is read more in the vertical than the horizontal plane, while film and advertisment force the printed word entirely into the dictatorial perpendicular. . . . Other demands of business go further. The card index marks the conquest of three-dimensional writing, and so presents an astonishing counterpoint to the three-dimensionality of script in its original form as rune or knot notation' (1928b: 456).

4 The disjunctive categories of relation and modality form a fascinating but unexplored exception to this rule in Kant's table of the categories. For example, the significance of possibility is not only gained in relation to intuition, but also from its relation to logical impossibility.

5 *Zur Aktualität Walter Benjamins*, hsg., Siegfried Unseld, 51.

6 Benjamin was also deeply influenced by Riegl's distinction between haphic and ocular forms of perception; as will be seen, this distinction plays an important role in *The Work of Art in the Epoch of its Technical Reproducibility*.

7 For the dangers of an appeal to culture see 1940: 258.

8 Benjamin identified this danger in Fuchs's tendency towards an intuitive logicism: 'The course of art history is seen as *necessary*, styles in art as *organic*, even the most disconcerting art forms as *logical*' (1937: 368).

9 Citations from a letter to Werner Kraft 27 December 1935 (C, 517). After describing *The Work of Art in the Epoch of its Technical Reproducibility* as a 'programmatic essay in art theory' Benjamin continued, 'In terms of content it bears no relationship to the long book which I mentioned I was planning. Methodologically, however, it is most intimately related to it, since the locus of contemporaneity in the objects whose history is meant to be presented must be precisely fixed before any historical work is undertaken . . .'.

10 The historian 'grasps the constellation which his own era has formed with a definite earlier one' (Thesis XVIII on the Philosophy of History) (1940: 265).

11 *Paris Arcades*, Convolut N, G. Smith (ed.), *Benjamin: Philosophy, History, Aesthetics*, Chicago and London: University of Chicago Press, 1989, p. 60.

12 Benjamin reiterated the importance of the constellation formed by *The Work of Art in the Epoch of its Technical Reproducibility* and the *Arcades Project* on several other occasions: in a letter to Scholem of 24 October 1935 he wrote of the former 'These reflections anchor the history of nineteenth century art in the recognition of their situation as experienced by us in the present' (C, 514) to Werner Kraft on 27 December 1935 he wrote that 'the locus of contemporaneity in the objects whose history is meant to be presented must be precisely fixed before any historical work is undertaken' (C, 514); while to Alfred Cohn on 26 January 1936 he noted that the essay 'fixes the contemporary locus, whose conditions and problems will set the standard for my retrospective look at the nineteenth century' (C, 519).

13 The first version has only 'coins and terra cottas' (1935b: 446).

14 Indeed, if the 'authentic' were capable of being lost, then it cannot have been very authentic, since 'authenticity' is precisely that which cannot be lost.

4 THE EXPERIENCE OF THE CITY

1 Sometimes even to names of cities that no longer exist, as in Place Stalingrad in Paris.

2 Benjamin visited Moscow in the winter of 1926–7, during the period of the 'New Economic Policy'. For more details of his stay, see the *Moscow Diary*.

3 The theme of eternal return in urban experience returns as a central organising concept of the *Arcades Project*.

4 In an article from 1928 entitled *Books That Are Still Alive* Benjamin identified *History and Class Consciousness* as one of four 'major works of German scholarship, those erudite

confessions whose burial in specialist libraries is but a special kind of oblivion'. These were first of all Alois Riegl's *Late Roman Art Industry* (Vienna, 1901) of which Benjamin commented: 'This epoch-making work applies, with prophetic certainty, to the monuments of the late Roman Empire the insights and the feeling for style which was to characterise Expressionism twenty years later . . . no other work in art history in recent decades has had the same fruitful influence in terms of both content and method.' The second was Alfred Gotthold Meyer's *Building with Iron* (Esslingen, 1907) which 'recognised, and described with uncompromising clarity, how the laws of technical construction at the beginning of the century became, through the construction of the home, laws of life itself. If Riegl anticipated Expressionism, this book anticipates New Objectivity.' The third of the books was Franz Rosenzweig's *Star of Redemption*, in Benjamin's words: 'a system of Jewish philosophy. The work is noteworthy for its origins in the trenches of the Macedonian front, and marks the victorious entry of Hegelian dialectic into Hermann Cohen's *Religion of Reason out of the Sources of Judaism*.' The last of the four books was none other than Lukács' *History and Class Consciousness* (Berlin, 1923) which Benjamin praised as 'the most integrated philosophical work of the Marxist literature. Its uniqueness lies in the certainty with which it discerns in the critical situation of philosophy the critical situation of the class struggle, and in the coming revolution the absolute presupposition, even the accomplishment and last word of theoretical knowledge' (*Die Literarische Welt*, 17 May 1929, GS, III, 169–71).

5 Letters to Scholem, 23 April 1928 (C, 333) and 15 March 1929 (C, 348).

6 Benjamin drew all these factors together in an account of the origins of the project written to Adorno on 31 May 1935, adding to them the importance of the meeting with Brecht, 'bringing with it the high point of all aporias relating to the project' (C, 489).

7 Apart from the paralipomena the surviving remains of the *Arcades Project* comprise thirty-six 'konvoluts' or headed files listed in terms of alphabetical upper and lower cases (all upper case letters used, not all lower case) in which Benjamin collected citations from a wide range of sources and added his own observations. The headings of the files refer to names (Baudelaire, Fourier, Marx Daumier), characters (the collector, the *flâneur*, and institutions).

8 Naples of course itself possesses a splendid arcade in la galleria Umberto I, which Benjamin could not have missed when walking to the city from the Capri ferry.

9 Already in 'Naples', the mention of the arcade was accompanied by a sense of the demonic character of its space, being a 'fairy tale gallery' where the careless *flâneur* might 'fall prey to the devil' (1924: 419).

10 'Convolut N', p. 50.

11 The fragments currently available are 'Paris of the Second Empire in Baudelaire' (1938) and 'On Some Motifs in Baudelaire' (1939). The Baudelaire book has been the occasion for an academic debate on the issue of whether the book superseded the *Arcades Project*, a position which rests on a misunderstanding of the relationship between the project and its associated critical essays. More than paralipomena, these critical works depend on the *Arcades Project* while also contributing experimentally to the refinement of its major themes.

12 *Briefe II*, pp. 751–2

13 Letter from New York, 10 November 1938, in *Aesthetics and Politics*, London: New Left Books, 1979, pp. 129–30.

14 See *Aesthetics and Politics*, p. 136.

15 Benjamin's focus upon marginal figures and Baudelaire's poetry of marginality is in complete agreement with his earlier conviction that speculation should depart from whatever, or now whoever, is excluded or marginalised.

16 *Some Motifs in Baudelaire* (CB, 120). This is the reworked version of 'Paris of the Second Empire in Baudelaire' which contains some interesting developments of the themes announced in the earlier version, but at a much reduced level of intensity.

17 Ibid. (CB, 154. Benjamin goes on to describe the *Erlebnis* which provokes Baudelaire's poetic *Erfahrung* in terms of 'the price for which the sensation of the modern age may be had: the disintegration of aura in the experience of shock'.
18 GS V.I, J 72, p. 449.
19 Ibid., p. 450.
20 C. Day Lewis's translation.

BIBLIOGRAPHY

Works by Walter Benjamin cited in the text

1913 *Ziele und Wege der studentisch-pädagogischen Gruppen*, GS II.1, 60–5.

1914a *Metaphysik der Jugend* (*Metaphysics of Youth*), GS II.1; SW, 6–17.

1914b *Die Farbe von Kinder aus betrachtet* (*A Child's View of Colour*), GS VI; SW, 51–2.

1914c *Die Reflexion in der Kunst und in der Farbe* (*Reflection in Art and in Colour*), GS VI, 117–18.

1914d *Die religiose Stellung der Jugend*, GS II.1, 72–4.

1915a *Zwei Gedichte von Friedrich Hölderlin* (*Two Poems by Friedrich Hölderlin*), GS II.1; SW, 18–36.

1915b *Das Leben der Studenten* (*The Life of Students*), GS II.1; SW, 37–47.

1915c *Der Regenbogen: Gespräch über die Phantasie* (*The Rainbow: A Dialogue on Phantasie*), GS VII, 19–26.

1915d *Der Regenbogen* (*The Rainbow or the Art of Paradise*), GS VII, 562–4.

1916a *Über Sprache überhaupt und über die Sprache des Menschen* (*On Language as Such and on the Language of Man*), GS II.1; SW, 63–74.

1916b *Das Glück des antiken Menschen* (*The Happiness of Ancient Humanity*), GS II.1, 126–8.

1916c *Über das Mittelalter* (*On the Middle Ages*), GS II.1, 132.

1916d *Trauerspiel und Tragödie* (*Mourning Play and Tragedy*), GS II.1; SW, 55–8.

1916e *Die Bedeutung der Sprache in Trauerspiel und Tragödie* (*The Significance of Speech in Mourning Play and Tragedy*), GS II.1; SW, 59–61.

1917a *Malerei und Graphik* (*Painting, and the Graphic Arts*), GS II.2; SW, 82.

1917b *Über die Malerei oder Zeichen und Mal* (*Painting, or Signs and Marks*), GS II.2; SW, 83–6.

1917c *Über die Wahrnehmung* (*On Perception*), GS VI; SW, 93–6.

1918 *Über das Programm der kommenden Philosophie* (*On the Program of the Coming Philosophy*), GS II.1; SW, 100–10.

1919 *Der Begriff der Kunstkritik in der deutschen Romantik* (*The Concept of Art Criticism in German Romanticism*), GS I.1; SW, 116–200.

1920 *Zur Malerei* (*On Painting*), GS VI, 113–14.

1921a *Zur Kritik der Gewalt* (*Critique of Violence*), GS II.1; SW, 236–52.

1921b *Die Aufgabe des Übersetzers* (*The Task of the Translator*), GS IV.1; I, 69–83.

1921c *Kapitalismus als Religion* (*Capitalism as Religion*), GS VI; SW, 288–91.

1921d *Die Bedeutung der Zeit in der Moralischen Welt* (*The Meaning of Time in the Moral Universe*), GS VI; SW, 286–7.

1921e *Zu einem Arbeit über die Schonheit Farbiges Bilder in Kinderbuchern* (*Notes for a Study of the Beauty of Coloured Illustrations in Children's Books*), GS VI; SW, 264–5.

1922a *Goethes Wahlverwandschaften* (*Goethe's Elective Affinities*), GS I.1; SW, 297–36.

160

1922b *Ankundigung der Zeitschrift: Angelus Novus (Announcement of the Journal: Angelus Novus)*, GS II.1; SW 292–6.

1924 (with Asja Lacis) *Neapel (Naples)*, GS IV; SW 414–21.

1926 *Franz Hessel*, GS III.

1927a *Die politische Gruppierung der russischen Schriftsteller (The Political Groupings of Russian Writers)*, GS II.2, 743–51.

1927b *Moskau (Moscow)*, GS IV.1; OWS, 177–208.

1927c *Gottfried Keller*, GS II.1,288–95.

1927d *Franz Hessel, Heimliches Berlin (Franz Hessel, Secret Berlin)*, GS III, 82–4.

1927e *Passagen (Arcades)*, GS V, 1041–3.

1927f *Pariser Passagen I (Paris Arcades I)*, GS V, 993–1038.

1927g *Pariser Passagen II (Paris Arcades II)*, GS V, 1040–59.

1928a *Ursprung des deutschen Trauerspiels (The Origin of the German Mourning Play)*, GS I.1; tr. John Osborne, London: NLB/Verso, 1977.

1928b *Einbahnstrasse (One Way Street)*, GS IV.1; SW, 444–88.

1929a *Der Surrealismus (Surrealism)*, GS II.1; OWS, 225–34.

1929b *Piscator und Russland (Piscator and Russia)*, GS IV.1, 543–5.

1929c *Zum Bild Prousts (The Image of Proust)*, GS II.1; I, 203–17.

1929d *Bücher, die lebendig geblieben sind (Books that have Remained Alive)*, GS III, 164–71.

1929e *Die Wiederkehr der Flâneurs (The Return of the Flâneur)*, GS III, 194–9.

1930a *Krisis des Romans (Crisis of the Novel: On Döblins Alexanderplatz)*, GS III, 230–6.

1930b *Theorien des deutschen Fascismus (Theories of German Fascism)*, GS III; tr. Jerolf Wikoff, *New German Critique* 17 (1979): 120–8.

1930c Fragment 132: *Programm der literarischen Kritik (Programme for Literary Criticism)*, GS VI, 161–7.

1930d Fragment 136: *Erste Form der Kritik (First Form of Criticism)*, GS VI, 170–1.

1930e Fragment 137: *Die Aufgabe des Kritikers (The Task of the Critic)*, GS VI, 171–2.

1931a *Was ist das epische Theater? (What is Epic Theatre?)*, GS II.2; UB, 1–22.

1931b *Kleine Geschichte der Photographie (A Small History of Photography)*, GS II.1; OWS, 240–57.

1932–3 *Strenge Kunstwissenschaft (Rigorous Study of Art)* [1st version; 2nd version 1933], GS III; tr. Thomas Y Levin, *October* 47 (1988): 84–90.

1933a *Lehre von Ahnlichen (Doctrine of the Similar)*, GS II, 1; tr. Knut Tarnowski, *New German Critique* 17 (1979): 65–9.

1933b *Uber das mimetische Vermogen (On the Mimetic Faculty)*, GS II.1; OWS, 160–3.

1934a *Der Autor als Produzent (The Author as Producer)*, GS II.2; UB, 85–103.

1934b *Franz Kafka*, GS II.2; I, 111–40.

1935a *Brechts Dreigroschenoper (Brecht's Threepenny Opera)*, GS III; UB, 75–84.

1935b *Das Kunstwerk im Zeitalter seiner technischen Reproduzierbarkeit (The Work of Art in the Epoch of its Technical Reproducibility)* [First Version], GS 1.2, 431–69.

1935c *Paris, die Hauptstadt des XIX. Jahrhunderts (Paris, the Capital of the Nineteenth Century)*, GS V.1; CB, 157–76.

1936 *Pariser Brief (2). Malerei und Photographie (Paris Letter (2): Painting and Photography)*, GS III, 495–507.

1937 *Eduard Fuchs, der Sammler und der Historiker (Eduard Fuchs, Collector and Historian)*, GS II.2; OWS, 349–86.

1938 *Das Paris des Second Empire bei Baudelaire (The Paris of the Second Empire in Baudelaire)*, GS I.2; CB, 11–106.

1939a *Das Kunstwerk im Zeitalter seiner technischen Reproduzierbarkeit (The Work of Art in the Epoch of its Technical Reproducibility)* [Final Version], GS I.2; I, 219–53.

1939b *Zentralpark (Central Park)*, GS I,2; tr. Lloyd Spencer and Mark Harrington, *New German Critique* 34 (1985): 32–58.

1939c *Über einige Motive bei Baudelaire* (*On Some Motifs in Baudelaire*), GS I.2; I, 157–202.
1940 *Über den Begriff der Geschichte* (*Theses on the Philosophy of History*), GS I.2; I, 255–66.

Selected studies of Walter Benjamin

Monographs

Arendt, Hannah (1968) 'Walter Benjamin 1892–1940' in *Men in Dark Times*, San Diego: New York and London, Harcourt Brace Jovanovich.

Brodersen, Momme (1996) *Walter Benjamin: A Biography*, London: Verso.

Buck-Morss, Susan (1989) *The Dialectics of Seeing: Walter Benjamin and the Arcades Project*, Cambridge, Mass. and London: MIT Press.

Eagleton, Terry (1981) *Walter Benjamin, or Towards a Revolutionary Criticism*, London: NLB.

Handelman, Susan A. (1991) *Fragments of Redemption: Jewish Thought and Literary Theory in Benjamin, Scholem and Levinas*, Bloomington and Indianapolis: Indiana University Press.

Jennings, Michael (1987) *Dialectical Images: Walter Benjamin's Theory of Literary Criticism*, Ithaca and London: Cornell University Press.

McCole, John (1993) *Walter Benjamin and the Antinomies of Tradition*, Ithaca and London: Cornell University Press.

Mehlman, Jeffrey (1993) *Walter Benjamin for Children: An Essay on his Radio Years*, Chicago and London: University of Chicago Press.

Perret, Catherine (1992) *Walter Benjamin sans destin*, Paris: La Différance.

Scholem, Gershom (1981) *Walter Benjamin: The Story of a Friendship*, tr. Harry Zohn, Philadelphia: The Jewish Publication Society of America.

Witte, Bernd (1991) *Walter Benjamin: An Intellectual Biography*, tr. James Rolleston, Detroit: Wayne State University Press.

Wolin, Richard (1994) *Walter Benjamin: An Aesthetic of Redemption*, Berkeley and London: University of California Press.

Essay collections

'The Actuality of Walter Benjamin' (1993), *New Formations*.

Benjamin, Andrew and Osborne, Peter (eds) (1994) *Walter Benjamin's Philosophy: The Destruction of Experience*, London: Routledge.

'Commemorating Walter Benjamin' (1992), *Diacritics* 3–4.

Modern Language Notes (1992) 106–7.

Nagele, Rainer (1988) *Benjamin's Ground: New Readings of Walter Benjamin*, Detroit: Wayne State University Press.

Smith, Gary (ed.) (1989) *Benjamin: Philosophy, History, Aesthetics*, Chicago and London: University of Chicago Press.

INDEX

form 10, 12, 36, 39, 45, 64, 73, 77, 82, 88, 96
formalism 26, 89
freedom 25–7, 120
Fuchs, E. 91–3
future 7, 9, 35, 45, 60, 68, 70, 72, 78–9, 81, 92, 96, 103, 107, 119, 121, 133, 142, 148, 152

genius 44, 46, 100–1
God 19, 21
Goethe, W. 41, 47–9, 52, 63, 72, 134
Grünewald, M. 12, 151

hallucination 113
Haussmann, G.E. 122, 147
Hegel, G.W.F. 3, 6, 23, 41, 47, 52, 129, 148
Hessel, F. 64, 72–3, 80, 132
history 8, 80, 91, 101, 142, 151
Hofmannsthal, H. von 55, 129
Hölderlin, F. 36–41, 46, 48, 52, 63, 72, 134
hope 51, 63, 134, 142
Horkheimer, M. 97
Hugo, V. 119, 137–8

idea 2, 25–6, 35, 39, 58, 89
identity 11, 21–2, 103, 108, 131
illusion 50
image 10, 76, 80–1, 86, 88, 108, 141–3, 147
imagination 10
infinite 4, 6, 9, 11, 14, 17, 21–2, 42–3, 81, 83
intuition 2, 23, 37–9, 81, 83, 105, 112, 123–4, 136 (see also concepts, Kant)

judgement 15, 23, 46, 64, 75, 108, 126

Kafka, F. 119
Kant, I. 2, 23–7, 35, 42, 48, 51, 77, 84–5, 129, 130
Keller, G. 64–6, 80
knowledge 25

lament 20, 52, 54, 81, 138, 142
landscape 8, 10–11, 30–1, 59, 65, 68, 147
language 13–14, 16–22, 55
law 21, 27–8, 83, 152
Leibniz, G. 44
life 37, 48, 50–1, 61
light 132
limit 22
love 48, 65, 150

Lukács, G. 71, 129–30, 158

madness 54
magic 98, 106, 110, 135
Marxism 47, 91, 98–9, 136, 143, 158
material content (Sachgehalt) 11, 22, 38, 49–50, 56–60, 91, 138
medium 87
melancholy 26, 60–1, 134
memory 66–7, 72, 81, 141
Messianic theme 149–52
metaphysics 24, 44
modernism 61, 72, 120
modernity 29–33, 55, 63, 69, 72, 77, 116, 134–5, 141, 143, 150
monad 44, 58
money 127, 129, 131
montage 64, 71, 74, 78, 100, 111
monumentality 93, 95–7, 105, 123, 125, 128
Moscow 72, 116, 118, 124–8
mourning 20, 52, 54, 59, 72, 77, 103
mourning play (Trauerspiel) 57–9, 138
Mouse, M. 31, 112
mysticism 23
myth 24

Naples 26, 116, 118, 121–4, 132
narrative 66
National Socialism 30, 128 (see also fascism)
Nietzsche, F.W. 26, 52, 56, 65, 125
nihilism 11, 27, 30, 32, 47, 56, 60, 93, 95, 117, 125, 129, 131, 150
Novalis 41

organisation 75–6, 81, 88, 96, 152
origin 52, 57–8, 69, 92, 133–4
originality 92, 101

Paris 69–70, 116, 118, 122, 129, 130, 132
past 60, 70, 72, 121
philosophy 23, 25, 30, 51, 121, 124
photography 71, 78, 94, 99, 102, 108, 114, 145
politicisation of art 39 (see also aestheticisation of politics)
politics, 27, 75, 79, 105, 206–7, 109, 117, 127, 134, 144–8, 151
porosity 26, 115–16, 120, 121–2, 125–6, 127, 130, 132
present 8, 9, 94–5, 121, 123, 125
progress 53, 92, 138, 143
proletariat 55–7, 73